Captured: The Animal Within Culture

Captured: The Animal Within Culture

Edited by

Melissa Boyde
Faculty of Law, Humanities and the Arts
University of Wollongong, Australia

First published 2014 by
PALGRAVE MACMILLAN

Palgrave Macmillan in the UK is an imprint of Macmillan Publishers Limited,
registered in England, company number 785998, of Houndmills, Basingstoke,
Hampshire RG21 6XS.

Palgrave Macmillan in the US is a division of St Martin's Press LLC,
175 Fifth Avenue, New York, NY 10010.

Palgrave Macmillan is the global academic imprint of the above companies
and has companies and representatives throughout the world.

Palgrave® and Macmillan® are registered trademarks in the United States,
the United Kingdom, Europe and other countries.

ISBN: 978–1–137–33049–9

This book is printed on paper suitable for recycling and made from fully
managed and sustained forest sources. Logging, pulping and manufacturing
processes are expected to conform to the environmental regulations of the
country of origin.

A catalogue record for this book is available from the British Library.

A catalog record for this book is available from the Library of Congress.

This book is dedicated to the dear cows Minstrel, Mintie and Minuet and the rest of their herd, to my beautiful furry boys Ambrose, Algie and Leo, and to the girls, Lillian the cat and Madeleine the goose

Contents

List of Illustrations

List of Plates

Acknowledgements

I would like to thank my colleagues in the English Literatures program and across various faculties at the University of Wollongong who participated in the Literature Identity and Culture seminar series 'Animals' which I convened in 2008 and which provided the initial impetus for this volume. The Global Animal conference in 2011, hosted by the Faculty of Arts and the Faculty of Creative Arts, was also a valuable forum for developing the project. I would like to thank the Colloquium for Research in Texts, Identities and Cultures (CRITIC) for financial assistance for proofreading, and my thanks to Dr Irmtraud Petersen for her efficient work on the collection. Thanks also to my former Head of School, Professor Leigh Dale, for her support of my work.

Sincere thanks to Professor Wendy Woodward for her valuable insights on my work, and for the questions she suggested for my interview with Ace Bourke. My gratitude to those who read and commented on the work at various stages: Assoc. Professor Anne Collett, Assoc. Professor Graham Barwell, Assoc. Professor Annie Potts, and Professor Una Chaudhuri. My colleague Dr Denise Russell has been a guiding light for my work in animal studies.

The ongoing conversation I have with Professor Peta Tait, over many years now, enriches my life and work. Heartfelt appreciation to Professor Amanda Lawson, who has helped in so many ways I hardly know how to thank her. For keeping an eye on the elderly, and not so elderly, animals at my farm while I was working on this book, thanks to my sister Julie and brother-in-law Dennis.

There are several people I want to thank for the Tall Horse cover image: the photographer Geoffrey Grundlingh; Basil Jones, Executive Producer of Handspring Puppet Company; Associate Director Janni Younge; and James Nilsen who worked tirelessly until the photograph was tracked down to the apricot farm (it's a long story).

Many thanks to the staff at Palgrave Macmillan, in particular Paula Kennedy who recognised the potential of the book and oversaw its production, and to Christine Ranft for her thorough editorial work. Chris Tiffin has once again created a splendid index. Finally, a very big thank you to each of the contributors for making this, if I may say so, a very worthwhile collection.

Notes on Contributors

Graham Barwell works in the Faculty of Law, Humanities and the Arts at the University of Wollongong, Australia. He has a long-standing interest in birds, especially in their place and role in human cultures, and has published on the albatross in particular. He nurtures his fondness for albatrosses by frequent participation in the pelagic trips run out of Wollongong by the Southern Oceans Seabird Study Association.

Anthony 'Ace' Bourke is one of Australia's leading independent art curators and is a specialist in Aboriginal and colonial art. Ace co-wrote with John Rendall *A Lion Called Christian* in 1971 (revised and updated 2009) and participated in two documentaries made about Christian and his return to the wild in Kenya with George Adamson. A clip of Ace and John's reunion with Christian in Kenya in 1971 caught the imagination of the world nearly 40 years later on YouTube where the clip has been viewed by more than 100 million people. Ace actively supports environmental and animal welfare causes.

Melissa Boyde is a Senior Research Fellow in the Faculty of Law, Humanities and the Arts at the University of Wollongong, Australia. Her research is in the fields of visual and literary modernism and animal studies. Her work in modernism is on the *roman à clef* and writers such as Hope Mirrlees and Renee Vivien. Boyde has curated exhibitions and written about Australian modernist artists Mary Alice Evatt and Moya Dyring. Her work in the field of animal studies is based in cultural theory and research with a focus on the lived experience of animals – particularly in the cattle industries in Australia. Boyde is chairperson of the Australian Animal Studies Group (AASG) and editor of the *Animal Studies Journal*: http://ro.uow.edu.au/asj.

Anne Collett is Associate Professor in the English Literatures Program at the University of Wollongong, Australia. She has published widely on postcolonial literatures, with a focus on poetry, women's writing and the relationship between literary and visual arts. Collett is currently co-authoring a book on the life and work of Australian poet, Judith Wright and Canadian painter, Emily Carr, and has recently published essays in the *Journal of Australian Studies* (2013, on Judith Wright and Japanese poet Bashō), *Social Alternatives* (2012, on a post-3/11 photographic

exhibition) and *Asiatic* (2012, on Maori poet Hone Tuwhare). She is the editor of *Kunapipi*: journal of postcolonial writing and culture.

Denise Russell is an Honorary Research Fellow in the Philosophy Program at the University of Wollongong, Australia. Denise was the founding editor of the journal *Animal Issues: Philosophical and Ethical Issues Related to Human/Animal Interactions* when in the philosophy program at the University of Sydney. Together with Melissa Boyde, she established the *Replace Animals in Australian Testing* (RAAT) website. She is the author of *Who Rules the Waves: Piracy, Overfishing and Mining the Oceans* (2010). She has published numerous articles in philosophy recently focusing on animal ethics.

John Simons is Executive Dean of Arts at Macquarie University, Australia, and previously worked at a number of universities in the UK. Since 2000 his research has concentrated on the history of cultural representations of animals. His monographs include *Animal Rights and the Politics of Literary Representation* (2002), *Rossetti's Wombat* (2008), *The Tiger that Swallowed the Boy* (2012) and *Kangaroo* (2013).

Peta Tait is Chair in Theatre and Drama at La Trobe University, Australia, and publishes on the practice and theory of theatre, drama and body based performance including animals and social languages of emotion. She is also a playwright. Her most recent books are *Circus Bodies: Cultural Identity in Aerial Performance* (2005), and *Wild and Dangerous Performances: Animals, Emotions, Circus* (2012).

Helen Tiffin has written several books on post-colonial literatures and literary theory, including *The Empire Strikes Back: Theory and Criticism in Post-colonial Literatures* (with Bill Ashcroft and Gareth Griffiths, 1989), *Postcolonial Ecocriticism: Literature, Animals, Environment* (with Graham Huggan, 2009) and *Wild Man from Borneo: A Cultural History of the Orangutan* (with Helen Gilbert and Robert Cribb, 2013). She is a Fellow of the Australian Academy of the Humanities and Adjunct Professor of English and Animal Studies at the University of Wollongong, Australia.

Yvette Watt is a Lecturer in Fine Art at the Tasmanian College of the Arts, University of Tasmania, Australia. She is a committee member of the both the Australian Animal Studies Group and the UTAS Animals and Society Study Group. Watt's art practice spans more than twenty years. She has held numerous solo exhibitions and has been the recipient of a number of grants and awards. Her work is held in numerous

public and private collections including Parliament House, Canberra, Artbank and the Art Gallery of WA. She has been actively involved in animal advocacy since the mid 1980s, and her artwork is heavily informed by her activism. Watt is a co-editor of, and contributor to the collection titled *Considering Animals: Contemporary Studies in Human–Animal Relations* (2011). Her essay 'Artists, Animals and Ethics' was published in the winter 2011 issue of *Antennae: the Journal of Nature in Culture,* and she was commissioned to contribute an entry on 'Animals Art and Ethics' for the *Encyclopedia of Animal Rights and Animal Welfare* (Marc Bekoff ed., 2010).

Wendy Woodward teaches southern African Literature, Animal Studies and Creative Writing in the English Department at the University of the Western Cape, Cape Town, South Africa. *The Animal Gaze: Animal Subjectivities in southern African Narratives* (2008) was awarded the Deputy Vice Chancellor's Book Award for 2006–2008. Her second volume of poetry, *Love, Hades and other Animals* (2008) deals with nonhuman animals in Greek myth and the quotidian, as well as intersections between family histories and colonialism. She was instrumental in organising the Colloquium 'Figuring the Animal in Post-Apartheid South Africa' (May 2011) at UWC, where a decision was taken to form the Animal Studies Round Table in Africa (ASRA) which now holds an annual colloquium at UWC. She is a Research Associate of the New Zealand Centre for Human–Animal Studies in Christchurch and was on the academic advisory board for the Minding Animals International Conference in Delhi in 2012. Her current research focuses on posthumanism, embodiment and animality in contemporary fiction.

Introduction

Melissa Boyde

In 2006 a clip was posted on YouTube which was to become a worldwide sensation. The clip showed footage of an emotional reunion between two men and a lion edited from a film made in 1971. A few years later another version of the clip was posted on YouTube, this time over-dubbed with an audio track of Whitney Houston singing the hit song 'I will always love you' and with captions at the bottom of the screen which told the story of how the two young men in the clip bought a lion cub in Harrods, kept him as a pet, then, eventually, rehomed him in Kenya on conservationist George Adamson's Kora Reserve. The clip ends with the caption: 'Love knows no limits and true friendships last a lifetime. Get back in touch with someone today. You'll be glad you did.' This multi-media experience went viral, and has by now captured the attention of more than 100 million viewers.

Key themes of *Captured: The Animal within Culture* are encapsulated in the story of Christian the lion's journey from Harrods 'Zoo' to Kenya: the physical captivity of animals in relation to the ways in which they are caught in the dynamics of human–animal relations – whether as commodities trafficked for profit or spectacle, as subjects of scientific or artistic endeavour, or pressed into metaphoric reflections of various human conditions. What are the implications for the lived reality of animals when they are all but erased in cultural representations and interpretations which figure them as 'the animal' and in service of human subjectivity?

As Jacques Derrida points out human language can imprison with a word:

> *Animal* is a word that men have given themselves the right to give. These humans are found giving it to themselves, this word, but as if

1

they had received it as an inheritance. They have given themselves the word in order to corral a large number of living beings within a single concept ... at the same time according themselves, reserving for them, for humans, the right to the word, the naming noun, the verb, the attribute, to a language of words, in short to the very thing that the others in question would be deprived of, those that are corralled within the grand territory of the beasts: The Animal. (Derrida 32)

The essays in *Captured* reveal implications for animals of the cultural elision of 'The Animal' caught within the limits of human discourses.

Many Western countries trade on images and words of social equality and freedom yet have the containment of animals at their heart – the captivity of animals is an accepted part of the landscape both figuratively and literally. Fencing, for example, demarcates not just property ownership but also the pervasive practices of keeping animals captive. Whether wild or captive, indigenous or introduced, animals are subject to human control. In Australia the infamous Rabbit Proof Fence, completed in 1907, crosses the continent from north to south. Its purpose was to keep rabbits and other so-called agricultural pests out of Western Australia, until the deadly *myxomatosis* virus was introduced in the 1950s to take its place. Meanwhile, strung along beaches in places such as South Africa, Australia and Hong Kong, nets shield humans from sharks. The large mesh size of the nets is designed so that sharks are caught and eventually drowned. An acknowledged 'downside' is the so-called by-catch of many other large marine animals including dolphins, sea turtles and dugongs. Marine animals are subject to an enormous capture in recreational and commercial fishing globally which seriously depletes fish populations as well as abalone, lobsters, squid and prawns. Research into long-line fishing shows that hundreds of thousands of albatrosses and other sea birds die each year as a result of drowning after attempting to eat the baits on long-line hooks.

Throughout the world, animals are captured by humans for pleasure and profit. When not wanted by humans, domestic dogs and cats are euthanased in their millions.[1] Millions more animals are kept captive as test subjects in research laboratories – estimated annual figures worldwide on animal use in toxicity testing, biomedical research and education amounts to more than 58 million 'living non-human vertebrates' (De Boo and Knight). Twenty-first century practices of intensive farming have reached new lows for animals held captive such as dairy cows, pigs and chickens – the conditions of their lives of confinement, their suffering and deaths, are widely documented by scholars and

animal activists but continue nevertheless.[2] Yet despite these kinds of realities for animals who are captured in a multiplicity of ways, humans most often turn a blind eye. The refusal to witness and the pretence of not knowing occurs even when the human gaze is directly focused on the captive animal. Film footage taken of Christian the lion's mother at the now defunct Ilfracombe zoo shows her relentlessly pacing, back and forth, in the cage in which she was forced to live. Like Christian's mother, there are all kinds of animals who live and die in zoos and who endure, 'whether or not someone happens to be watching … the constant servility of the subject under surveillance' (Malamud 222). Captured in practice, captured in culture: how these aspects of capture operate and interact in human–animal relations is a focus of the essays in this book.

In what may appear as a paradox, the invisibility of animal capture and the suffering it invariably brings takes place in the context of a proliferation of representations of animals in all aspects of human culture, indicating, among other things, intense human fascination with 'The Animal'. As Elizabeth Grosz points out, the word fascination has at its heart dual and opposite meanings: 'to attract, irresistibly enchant, charm'; or 'to deprive a victim of the powers of escape or resistance by look or presence' (Grosz 6). The human fascination with animals evokes both of these meanings; it may well be what Grosz describes as a 'consequence of an imaginary identification in which the self strives to incorporate the other in an act that is as aggressive as it is loving' (Grosz 6–7). The cultural capture of animals in media such as writing, performance and the visual arts is, as in all representation, at best partial, at worst not only misleading or obscuring but also a subsumption of all who are not human. To complicate this further, 'the lives of animals as currently configured generally resist meaningful cultural visitation on any significant scale' (Chaudhuri 10).

This collection of essays is framed with a word – captured – often used to suggest that a cultural representation of the real has been achieved. The violence inherent in the term captured – derived from the practices of capturing, experiences of being caught and living in captivity – is embedded in the phrases which simultaneously conceal it: capturing a likeness, captured on film, captured in a photograph. When used in relation to animals the word capture loses its potential to masquerade as benign and its other meanings become evident. The hidden lives of animals, taken captive through the violence of representation and in reality, emerge – even if initially only as shadowy presences.

In Chapter 1 Wendy Woodward writes about vulnerability and animal bodies, specifically giraffes who were forced from their African

homelands and taken to Europe. In her discussion of the puppet play *Tall Horse*, about a giraffe sent as a royal tribute to post-revolutionary France, and J. M. Ledgard's novel *Giraffe*, which tells the story of a herd of giraffes taken from Kenya to Soviet-defined Czechoslovakia in the 1970s in order to breed a new species, Woodward discerns an emphasis on the vulnerable giraffe body and 'embodied, vertiginous relationships between human and nonhuman'. The life-size giraffe puppet body in performances of *Tall Horse* functions as a reminder of the 'real' animal, and her vulnerable status as an exiled captive in Paris. In the novel, which culminates in the gratuitous slaughter of the herd, the textual insistence on the individual giraffe as a knowing subject forces an apprehension of embodied violence wrought on animals, even though 'the discourses of captivity disembody them'. These works, Woodward suggests, present ethical possibilities of reading and experiencing narratives of animal capture that can contribute to breaking down species boundaries.

The rise of commodity culture in the nineteenth century was long foreshadowed by the trading of animals across continents and oceans. Traffic in animals was common in the Roman Empire, for example, when thousands of animals from Asia and Africa were captured and transported by ship to be killed in bloody spectacles in the Colosseum or used for the entertainment of the wealthy. In Chapter 2 John Simons documents the extent of the trade in exotic animals in Victorian England, finding that from the early decades of the nineteenth century vast numbers of animals, including elephants and lions, were captured in places such as Africa and India and shipped to England. On arrival they were displayed in shops in cities such as London and Liverpool and sold for considerable sums of money. His work shows that well before commodity became entrenched as a defining social attribute, the ownership of exotic animals had been established as a symbol of status and wealth and contributed to the ideology of Empire. Simons's research reveals the cost to individual animals caught in the trade, such as koalas and wombats, many of whom died on the long boat journeys or were killed in their homelands and sold for their skins which 'were much prized as carriage rugs or hearth rugs'.

In Chapter 3 Ace Bourke, one of the young men who purchased Christian in Harrods, discusses the story in an interview which ranges from its origins in the commodity culture of London in the late 1960s – when as a lion cub Christian was displayed for sale as an exotic animal in a department store – to the twenty-first century media frenzy that erupted following the reunion's mass exposure via

YouTube. Interwoven with this narrative about human–animal relations and its emotional reception is another narrative which Melissa Boyde's interview with Bourke brings out: one which considers the physical experience of an individual lion, born in captivity, offered for sale as part of the 'exotic' animal trade, kept as a pet and, unusually, released into the wild; and the movement for wild animal protection that facilitated this outcome.

The trade in live animal export continues into the present and affects not only so-called exotic animals but also animals marked as human food. Live animal export is currently a multi-million dollar global industry in which captive 'farm' animals such as sheep and cattle are shipped live to destinations where those who survive the journey will be slaughtered for food. The industry has recently been in the spotlight in Australia after footage taken by animals activists showing the brutal slaughter in an Indonesian abattoir of cattle from Australia went to air in the national news media. In Chapter 4 Boyde suggests that the live export of cattle is an instance of what Giorgio Agamben refers to as the state of exception which renders those caught within it as both insiders and outsiders. The discussion of the blockbuster film *Australia* reveals that although the cattle are central to the narrative and for much of the film dominate the screen they are nevertheless unnoticed; the cattle are what Steve Baker refers to as 'the sign of that which doesn't really matter' (Baker 174). With reference to historical, statistical, legal and fictional accounts, the chapter discusses the creation and maintenance of such cultural blindspots and offers autobiographical material as a counter-discourse.

In Chapter 5 artist Yvette Watt explores the role of the artist in relation to the ethics of human–animal relationships, in this case to 'farm' animals. Watt poses the question 'Can contemporary art enact social change?' In her series of photographs of the exterior of actual factory farms to which she travelled in several states of Australia, Watt captures on film one of the most pervasive ways in which animals within human culture are made captive and rendered invisible. The choice of photography to show the outer reality of the culturally hidden practice of intensive factory farming not only resonates with the form itself but enables exposure: 'the photograph seems the ideal place to conceal a secret, given its confident manipulation of darkness and light. Both darkness and light rely upon each other for their existence ... the photograph alone has the power to tilt the balance' (Biber 105).

Several essays consider the limitations as well as the possibilities that arise when humans imagine and attempt to capture animal subjectivities,

lives and environments, as well as bodies, both for scientific and cultural purposes. In Chapter 6 Graham Barwell explores how cultural attitudes and representations of albatrosses were formed over the past two centuries through a variety of influences such as folklore, superstition, literature, religion, science and commercial practices. While the ethics of catching and killing these wild birds were often debated, particularly given longstanding cultural understandings of their prophetic significance, concern about the serious effects of human impacts on them did not become widespread until the twentieth century. As a result of publicity campaigns and an outpouring of accounts and representations of albatrosses in a variety of media, they became the focal point of wider concerns about the wildlife of the southern oceans, even for people who had no direct contact with the birds. Barwell asks whether the cultural imagining of the albatross has been and will be sufficiently powerful to challenge established understandings of the relationship between humans and the natural world.

In Chapter 7 Denise Russell considers particular communications of humpback whales, or whale songs, in the Pacific Ocean. Acknowledging recent research which indicates that the brain structures of Cetaceans may not only be shared with humans but also exceed human capabilities, Russell argues for the need to imagine new communicative and cognitive possibilities for whales, as well as new concepts of individual identity. While whale songs have often been aligned with sexual display, Russell contends that these are reductionist scientific accounts which should be held up to critical scrutiny and suggests that humans become more imaginative in their attempts to interpret whale communications.

The power of imagination, its Romantic affiliation with empathy and the associated capacity of a human being to imagine 'the other' is discussed by Anne Collett in Chapter 8. She discusses how two novels – J. M. Coetzee's *Disgrace* and Michelle de Kretser's *The Lost Dog* – take a position on the capacity of the 'poet' (imaginative writer) to create a fictional world in which that which is not self, and not human – in this case, the dog – is both represented and recognised as an equal subject. Collett asks: how do these novelists narrate a story of human–dog relationships in such a way that contradicts assumed superiority of the human over the nonhuman animal? And what might it mean to position the poet as 'chameleon' – to take Keats's famous phrase? The complex ethical position of the Romantic claim to 'sympathetic imagination', described by Coetzee's Elizabeth Costello, is considered. Collett discusses whether such a claim is an act of colonisation that maintains the power differential of a subject/object relationship, or an ethical act,

one which is essential if animals are to be made real to humans as 'subjects of justice' (Nussbaum 319) .

In Chapter 9 Helen Tiffin discusses how cultural representations of animals are often the major way in which humans develop a sense of familiarity with particular species. Tiffin suggests that Cephalopods, particularly octopus and giant squid, are more familiar to humans as 'shadows in the myths and legends we have concocted about them' than as living animals. The chapter, which traces representations of Cephalopods in a broad range of cultural material including texts such as Herman Melville's *Moby Dick*, Alfred Lord Tennyson's poem, 'The Kraken', ancient Greek artefacts, Japanese imagery and in contemporary popular culture, emphasises the paradox whereby they are feared as monstrous, yet captured for both human consumption and use in medical experimentation. In contrast to our 'unashamedly anthropocentric captures' of octopus and squid, Tiffin puts forward the idea that the practices of anthropomorphism may facilitate human recognition of our connectedness to animals and thereby work in favour of more equitable human–animal relations.

In Chapter 10 Peta Tait explores how representations of kangaroo identities in modernist popular culture reveal contradictory attitudes towards animals that have been habituated by body-based phenomenologies. The extent to which an animal species' identity is distorted – polarised to either endear or demonise – within human society becomes particularly apparent in entertainment, not only across species but also within species. Tait's approach shows how human attitudes to nonhuman animal species are accentuated by performance practices with captive animals. In an extreme example of the staging of kangaroos as human, kangaroos were coached from the 1890s through to the 1970s to perform live. Costumed as a boxer, the kangaroo in the circus appeared human-like, even though the act used the animal's repertoire of playful fighting movements in its staging of animality. The popular Australian TV series *Skippy*, filmed in a natural bush setting, showed the kangaroo as human friend and saviour. While the idea of the kangaroo was elevated through the training and use of captive individual kangaroos, the living wild animals were ignored, denigrated or culled. Tait discusses how emotional resonances that accompany or are created by the development of emotionally evocative symbolic shapes blind humans to living animals and allow schismatic values to arise in relation to the treatment of animal bodies.

The essays in this collection reveal and interrogate the intertwining concepts of capture, both in representation and in practice. In the process they provide ethical glimpses into the lives of animals who are

enduring subjects of human fascination, including: tigers, elephants, koalas, wombats, kangaroos, dogs, cattle, chickens, whales, cephalopods, albatrosses, one particular lion and a giraffe who walked to Paris.

Notes

1. For example, the American Society for the Protection of Animals estimates at least 3 million dogs and cats are euthanased in shelters every year: http://www.aspca.org/about-us/faq/pet-statistics.aspx. The Royal Society for the Protection of Cruelty to Animals (RSPCA) in Australia euthanased over 70,000 animals in the 2009–10 financial year: http://www.rspca.org.au/assets/files/Resources/RSPCAAnnualStats2009–2010.pdf
2. For example see Animal Studies Group, *Killing Animals*; Kalof and Fitzgerald, *The Animals Reader*.

Works cited

Animal Studies Group, The. *Killing Animals*. Urbana and Chicago: University of Illinois Press, 2006.

Baker, Steve. *Picturing the Beast: Animals, Identity and Representation*. Urbana: University of Illinois Press, 2001.

Biber, Katherine. *Captive Images: Race, Crime, Photography*. Abingdon, UK: Routledge-Cavendish, 2007.

Brown, Eric, ed. *Insect Poetics*. Minneapolis: University of Minnesota Press, 2006.

Chaudhuri, Una, ed. *TDR: The Journal of Performance Studies*. Special issue on Animals and Performance, March 2007.

Coetzee, J. M. *The Lives of Animals*. Princeton: Princeton UP, 1999.

De Boo, J., and A. Knight. 'Increasing the Implementation of Alternatives to Laboratory Animal Use'. *Alternatives to Animal Testing & Experimentation (AATEX)* 13.3 (2008): 109–17.

Derrida, Jacques. *The Animal That Therefore I Am (More to Follow)*. Trans. David Wills. New York: Fordham UP, 2008.

Grosz, Elizabeth. *Jaques Lacan: A Feminist Introduction*. New York: Routledge, 1990.

Malamud, Randy. 'Zoo Spectatorship'. *The Animals Reader: The Essential Classic and Contemporary Writings*. Ed. Linda Kalof and Amy Fitzgerald. Oxford: Berg, 2007. 219–36.

Mirzoeff, Nicholas. *The Visual Culture Reader*. 1998. 2nd edn. London: Routledge, 2002.

Nussbaum, Martha. 'Beyond "Compassion and Humanity": Justice for Nonhuman Animals'. *Animal Rights: Current Debates and New Directions*. Ed. Cass Sunstein and Martha Nussbaum. Oxford: Oxford UP, 2004. 299–320.

Woodward, Wendy. *The Animal Gaze: Animal Subjectivities in Southern African Narratives*. Johannesburg: Wits UP, 2008.

1

Verticality, Vertigo and Vulnerabilities: Giraffes in J. M. Ledgard's Novel *Giraffe* and in the Handspring Puppet Company's Play, *Tall Horse*

Wendy Woodward

Giraffes, with their beauty and charisma, have always been vulnerable to capture. Caught young, giraffes, or at least the females, can become tractable, even domesticated. No wonder then that Mehmet Ali, the Ottoman envoy in Egypt, wishing in 1826 to gain the support of Charles X of France in the Greek War of Independence decided to send an Ethiopian giraffe as a tribute and a highly desirable addition to the king's planned menagerie (Allin 64, 67). No wonder also that Czechoslovakian scientists and politicians in the 1970s committed to transforming and manipulating nature in order to glorify Communism set in motion a scheme to capture giraffes in Kenya and transport them to the Dvur Kralove zoo where they would breed a new species. In these histories of capture, the giraffes were made to perform their vertical identities. They were always already spectacle – to the French full of admiration for the single female giraffe made to walk from Marseilles to Paris, to the Czechs who marvelled at the giraffe herd in their local zoo, but as African animals exiled from their native environments, they were vulnerable to foreign climates and diseases and to the whims and schemes of their captors. The single giraffe was displayed in the first municipal zoo in early nineteenth-century France – a royal, exclusive menagerie no longer politically feasible in post-Napoleonic France – the herd in communist Eastern Europe was deployed for research as well as display.

The narratives of the Ethiopian giraffe and the Kenyan giraffes appear in two texts respectively: the puppet play *Tall Horse* (2006) and the novel *Giraffe* (2007) by J. M. Ledgard. *Tall Horse* tells initially of the trajectory of two young giraffes destined to be royal tributes, who were captured in the Ethiopian Highlands and then shipped to Marseilles. The more fragile giraffe was sent to the English king while the other was placed under the guardianship of one Hassan and the slave Atir. The illustrious scientist Geoffroy Saint-Hilaire came to ensure the safe passage of the giraffe who walked 7000 kilometres to Paris. This extraordinary journey inspired the South-African based Handspring Puppet Company in collaboration with the Sogolon Marionette Troup of Mali to bring to the stage the giraffe's story – an African animal who had enchanted all of France. Now, roughly a hundred and seventy years later (2004–2005), two African puppet companies could beguile international audiences with this play, which featured a life-sized giraffe puppet and only two human actors alongside many other puppets and puppeteers.

In the frame of the play Jean-Michel, a young Frenchman, enters the museum at Bamako, Mali in search of Atir his ancestor, and is magically drawn into the past as he transforms into Atir himself via a journey through the Special Collections. The play is not plot-driven but foregrounds a kind of pageantry as it depicts the responsiveness of the French and Atir to the young giraffe. The script is based on Michael Allin's account *Zarafa* (an Arabic word for gentleness and the etymological basis for the word giraffe), subtitled *The true story of a giraffe's journey from the plains of Africa to the heart of post-Napoleonic France* (1998). The historical giraffe Sogo Jan (her name in the play) lived in Paris for eighteen years. Atir, who accompanied her on much of her journey, remained her keeper for the rest of her life. Even if this *could* suggest a 'happy' story of a kind, or at least one of some stability and longevity for an African animal in Europe, the near-solitary captivity of a herd animal accustomed to unlimited space is a tragic diminishing of her life.

Like *Tall Horse*, the novel *Giraffe* is a dramatically effective and extraordinary story. The more recent giraffe narrative is one of tragedy, violence and state secrecy. When J. M. Ledgard, *The Economist* correspondent, was stationed in Eastern Europe in the 1980s, he was apprised of the silenced history of a herd of giraffes captured in Kenya in 1973 and transported to the Dvur Kralove zoo in the CSSR. The motivation behind acquiring these African animals (ironically they did not constitute a natural herd as they consisted of different strains) was to breed a new species for the glory of Communism. The breeding programme was

highly successful until the night of April 30 and the early morning of 1 May 1975 when the herd was massacred by orders from the Politburo. As Ledgard puts it in a postscript to his novel, *Giraffe*:

> The Dvur Kralove Zoo is still awaiting an official acknowledgement and explanation of the liquidation of its forty-nine giraffes... It was the largest captive herd in the world. Twenty-three of them are thought to have been pregnant. (327)

In the Acknowledgements, Ledgard thanks all his interviewees who remain anonymous – the scientists, the veterinarian, 'the sharpshooting forester Mr P, who still has nightmares about pulling the trigger' (327–8) – but he stresses that the truth remains hidden. The records of the professors have disappeared; a giraffe tongue dispatched to the University of Brno has never been located, nor have the containers of giraffe blood 'collected by a Security Service operative on the night of the shooting' (328).

Set initially in 1973, just five years after the Soviet Union had quashed Dubček's attempts at liberalisation in the CSSR and invaded the country, the novel is imbued with the stifling rigidities of communism and the characters' fears of Soviet surveillance during the Cold War. The narrative itself is polyphonic and begins with the point of view of Snehurka (or Snow White because of her unusually pale chest and underbelly) as she is being born, then her experience of her subsequent seizure and the start of the journey. Emil (rather heavy-handedly named) Freymann, the haemodynamicist, who travels with the giraffes from Hamburg to the zoo in the CSSR, studies 'the flow of blood in vertical creatures' (Ledgard 27). He interacts mainly with Snehurka, the most confident giraffe on the barge. He provides a sense of history of other diasporic animals, as he reiterates his ideological rejection of 'the communist moment' (19 and passim). Once the giraffes reach the zoo, the principal narrative voice is that of Amina, a young orphaned worker in a dangerously pollutive factory. The giraffes wake her from her somnambulism, both literal and metaphoric, of the sleepwalking life she leads and it is she who embodies some calm and love for them as they are massacred. This final, traumatic event is repetitively represented, told through the points of view of the witnesses and participants.

While the novel is a tragedy interlaced with stringent political critique of a heartless communist state and its effects on both human and nonhuman, the play is a social comedy replete with mostly gentle satire as it critiques the colonial narrative of Atir and Sogo Jan and celebrates

the advent and reception of the giraffe in France. My concern in this chapter is the recurring element in both play and novel, the vulnerability of the giraffe body, and the concomitant embodied, vertiginous relationships between human and nonhuman. The life-size giraffe puppet body in *Tall Horse* serves as a reminder of the live animal presence behind its construction, thus suggesting a way of reading both the play and the novel which incorporates animal ethics. This body is not a symbolic body, in the way that animal bodies have been made to stand for human character traits. Instead the puppet body approximates that of the 'real' giraffe being. As Basil Jones stresses, 'the primary work of the puppet is the *performance* of life' (254) as it 'striv[es] to depict and embody life' (255). This dramatic figuration of the animal body does not imagine the giraffe as a mere play of surfaces; on the contrary, the animal's interiority or subjectivity is undeniable.

Such a reading is underpinned by a number of theorists in Animal Studies who consider a focus on the body of the animal and the human an ethical, posthumanist strategy. Rosi Braidotti suggests a 'neoliteral approach' which eschews the metaphorisation of animals for an approach in which 'the other...needs to be taken on its own terms' (528). Following Deleuze and Guattari, she argues for 'an ethical appreciation of what bodies (human, animal, other) can do' proposing that:

> The animal...is rather taken in its radical immanence as a body that can do a great deal, as a field of forces, a quantity of speed and intensity, and a cluster of capabilities. This is posthuman body materialism laying the ground for bioegalitarian ethics (528).

For Cora Diamond in 'The Difficulty of Reality and the Difficulty of Philosophy' humans share an embodiedness with nonhuman animals which we 'respond to and imagine' and which counteracts the strangeness of animals. An intense appreciation of human embodiment encourages an acknowledgment of the common embodied vulnerability which we 'share' with animals, as well as a heightened awareness of physical mortality, so much so that this can elicit extreme feelings like panic (74).

In Cary Wolfe's analysis, like that of Braidotti and Diamond, posthumanism very specifically undermines anthropocentrism and speciesism, but rather than rejecting the human he recommends engaging with human particularity 'once we have removed meaning from the ontologically closed domain of consciousness, reason, reflection, and so on' (*Posthumanism* xxv). Thus we re-consider what we have always

accepted as 'human experience' by 'recontextualizing [the normal perceptual modes and affective states of *Homo sapiens* itself] in terms of the entire sensorium of other living beings and their own autopoietic ways of "bringing forth a world"' (xxv).

Anat Pick's consideration of posthumanism echoes, to some extent, that of Wolfe. Through embodiment, she proposes, we both render ourselves '"less human"…whilst seeking to grant animals a share in our world of subjectivity' (*Creaturely Poetics* 6), but she is sceptical of the notion of animal subjectivity in itself, disavowing 'interrogating and expanding the possibilities of (non-human) subjectivity' (6). Pick prefers to 'proceed…*externally*, by considering the corporeal reality of living bodies' (2–3). Like Diamond she stresses vulnerability, analysing it through the philosophy of Simone Weil in which 'the vulnerability of precious things is beautiful because vulnerability is a mark of existence' (3). Pick regards this notion of beauty as always already ethical in its implication, 'a sort of sacred recognition of life's value as material and temporal' (3).

While my reading of the two texts under discussion is influenced by the theorists quoted above on embodiment, representations of the interiorities of the giraffes will also be included. To do so is not to regard them as humanist subjects but to align my reading with Wolfe's insistence on reconsidering 'our assumptions about who the knowing subject can be' ('Human, All Too Human' 571). His essay simultaneously pays attention to representations of human and nonhuman commonalities of lived embodiment, its vulnerabilities and finitude and its ethical dimensions. I will also read the giraffe body metonymically in relation to human bodies. In *Animals in Film* Jonathan Burt's critique of the ubiquity of 'rhetorical animals on screen' which includes 'animals as metaphors, metonyms, textual creatures to be read like words' (31) resonates with Braidotti's call for animals not to be metaphorised. When the human body and the animal body are made to metonymise each other reciprocally in trans-species knots, however, Braidotti's sense of the 'radical immanence' of the nonhuman animal body is incorporated. Further, the human body may then be located in relation to Wolfe's 'entire sensorium of other living beings'. In the play and novel under discussion both humans and giraffes figure intertwining trans-species vulnerabilities while remaining, always, embodied, separate beings with their own histories and lives.

The vulnerabilities we share with animals

A puppet play and a novel, both of which centrally examine the vulnerabilities of animal bodies, demand that the audience and readers,

respectively, experience Sogo Jan and Snehurka relationally and in ways which break down species boundaries. Peta Tait argues, in connection with circus, that 'spectators receive a performance bodily with capacities inherent to their own species' (183). Perhaps a play and a novel may not appear to carry the immediacy and drama of live circus acts with the sights, sounds and smells of animal performers, yet an extraordinary life-sized giraffe puppet and a vibrant narrative about giraffes can surely elicit sensory bodily responses, including emotional ones, as Tait suggests about circus (183). The capturing of the young giraffes in both *Tall Horse* and *Giraffe*, for instance, is viscerally distressing; the detailed account of the long drawn-out slaughter of the giraffe herd in the Dvur Kralove zoo is not only nauseating in its violence, but grief-inducing in the tragedy of the majestic African animals' needless deaths. Thus the actions of the puppet Sogo Jan and the representation of Snehurka grant us access to their interiorities, fostering what Ralph Acampora in *Corporal Compassion* terms 'symphisis', that is, the mediation of bodily experiences on trans-species compassion (23).

Una Chaudhuri observes that drama is the 'most anthropocentric of all the arts' (522). A life-size giraffe puppet contradicts conventional theatre, of course, yet the animation of the puppet is dependent on the skill of the puppeteer who has to make the audience believe in its 'life and credibility' (Jones 254). The puppet may appear to be all body but its very movement denotes an inner life (Jones 266). For Jones, puppeteer and producer of *Tall Horse* and other Handspring Puppet Company plays, this '*embodied* form of thinking, of thinking incarnate' signifies a refusal 'to make a separation between mind and body' (266). Thus, according to Adrian Kohler, Handspring master puppet designer and maker, the giraffe puppet has to simultaneously embody 'some kind of strength and determination within her complete victimhood' (Adrian Kohler qtd in Millar 232).

The aesthetic expressivity of the puppet body animated by human actors inside the puppet reminds us that the body of the giraffe is key to *trans-species* relationships between human and nonhuman in both novel and play. With this puppet body looming over the human actors and other puppets, a narcissistic identification with the animal (on the part of the players or the audience) is scarcely feasible. Instead, trans-species connections are embodied, materialist, and incorporate Weil's sense of vulnerability which Pick discusses. Acampora's 'symphysis' between humans and animals as opposed to 'erotogenic romantic models of fusion' (114) is useful in its suggestion that such a 'bodily consciousness' is both human and animal. (Even so, the term 'con-

sciousness' seems an odd one to use, given its connotation of 'think-ing' and 'cogitation' as J. M. Coetzee has Elizabeth Costello complain [33] in another context.)

The giraffe puppet interacts with Atir, who is played by a human actor. The strongest connection between them is their common vul-nerability to slavery, with the image of a slave body recurring in the intersecting embodiment of human and nonhuman. The identities of both Sogo Jan and Atir are historically framed by the horror of slavery: Mehmet Ali who masterminded sending the giraffe as a royal tribute had 'monopolised the slave trade for fifty years' (Allin 36). Atir served as a slave of Bernadino Drovetti, the adept plunderer and marketeer of Egyptian antiquities. Soon after Sogo Jan is captured in the hunt and her mother killed, Atir, perhaps in an attempt to expiate his culpabil-ity, confides to her his own traumatic history 'I was once a slave like you – stolen from my village in Mali by the jonserelao' (Burns 250). When the young giraffe demands more sustenance he acknowledges 'Already you have made a servant of the one who captured you' (Burns 249). Subsequently, as it becomes clear in Paris that Atir will not return to Africa, partly because he fears that his Malian home has been oblit-erated by the slave trade, partly because Sogo Jan has become exclu-sively dependent on him, he taunts the giraffe repeatedly 'I am not your slave' denying his attachment to her (Burns 262, 263, 276). Like Atir, the giraffe is, potentially, both slave holder and enslaved. Reciprocally, they have changed each other's life trajectories; both are irrevocably diasporic beings, Africans in Paris with a sense of what has been lost. Sogo Jan's narrative had been written on her very body according to Atir: her markings, her taamaki, reveal her destiny of a long journey from which she will never return.

On a lighter note, the negrophilia in Paris at the time (Millar 45) renders Atir a sexualised and highly desirable body. In the play he is seduced by Lady Clothilde Grandeville de Largemont, wife of the pre-fect of Marseilles, who finds him in the stable where he sleeps with Sogo Jan. In the stage directions she is *'thrilled to be making love under the eyes of the giraffe'* (Burns 267), as though the very gaze of the giraffe contrib-utes to Atir's desirability. In the narrative of the play, Sogo Jan is also exoticised and eroticised. In her Africanity, her grace and beauty, her femininity, Sogo Jan fits right into the Orientalising of Parisian culture in the early nineteenth century (Root 161–5), as human embodiment mimics that of giraffes. Women attempt an exaggerated verticality performing their desire to become giraffe, by stretching their necks into high hairstyles and lowering them in décolletage, a fashion which

results in a 'bosom boon' to the delight of the Newspaperman in the play (Burns 259).

In *Giraffe* Ledgard deploys the interpretations of science to represent the lack of embodied difference between human and nonhuman animals. Emil studies cerebral haemodynamics 'in vertical creatures, in men and giraffes' (27). He imagines Snehurka coming into a subjectivity at birth asserting: 'I am a giraffe, I am about that space a little above the blade, and my bodily intent is to be elevated above all other living things, in defiance of gravity' (6). When Emil conceptualises and spatialises blood-flow he does so for both human and nonhuman animals in terms of rivers and sea. Later when he imagines a giraffe who has died galloping over the water from the transport ship, he imagines his own birth and death. Ledgard has Emil's sense of mortality echo that of Diamond:

> I have fallen into hands at my birth, just as I will again fall at my death, felled by disease or upended by accident. I will also fall to the earth. My veins will collapse too and all the celestial bodies will fall into a soup of dioxides. (124)

If the giraffes appear metonymic of the position of most humans under Communism, this metonymy is reciprocal. Like the giraffes, Emil is 'bound' because of his nationality under Soviet rule. Emil's pessimism – or realism – is symbolically endorsed by a cutting he keeps from a Polish magazine of the Salvador Dali painting: *Giraffes and Burning Telephones* and which, in its depiction of giraffes on fire, so cruelly foreshadows the fate of the giraffes as they are slaughtered. In the political dispensation, human embodiment, or representations of it, is also at risk of incineration – exemplified by the burning of the child's text, *Emil and the Detectives,* by the Nazis, but also by the 'students who doused themselves in petrol and made human torches of themselves in protest at our captivity' (36). Sinisterly, notes Emil, children and adolescents, during their 'Communist indoctrination' are given badges of 'a book of knowledge set alight and no one comments on it' (36–7).

Emil experiences a profound empathy for the suffering of diasporic animals throughout history from those slaughtered in circuses in ancient Rome to North American horses shipped to France in World War I. Passing through Dresden, he imagines Arabian mares and stallions from Polish stud farms being evacuated from Allied bombing during World War II: 'some survived, others galloped swift and white through the inferno until the "J" shaped brands on their flanks caught flame. They collapsed without oxygen and boiled also' (110). What he calls the 'Dresden feeling' recurs,

like an epiphany, when he is overwhelmed 'by an understanding that we are all of us [human and nonhuman animals] bound together by suffering, even more than joy' (140). This nonhuman suffering echoes Diamond's sense of 'sheer animal vulnerability [which] we share with them' (74) and Bentham's question about animals: 'Can they suffer?' That Ledgard has the emotion of joy feature here too, suggests that human–animal embodiment in this novel is not merely external as Pick would have it, but rather psychological and ontological. Certainly, in other passages above, Snehurka is a knowing subject, vulnerable to the 'embodied finitude' (Wolfe 'Human, All Too Human' 570) of her life, as is Emil.

In another entanglement with giraffes, Emil, who is 'drawn to the edge of things' (39), nurtures desires to live vertiginously. As a boy he climbs often to the top of the diving platform 'rising slender like a giraffe' (39) which his mother had designed above a famous pool in Prague, but vertigo always overwhelms him, even though he can scientifically determine the haemodynamic reason for his dizziness. As an adult standing on the observation deck of the family villa's roof he 'feel[s] gravity coming up at me, as if with hands, to pull me under' (39). As a scientist he is incapacitated, ultimately, by a failure of nerve, the imperative 'to make the safe choice' (40) in the Communist state. Although he studies the science of the physical context of vertigo, he remains earth-bound, obedient to Soviet directives. Amina, on the other hand, sustains the courage to live vertiginously. Her namesake is the heroine from Bellini's opera *La Somnambula* who is unconsciously attracted to heights and danger in her sleepwalking yet survives.

Amina's literal sleepwalking symbolises a national passivity and unconsciousness. She feels that the CSSR 'is a country of sleepwalkers by day, who drink by night only as a lesser form of sleepwalking' (181). The giraffes' captivity is congruent with Amina's claustrophobic existence in her minute living space and in the monotony of her factory labour making Christmas decorations, but she is inspired by their embodied similarities. Because 'her element is air' (162), the giraffes 'awaken' her. Like her, the giraffes are 'slender...with sensitivity of expression' (161), and Snehurka's awareness of her body and those of her companions once they reach the zoo overlaps with that of Amina: 'We are sleepwalking beasts...We bump into each other, not waking but galloping inward across ash-coloured grassland, stretching ourselves up to the highest branches' (173). Tragically, Amina attains giraffe heights both figuratively and literally in her caring for the giraffes as they are slaughtered; she climbs onto a high fence to hold the sharpshooter's feet so that he can aim more skillfully at the back of the giraffes' heads.

Ledgard has the sight of restrained giraffe bodies in the zoo 'recontextu-alize' human affect and perceptions to use Wolfe's terms; Amina is sure that some visitors to the zoo have been awakened by the extraordinary sight of the giraffes, just as she has been. This 'awakening' is highly symbolic and Ledgard implies that it involves a distancing from the oft-reiterated 'Communist moment' (19 and passim) through attaining a sense of embod-iment, an ecological sensibility (no matter how polluted nature may be), the ability to dream beyond the present moment, even a spiritual dimension, which will become most evident during the ending of the novel.

Disembodied vulnerabilities

Throughout *Tall Horse*, Sogo Jan is admired and feted on her marathon journey through France. Although she is captive and domesticated, she is not yet a zoo animal, strictly speaking, for she is not caged. After having been welcomed by King Charles X himself, however, the giraffe is settled into Le Jardin des Plantes in *'The beautiful giraffe-house. [with] [m]oon in the garden at night'* (276) according to the stage directions. The scene is romantic, Sogo Jan's airy new home is made of glass and the final interaction between her and Atir, intent on leaving for Africa with his baggage in hand, replicates a positive resolution to a lover's quarrel as her neediness deflects him from his journey so that he lies at her feet, promising to feed her 'Tomorrow'. Visually, then, the embodied life of the giraffe seems unchanged, and the ongoing stability of Atir will sus-tain her in their interwoven future. But Sogo Jan will never again return to her home country and this is confirmed in the final scene, set in the present day. A film is projected onto the wall: *'gates of the Jardin shut, into Paris skyline. The giraffe walks across Paris skyline and turns into the Eiffel tower'* (277). The giraffe is aestheticised and, in some ways, honoured, but the embodied existence of Sogo Jan held captive in a zoo is glossed over. *Tall Horse* does not deal dramatically with what Diamond calls 'the difficulty of reality', in this case the life of a captured animal in the Parisian zoo, but leaves it rather to the audience to imagine her life beyond the ending of the play.

In bringing the curtain down on Sogo Jan's captive life, the play fore-closes a narrative of immobility in her attractive glass house. The disap-pearance of the giraffe body from the stage at this point in the animal's life is indicative of the lack of dramatic appeal of incarceration in a zoo, which robs animals of their being in the world and their very embodi-ment. Tragically, animals in zoos lose any possibility of retreating to a safe place or a habitat with which they can identify; thus 'ex-hibiting

an animal not only renders it homeless, but also – consequently – disembodies that creature of its world-flesh identity' (Acampora 104). The giraffes in Ledgard's novel spend a large part of the narrative within an enclosure, extensive though it may be. Being held in a zoo cheats animals of any authentic kinetic expression, possible only in the extended spaces of their natural environments and Snehurka longs for the openness of the Kenyan plains. In touting 'narratives of freedom and happiness' (Rothfels, *Savages and Beasts* 199), the zoo, like the one in Dvur Kralove, can only present a fabricated world. Acampora, in his critique of this artificiality, proposes that the animal in a zoo approximates a simulacrum, the 'real fake' (105): 'Perhaps the ultimate creature of naturalized presentation is an artifact of somatological hyper-reality, a disembodied entity reincarnated as a nicer replica of its former self' (105). Most visitors are unaware of this fracturing of the animal beings; as Rothfels points out 'there is an escapable difference between what an animal is and what people *think* an animal is' (5).

In *Giraffe* Ledgard reminds us of the historical and cultural situatedness of bodies as he represents the ideological reconfiguration within communist discourse of the advent of the Kenyan giraffes and their settling in the Dvur Kralove zoo. The Czechoslovakian zoo director refuses the label 'shipment' of the giraffes insisting, rather, on the term 'migration'. In this way, he contributes to yet another national fiction: that these 'red-starred giraffes' (67) have chosen to travel instinctively to the CSSR, so committed are they to the grandiose scheme of being part of a breeding programme to promote Communism. In reality, they are forced to adapt to being zoo animals in Europe after roaming without boundaries in Africa. When Emil sees the giraffes in the zoo two years after escorting them there, he notes that 'they have become fully zoo animals. Their eyes have changed in aspect' (252).

The 'comrade captain' of the *Eisfeld* which had transported the giraffes from Kenya to Hamburg tells Emil of their distress on the voyage, especially after rounding the Cape of Good Hope when they irrevocably 'no longer have a home, but are instead delivered into captivity' (65). Both men 'allow' the possibility that the giraffes might dream of home as the captain does, but Emil in particular imagines the giraffes' loss of all places African as they are transferred from the ship onto a Czechoslovakian barge:

> The giraffes [are] searching for certain trees and animals, but finding no acacias and no hippos moving along the poisonous mud-banks... A sailor stands beside me and also looks up at the swinging crates.

'Let them walk on air,' he says sadly, 'for they will never again walk on Africa.' (68)

Ungrounded and deprived of their native sanctuary, the giraffes transported through the Czechoslovakian countryside are offered beer in soup plates, the act of generosity confirming their reduced status: 'They are migrants, learning where they have arrived' (143). Just as diasporic subjects leaving their countries of origin have to re-think the notion of home and whether it is always nostalgically elsewhere, so the giraffes in both play and novel have to adapt to a captive existence in the northern hemisphere.

Once the giraffes are held in the zoo, Amina spends hours observing them, as well as discussing with their keeper their emotions, and the responses of visitors to the zoo. Rothfels contends that 'keepers, often, even typically, ha[ve] deep emotional and physical connections to the animals they care[.] for every day' ('Zoos' 486), which is evident here, but the keeper is pragmatic about habituated reactions to the animals on show:

The zoo is nothing more than a contrivance … to make workers forgetful of the monotony of their lives. They arrive here from industrial towns. They move from cage to cage. What do they want? Not to contemplate … but to make strange animals see them. (191)

For Alois Hus, the ambitious Czech zoo director '[t]he purpose of the zoo is to breed animals and to entertain the worker' (Ledgard 87), but the keeper, more aware of workers' reactions to the caged animals, acknowledges what Rothfels calls 'the disappointingness of zoos' because of the unmet desires of the visitors (*Savages and Beasts* 11). If the director echoes Berger's historical analysis of the zoo as a 'public institution … ha[ving] to claim an independent and civic function' (Berger 19), the Dvur Kralove zoo is not, of course, connected to the capitalist, imperialist project, which Berger critiques. Ironically, the giraffes in the Dvur Kralove zoo owe their captive existence to a communist project which is just as imperialist, in its quasi-scientific schemes, as any nineteenth-century zoo intent on nationalistic pride and colonial claims to exotic animals from foreign countries.

The Czechoslovakians who capture Snehurka and other giraffes in Kenya congratulate themselves that their 'disposal' of what Braidotti calls the 'zooproletariat' is politically motivated:

'There is socialism in our method,' [Snehurka] hear[s] them say. 'Capitalists capture one or two giraffes, while we take an entire herd;

because our intention is political, to issue forth a new subspecies.'
(Ledgard 11)

In objectifying the giraffes for this 'political' purpose, which they
so smugly and mistakenly conceive as ethical, the scientists negate
any common embodied vulnerability which we share with animals.
Instead, the zoo director regards his attempt to create a new species of
giraffe as more significant than any such capitalist attempt might be,
partly because his research is acknowledged by the State, partly because
'our socialist mind' (87), as he boasts, is well-disposed to the necessary
logistical minutiae of treating animals like breeding machines. Emil
critiques Hus's proposals, comparing them, but only *sotto voce*, to prac-
tices of the Komsomol (the Communist League of Youth). Hus is an
inspired ideologue, with his political beliefs overshadowing any pos-
sibility of scientific rationality: Communism will force nature to shift,
the giraffes will get acclimatised to the Czech winters and will learn to
move on ice.

While Emil's knowledge of haemodynamicism seemed, initially, to
depend on trans-species embodiment, in fact he cannot ameliorate the
lives of the giraffes themselves in his experiments during their European
journey and his science is drafted by the State. His approach is impera-
tive for the state's grandiose plans of conquering space and for the sci-
ence fiction future of space-colonies. Although the study of 'blood flow
in vertical creatures, in men and giraffes' might underscore a common
mammalian embodiment, his research is then used for its 'application
for cosmonauts and high-altitude fliers' (22) with the giraffe hides, in
their texture, used as prototypes for anti-gravity space suits. This sci-
ence disembodies the giraffes themselves, just as their exhibition in the
zoo does. If, in an echo of Saint-Hilaire, Emil deconstructs humanity as
an exclusive category, it is Czechoslovakian as well as Russian science,
with its wilful ignorance of African diseases and its disrespect for the
indigeneity of giraffes in Kenya, that directly causes the obliteration of
the herd in Dvur Kralove.

The vulnerability of Sogo Jan in relation to slavery, the vulnerability
of the giraffes transported to eastern Europe is exceeded by the ultimate
vulnerability of the giraffes at the Dvur Kralove zoo as they are slaugh-
tered. Ledgard's excruciatingly detailed representation of the deaths of
the giraffes spirals through different viewpoints so that the narrative
is repeated in a nightmarish way. For Pick: 'to deny the agency of crea-
turely suffering does not only deflect a difficult reality, but compro-
mises thought' (11). While Ledgard represents this 'agency of creaturely

suffering' in the depiction of the final traumatic scene, the individual, embodied agency of giraffes as knowing and experiencing subjects features strongly and distressingly. Paradoxically, Jiri, the sharpshooter, and Amina, who are ethically responsive to the giraffes, are forced into the position of caring for the animals while killing them. The former gets drunk to cope with being the instrument of bringing these huge beasts down to earth. He shoots from a high vantage point, having to aim precisely at the back of their necks to be more accurate. Amina, to ease the process, shines a light in their eyes to blind them; when they will no longer be herded past him, the giraffes have burning newspapers affixed to their tails to spur them on, in a macabre echo of the Dali painting. The apocalypse for the giraffes culminates in Snehurka's death when as matriarch of the herd she runs in exquisite terror on broken legs through blood and excrement. In their deaths, the giraffes are not accorded any respectful rituals which mourn their bodies: their bodies are brutally crushed to fit into slaughterhouse trucks – all evidence has to be urgently removed before the imminent May Day parades.

Imagining the giraffes in relation to spirituality or religion may appear to proffer consolation in a putting forward of an alternative space in which they flourish. Pick's reliance on a discourse of the sacred, embodied in animal suffering, seems to ameliorate the 'unbearable' in this way:

> The silence of the animals in the face of all that is said and done to them returns to the idea of martyrdom or rather to the notion of the saint. A saint does not pontificate...A saint reaches others not by canvassing but as embodied revelation...[T]he powerlessness of those who do or cannot participate in a given discourse paradoxically carries its own inalienable force. (189)

My reservation is that the notion of animal saintliness could approximate what Pick terms 'comfort-thinking' replete with 'consolatory illusions' (186). It reifies animal powerlessness, transforming it into a 'force' rather than an embodied, individual suffering of a knowing subject and elevates the victim, thereby almost acquiescing to the abject.

Given the religious imagery which Ledgard threads through representations of the giraffes, an interpretation of the suffering giraffes as martyrs or saints has, potentially, been ushered in. Atir loops his own amulet around Sogo Jan's neck as protection on her journey (262) in *Tall Horse*, but in *Giraffe* the animals' recurrent metaphysical contiguities are far more dramatic. When Amina connects with the spiritual

dimension of 'awakening' which she experiences through the giraffes, her epiphany extends to embrace all of nature in the forest near the zoo and an expectation that her country, superficially entirely secular, will experience a 'religious revival' (183) when Communism is defeated. Through the convergences of the giraffes with the sacred, Ledgard seems to suggest that the revival that Amina foresees is already brewing surreptitiously in relation to the vulnerable embodiment of the giraffes. Emil repeatedly imagines giraffe bodies in relation to Islam, possibly connecting the animals to the religion of their countries of origin: he compares giraffes felled in a hunt to 'a falling minaret' (23); during the slaughter he describes how 'the giraffes keep crumbling like minarets' (278). When he follows the dead giraffes loaded onto a lorry bound for the rendering plant Snehurka is 'a fallen tower of the Qasr al-Qadim' (317).

Christian imagery also recurs. The ineffectual epigraph to the slaughter of the giraffes is a quotation from Psalm 91: 'surely he shall deliver thee from the snare of the fowler, and from the noisome pestilence' (243). That the zoo director Alois Hus who cannot cope with the horror of the shooting has been kneeling in a field all night coheres with religious supplication. Although hitherto inspired by communist Science, he insists that the slaughter is not scientific: '"They didn't have to kill them," he says. "They could have done something else. It's political. They don't want animals running free' (281). Hus is adamant that the giraffes could have been dipped in a solution and thus cleansed of contagion. 'Like a baptism?' Emil asks (281). But the renewal of their lives after being baptised is not to be, for they are martyred to the imperative for state secrecy. Tadeas, a virologist, informs Emil of the infectiousness of the giraffes' contagion and the vulnerability of all even-toed ungulates, which includes camels, cows and sheep. Emil denies the imperative of international law to report the infection, justifying that 'National security is above the law' (239). The collective farms cannot be allowed to halt production, the borders of the country have to be kept open. Far better, according to Soviet directives, to hush up the contagion which could bring agricultural ruin to the country, to slaughter the giraffe herd and render their bodies into cattle feed at a nearby plant, thus obliterating the evidence their bodies could reveal.

If the bodies of the giraffes are made to disappear without trace in the narrative, Ledgard compels the reader to witness Emil's experience subsequently in the rendering plant of the butchered giraffe bodies, the tragedy of Snehurka's unborn calf, the ultimate vulnerabilities of African animals out of place in a mendacious European country which

has no ethical regard for the giraffes. In this way we are constrained to acknowledge what we, as humans, share with animals: a 'finitude' of the body, and 'the radical passivity and vulnerability' of suffering (Wolfe, *Posthumanism* xxviii). Ledgard's graphic, even sensationalist, representation, is, presumably, meant to underscore this vulnerability. In contradiction of this horror, Ledgard has Emil imagine the death of Snehurka in a way which can only be regarded as consolatory. He remembers her as a vibrantly alive being who looked back at him through a narrow window on a lorry before she became a zoo animal lacking a responsive gaze.

> There was a coldness, a sinking. She felt no pain, she was aware only of memory slipping from her, as dreams slip from the waking. She died. She could see a zebra, and then only stripes of a zebra, and then only a space, where the shape of the zebra was. She remembered she was single, then her thoughts became mingled.
> *Death is a confirmed habit into which we have fallen.* (317)

The attempt to ameliorate the cruelty of Snehurka's killing through a lyrical moment as she dies focuses on her visual imagination, then a disintegration of her 'thoughts'. The giraffe matriarch is very much a knowing subject rather than merely being indicative of an 'inalienable force'. Her subjectivity is what makes this narrative, this engagement with the 'reality' of the violence done to the giraffes, unbearable. Yet neither Sogo Jan nor Snehurka are imagined within the terms of humanism as humans manqués. Instead the irresistible performance of the body of the Ethiopian giraffe in *Tall Horse* and those of the giraffes in Ledgard's novel mean that their embodiment is undeniable, even when, paradoxically, the discourses of captivity disembody them, rendering them entirely vulnerable ethically.

For Pick 'perceiving the body *with* consolatory illusions' exemplifies 'comfort-thinking' (186) but if this tendency surfaces in the above quotation it surely does not contradict 'Weil's idea of reality recognisable in its "unbearableness"' (Pick 186). In my own desire for 'comfort-thinking', I would like to return to Braidotti's sense of 'radical immanence' of the animal body, to the intensities of the giraffe body, with its unique verticality and charisma, to the trans-species flows between Sogo Jan and Atir, between Snehurka and Amina which the play and the novel depict respectively, even as the performances and narratives make it impossible to gloss over the vulnerabilities of captured African animals.

Works cited

Acampora, Ralph R. *Corporal Compassion: Animal Ethics and Philosophy of Body*. Pittsburgh, PA: University of Pittsburgh Press, 2006.

Allin, Michael. *Zarafa: The True Story of a Giraffe's Journey from the Plains of Africa to the Heart of Post-Napoleonic France*. New York: Walker, 1998.

Berger, John. *About Looking*. London: Writers and Readers, 1980.

Braidotti, Rosi. 'Animals, Anomalies, and Inorganic Others'. *PMLA* 124.2 (2009): 526–32.

Burns, Khephra. 'Tall Horse: Performance Script'. *Journey of The Tall Horse: A Story of African Theatre*. By Mervyn Millar. London: Oberon Books, 2006. 237–77.

Burt, Jonathan. *Animals in Film*. London: Reaktion, 2002.

Chaudhuri, Una. 2009. '"Of All Nonsensical Things": Performance and Animal Life'. *PMLA* 124.2 (2009): 520–25.

Coetzee, J. M. *The Lives of Animals*. Ed. and Introd. Amy Gutmann. Princeton: Princeton UP, 1999.

Diamond, Cora. 'The Difficulty of Reality and the Difficulty of Philosophy'. *Philosophy and Animal Life*. Cavell, Stanley et al. New York: Columbia UP, 2008.

Jones, Basil. 'Puppetry and Authorship'. *Handspring Puppet Company*. Ed. Jane Taylor. New York: David Krut, 2009.

Ledgard, J. M. *Giraffe*. London: Vintage Books, 2007.

Millar, Mervyn. *Journey of The Tall Horse: A Story of African Theatre: Includes the Performance Script of Tall Horse by Khephra Burns*. London: Oberon, 2006.

Pick, Anat. *Creaturely Poetics: Animality and Vulnerability in Literature and Film*. New York: Columbia UP, 2011.

Root, Deborah. *Cannibal Culture: Art, Appropriation, and the Commodification of Difference*. Boulder, CO: Westview Press, 1996.

Rothfels, Nigel. *Savages and Beasts: The Birth of the Modern Zoo*. Baltimore: Johns Hopkins UP, 2002.

——. 'Zoos, the Academy, and Captivity.' *PMLA* 124.2 (2009): 480–86.

Tait, Peta. *Wild and Dangerous Performances: Animals, Emotions, Circus*. Basingstoke: Palgrave Macmillan, 2012.

Wolfe, Cary. 'Human, All Too Human: "Animal Studies" and the Humanities.' *PMLA* 124.2 (2009): 564–75.

——. *What Is Posthumanism?* Minneapolis: University of Minneapolis Press, 2010.

2
The Scramble for Elephants: Exotic Animals and the Imperial Economy

John Simons

In 1987 Harriet Ritvo's influential book *The Animal Estate* was the first major statement of the thesis that one can trace a relationship between the contours of Imperialism and the representation and status of exotic animals in nineteenth-century Britain. Since then studies such as those of Crosby, Mackenzie, Rothenfels and Kete have refined Ritvo's insight and Ritvo herself has re-visited it in various publications. However, although the basic notion that in capturing, hunting and displaying exotic animals the British were shadowing and representing their mastery of the colonised peoples and lands is very widely accepted, relatively little work has gone into exploring the finer details of the trade in animals and the mechanisms by which it became possible by the 1860s for a wealthy man like, say, the painter Dante Gabriel Rossetti to assemble a private menagerie consisting of wombats, woodchucks, armadillos, kangaroos, Brahmin bulls, raccoons and various other creatures in his Chelsea garden and seriously to consider adding a lion, an elephant and a penguin. All this was achieved without ever leaving London (see Simons, *Rossetti's Wombat*). Rossetti was by no means the only private zoo keeper and whether we are talking about the modest flock of llamas kept by Baroness Angela Burdett-Coutts up in Hampstead, the more domestic collection of small creatures such as guinea pigs (very exotic in the nineteenth century) kept by the now almost forgotten nature writer Elizabeth Brightwen at her home in the New Forest or the massive menageries kept by Lord Derby at Knowsley or Lord Rothschild at Tring – who also kept a flock of kiwis while he was an undergraduate at Cambridge – we can trace the pathways by which these animals were captured and transported to Britain in surprising detail and, by

doing so, we begin to understand how the nature of Empire enabled a lively (and live) trade, centred on London but with an important outlet in Liverpool and some outposts elsewhere, from the beginning of the nineteenth century until the 1880s when business began to decline (Simons, *Tiger*).

The establishment of the empire had severe consequences for the animals that inhabited it. Sir Stamford Raffles himself – founder both of the colony of Singapore and of London Zoo – made a very explicit connection between the purposes of Empire and the purposes of science:

> It has always appeared to me, that the value of these countries [modern Malaysia and Singapore] was to be traced rather through the means of their natural history, than in the dark recesses of Dutch diplomacy and intrigue; and I accordingly, at all times, felt disposed to give encouragement to those deserving men, who devote themselves to the pursuits of science. (Raffles 572)

It is, therefore, not surprising that the great Victorian adventures of exploration often included zoological sub-missions. For example, the two Speke and Burton expeditions – first to Somaliland and then to find the sources of the Nile – both incorporated activities designed to collect and preserve zoological specimens. These were for scientific purposes (and indeed one of the points of friction between Speke and Burton in Somaliland was the latter's sequestration of the former's specimens – Speke had hoped to put them in his own private museum) (see Jeal). Less officially the Anglo-Maltese ivory trader Andrea de Bono did some extensive exploration in his own right and kept up his income by capturing the odd animal for sale to zoos or menageries (Catania). There were numerous private explorations and hunting trips as well as networks of professional specimen finders and agents dotted from South America[1] to South-East Asia. Exploration, conquest, hunting and zoology form an interlinked quartet which even made its way into the Imperial fictions of Rider Haggard where zoological and botanical issues are a part of the general adventure.[2]

While we might begin to theorise that the capture and display of exotic animals was an unambiguous and unproblematic re-statement of the master discourses of the Empire, the practical effects were, in fact, deeply transgressive and carried a contradiction. In circuses, menageries and zoos the Empire was being brought home in triumph and, thus, continuity was established between the efforts of the modern British colonial impulse and the achievements of Rome. However the

sites at which animals might be encountered also reinforced the dia-logic nature of Empire and not a simplistic propagandist message. Here the races, especially the black subject races and dominant white races, mixed. Here women went far beyond the traditional place set out for them in the ideal picture of Victorian domestic harmony. Here crimes against both property and people were committed, the classes mixed, and drunkenness did on occasion prevail. Here were experiments in matings between animals that otherwise had no affinity. Here the Empire bit back as animals escaped their keepers and savaged passers-by and spectators.[3] A conflict can easily be seen here and, to some extent, it is a conflict that lies at the heart of every Imperial venture where culture is, inevitably, imposed through violence, the rule of law entails lawlessness and racial purity ends in miscegenation.

The basic fact of imperial politics could impact very directly on the animal trade as Table 2.1 shows.

Table 2.1 Prices of giraffes on the London market as quoted by the firm of Charles Jamrach (price per giraffe)

1879	£40
1885	£1000
1903	£400

Why did the price rise so steeply in the 1880s and then fall back but not to the level of the 1870s? The answer lies in the depths of Africa and the takeover of the Sudan by the Islamist movement led by the self-styled Mahdi. This event is best known for the creation of the eminent Victorian General Charles Gordon and the martyrology that grew up around his death in Khartoum and, in 1895, the famous cavalry charge at Omdurman which saw the final defeat of the Mahdist forces and marked the first appearance on the world stage of Winston Churchill. While the Mahdi ruled the Sudan it was more or less impassable to west-ern travellers unless they risked being killed or taken hostage, and as the Sudan lay across the only land transportation route for exotic animals out of Africa (indeed south Sudan was, in itself, a major source for exotic animals) the trade suffered. One impact of this was that there was a major shortage of giraffes and so the price escalated sharply upwards.

After the introduction of British rule the giraffes started to flow again, but between 1879 and 1903 the Suez Canal had come into its own as the premier trade route from the east to Europe (the impact of the canal, which was opened in 1869, was not fully felt until steam increasingly

replaced sail) and British ports were no longer pre-eminent in Europe. This meant that giraffes now had to be obtained from European traders or bought at much higher prices (because tariffs and freight costs were lower in Europe) from the few traders still bringing exotic animals direct into London. To put the prices into perspective, in the early 1850s the Nawab of Oudh – a very enthusiastic collector of exotic animals – was offering £4000 to buy a pair of giraffes that could be trained to pull his carriage. Of course, the Nawab was concerned to demonstrate his extreme wealth, but shipping giraffes to India would have been a much more expensive business than shipping them to London as the voyage to India went against the normal trade route for this commodity and getting giraffes – or indeed any large animal – to order was always more expensive than obtaining them from speculative importers.

The Suez Canal is the vital fact which binds the exotic animal trade into the economics of the British Empire and eventually led to German predominance in this branch of colonial economics. Before it was opened most ships coming to Europe from the Far East, Africa or the Americas made their first landfall in a British port and this gave British dealers, especially in London and Liverpool, a major advantage over their continental rivals. In the first half of the nineteenth century ships often carried exotic animals as extra cargo. Sailors brought home smaller animals (most famously parrots), tourists brought back larger creatures which had seemed a good idea at the time (ships from Australia were often filled with pet kangaroos), returning officers and other ex-colonials also had their pets (coming back from India the young Baden-Powell, for example, found that his pet panther Squirks was more of a handful in a London flat than he cared to deal with), and the ships' officers often brought in larger creatures as speculative investments (see Baden-Powell 52–53). Many of these animals were sold immediately they landed to the exotic animal traders who kept their businesses adjacent to the docks. In fact, there was such fierce rivalry and such money to be made that the various businesses employed the local idlers as runners to and from the docks to inform them of new rarities as they arrived (Simons, *Tiger*). Dealers would set out in boats to meet the ships as they came up the Thames and even beyond.

In London the centre of the trade was St George's Street East (which had once been called the Ratcliffe Highway until a grisly murder impelled a name change), a notoriously rough area full of brawling sailors and un-bonneted women. Here was to be found the premises of Charles Jamrach – the pre-eminent dealer in the world between the early 1840s and the 1880s – and his sons Anton and Albert; John

Hamlyn who worked along much the same lines as Jamrach but was never quite so famous even though he invented the chimpanzees' tea party; and John Abrahams (who was actually murdered outside his shop in 1904). Another of Jamrach's sons, William, had a dealership at Stoke Newington and ran an outpost in Calcutta. There were other dealers who have more or less disappeared from view and are known by name only, such as Bruce Chapman and other specialists such as John Bally, who dealt in exotic and game birds only, or William Lloyd who specialised in exotic fish and other sea creatures for the indoor aquarium.

In Liverpool William Cross was a rival to the Jamrachs and other London dealers. Cross's shop was in St Paul's Square and he had a menagerie at Earle Street. He advertised his premises as 'The Greatest Zoological Emporium on Earth' and 'known throughout the civilized and uncivilized world'. In the late nineteenth century he was selling lions, tigers, elephants, camels, bears, wolves and snakes ('by the mile' as he put it). In 1886 Cross helped the people of Liverpool organise the first ever International Exhibition to be held in that city. The show included zebras and elephants. The establishment of Liverpool as an Imperial city was thus underpinned by a display of exotic animals (Steele and Benbough-Jackson). An 1887 account of a visit to Cross's shop suggests it was not unlike Jamrach's. First there were vast numbers of birds stuffed into cages piled high along the walls, then came the lions, jaguars, panthers and bears and finally the elephants. Cross also furnishes an example of the ways in which the animal trade was integrated into the wider economics of Empire: he shipped mongooses a thousand at a time to the rat-plagued sugar plantations of the West Indies where they had nothing local that was so effective against vermin.

By 1905 Cross's stock list clearly shows how the changes in trade routes which killed off the London trade were also affecting him and by this time he seems to have carried mainly smaller animals and birds – many like Muscovy ducks or white swans were not very rare. However, his position in Liverpool, which was still a common first port of call for ships from the Americas, gave him some advantage. He was still carrying alpacas, a puma, a giant turtle, alligators, Brazilian tortoises (as well as the more common Greek ones), in addition to Amazonian parrots and other jungle creatures such as toucans and tree frogs, when the London dealers were finding it all but impossible to get the bigger animals at a worthwhile price.

Table 2.2, drawn from the London Post Office Directories for the relevant years, shows the rise and fall of the exotic animal trade.

Table 2.2 Animal dealers in London 1841–1908

Year	Number of animal dealers in London
1841	14
1882	81
1895	118
1908	32

The shift in the economics of the trade had had a catastrophic effect and anyone wishing to trace the decline of British Imperial fortunes in the run up to the Great War might do well to use the exotic animal trade as a barometer. The Table 2.3 shows the prices of five representative animals over a similar period.

Table 2.3 Decline in price of exotic animals in London 1879–1903

	Charles Jamrach 1879	William Jamrach 1896	Albert Jamrach 1903
Rhinoceros	£1000	–	£1000
Tiger	£300	–	£80
Lion	£100	£60	£20–25
Elephant	£400	£100	£120–150
Hyena	£10	–	£10

Here we can see that while animals of great size and rarity like rhinoceroses have held up well other more common animals have progressively lost value. This is partly because of competition from the Continent, especially Germany, which impelled dealers to lower their prices to remain competitive (even through their costs were rising – a hyena could easily consume £60 worth of meat before it was sold) and partly because of the increasing availability of home-bred animals. For example, Dublin Zoo kept itself going by means of what was known as the 'Irish Lion Industry', an astonishingly successful breeding programme that kept all manner of people supplied in lions.[4] The £10 hyenas were the common striped variety; even in 1903 the rarer spotted hyenas were still fetching £40 each. At the two auctions of menageries (Wombwell's No. 1 and Manders's in 1872 and 1879 respectively) lions sold for between £200 and £30 depending on their size and quality, a tiger for £155 and elephants went for £145 (small) or £680 (large and destined to be a money-making attraction at Manchester's Belle Vue Zoo). It is, of course, difficult to compare auction and retail prices but,

generally, the prices realised show that the dealers who were bidding intended to make a profit while the zoos were more interested in acquiring good specimens and were, on occasion, prepared to push the price up in order to obtain the animal they wanted. To show how common lions were becoming we know that a lion was bought by the menagerist John Ballard in about 1810 for the huge sum of £500.

By the 1890s the problem for the London dealers was that the German traders were able to undercut them both on costs and price. Not only did the German trade benefit from the Suez Canal but also the tighter regulation of the British steamship lines meant that the captains could no longer carry wild animals for sale as a perk and had to pay freight on them while the foreign firms going into Antwerp and Hamburg did not require this. A puma from South America would cost £40 from the London docks because of the freight charge, but one could be had for £10 in Hamburg. In fact, by 1903 Albert had all but abandoned the animal trade and was concentrating on the curio business. John Hamlyn kept going, but in 1916 his published price list bears out the decline in the trade with the only animals of real value being an antelope at £25, emus at £12 each, a twelve foot anaconda at £15 and an eight foot one at £6. Everything else was of lower value and less interesting and the fact that he was doing a bulk deal on raccoons (selling them at £3 each or £5 for two) shows something of the state into which the business had fallen. The general bird trade had not fallen off quite so sharply and William Jamrach was still able to sell birds, especially water-fowl, in bulk for stocking sporting estates.

The business model for the trade was originally developed in Germany by Charles Jamrach's father Jacob Gerhard Gotthold Jamrach. He was harbour master and chief of the Hamburg River Police and noted the bountiful flow of wild animals and other exotic curios passing through the port. He started buying and selling them and eventually set up a paying attraction called Handel's Menagerie at Spielbudenplatz 19 in the St Pauli area. Gotthold realised that if the trade in Hamburg was so good (and he kept the business until his death in 1863) it would be even better in London. So in 1839 his eldest son Anton arrived to set up shop in the East End. Unfortunately Anton died young in 1841 and so Charles Jamrach was sent to take over and, together with his sons, set up a dynastic enterprise that dominated the European trade for nearly fifty years. The last Jamrach to be trading in the St George's Street East premises was Albert who died in 1917, by which time the trade was all but dead although his brother William at Stoke Newington kept going into the early 1920s. A key element of the Jamrach business

was also exotic curios such as shrunken heads (there is one in the Pitt Rivers Museum that was bought from Jamrach), Japanese and Chinese porcelain, Indian statuary, tribal artefacts from Africa, the South Seas and Australia and sea shells on which Jamrach was an acknowledged authority. Collecting was another way of reinforcing the notion of Imperial domination and became a major vogue – especially as fashions in interior design such as *Japonisme* or the blue and white china craze encouraged exotic accessories – in the later nineteenth century.

Back in Hamburg the Jamrach business was sold off to Claus Gottfried Carl Hagenbeck, the father of Carl Hagenbeck, who would eventually be Jamrach's only real rival in the worldwide trade in animals and whose legacy still exists in the form of Hamburg Zoo where he pioneered the use of naturalistic enclosures rather than cages and extensive ethnographic exhibitions (Ames; Rothfels 'Catching Animals'). Claus Hagenbeck was a fishmonger by trade and had his own fishing fleet. He was involved in the caviar trade and in 1848 one of his teams of sturgeon fishers came back with six seals that had become entangled in their nets. Rather than killing them or leaving them to die Hagenbeck put them in two big basins and charged people to see them. He then took them on the road and exhibited them as far afield as Berlin – they were a popular attraction there even in the midst of the events of 1848 – where he finally sold them on (although it appears he never got the money). He then bought and exhibited other animals – including a polar bear, monkeys, hyenas, a talking parrot and many more common creatures – to set up a menagerie to rival Jamrach's. He also caught more seals but did not exhibit them, preferring to sell them on to other showmen. Hagenbeck finally bought the Jamrach Hamburg operation in 1863. After Claus's retirement Carl took the business to new heights and was, in the early stages, reliant on trips to London where the animal dealer Charles Rice (who was also his brother-in-law) worked as his agent. But eventually he sponsored major collecting expeditions into Africa and obtained his animals at source. He was also involved in the wider picture of Imperial politics and in the 1905 he mounted an expedition, using his long-time Somali associate Gorseh, to acquire one thousand camels for the German army. He wrote that his business was greatly enhanced once the German Empire was established as a worldwide force as this enabled better access to the habitats of animals in Africa particularly. For the British traders the combination of the rise of Imperial Germany and the widespread adoption of the Suez Canal was a fatal double blow (Hagenbeck).

However, for the central fifty years of the nineteenth century a combination of general Imperial strength and diversity and the strategic position of London and Liverpool on the global trade routes gave Britain pre-eminence, and we can look at the cases of Australia and India where Britain had a monopoly position (unlike in Africa or the Americas) to see how specific colonial and imperial conditions enabled the exotic animal trade to develop in Britain's favour.

The trade in animals, especially birds, from Australia was so significant that an article in *The Register* (a South Australian newspaper) for 17 February 1862 mentions ships with twenty to thirty thousand parrots on board leaving Adelaide for London on a regular basis and pointing out that 'Thus South Australia is establishing a new export item'. This created a secondary industry in seed to feed them and this left Adelaide in massive two hundred and four hundred gallon drums. Just one of Jamrach's consignments consisted of five thousand pairs of cockatoos. These exotic birds were intended both as pets and as material for the 'murderous millinery' industry that was a target of early animal rights campaigners such as Henry Salt and the women whose direct action, writing letters to people who wore feather-trimmed hats, led to the foundation of the Royal Society for the Protection of Birds (see Moss; Moore-Colyer; Hornaday; Salt). So not only was the mother country benefitting from this industry but the individual colonies were as well. By the end of the century it was not only live animals that were being exported but wombat and koala skins by the hundreds of thousands and various kangaroo products including tinned meat for human consumption. In 1889 alone three hundred thousand koala skins with a value of £15,000 were imported into Britain (by 1924 this had grown to two million skins), which shows how important the exotic animal trade was to the network of colonial economies and the co-dependencies between the economies of the colonies and the mother country. Wombat skins went in similar numbers and were much prized as carriage rugs and hearth rugs (Simons, *Rossetti's Wombat* 21; Moyal).

Birds formed a huge part of the exotic animal trade in general and the Australian business in particular. Jamrach probably imported the first live budgerigars into England and paid £26 for a pair selling them on for only £1 profit to a Dr Butler of Woolwich. However, by 1879 they were common and were breeding in captivity. By this time Jamrach was importing them by the thousand and exporting them across Europe at eight shillings a pair. The profitability of the trade can be seen by the price of budgerigars at this time in their native Australia. They were sixpence each and they could be bought by the flock to provide a means

of livening up shooting parties. So if we assume a wholesale price of say, threepence each, Jamrach's profit before costs was three shillings and ninepence per bird or £75 per thousand. The losses, however, were enormous. One account spoke of seeing such a shipment at Alexandria with the birds gasping for air, and when they got to the London shops they were packed so tightly into cages that they could not move. The day's dead exotic birds were brought to Jamrach on a large tray every evening when he filled in his 'death-book' and the losses in the shop amounted to between £150 and £200 per month cost price. The only consolation was that the carcasses could be fed to the flock of vultures which was usually in stock.

If you wanted to collect an Australian menagerie, this is what Jamrach would have charged you in 1879 (see Table 2.4).

Table 2.4 Prices of Australian animals quoted by Charles Jamrach 1879

King parrots	£4 per pair
Cassowaries	£50
Blue cranes	£20
Tasmanian crows	£2
Kangaroos	£25
Wallabies	£12
Kangaroo rats	£2
Possums	£2
Fruit bats	£1
Black swans	£5
Wombats	£5

Koalas are absent from the list as none had so far survived more than three days at sea. Jamrach correctly surmised that this was because they soon ran out of the fresh eucalyptus leaves that form their sole foodstuff. Live koala transportation was hindered by this feeding specialisation for many years – one did make it to London Zoo in 1880 and was kept alive for a year. Unfortunately it suffocated when its head became jammed between the rails of a wash-stand in the head keeper's office. It was not until well into the twentieth century that live koalas made it to Britain in viable numbers.

Anton Jamrach acted as an Antipodean agent for his father. In August 1865 he placed an advertisement in the *Adelaide Daily Telegraph* offering

to buy Australian animals from his ship, the *Coonalto,* or the Port Admiral Hotel. In his *Advance Australia* (1885) the Honourable Harold Finch-Hatton recalled his two encounters with Big Ben, a crocodile twenty-three feet in length. The first time they met was in Queensland; the second time was in Jamrach's shop. The dealers Walter Payne and Jack Wallace had a very specialised Australian business. They dealt in birds but they also trapped kangaroos which they tamed at a farm in Australia and then shipped to England. They sold them as attractive and interesting pets (which could be fed from the hand) from a specialist facility just outside Bath known as the Little Zoo.[5]

India was another important source of animals and William Jamrach made several trips there on behalf of his father. He was in India in 1869, 1871 and again in 1875. These visits were largely concerned with the purchase of rhinos. In 1872 he brought two rhinos to Berlin Zoo and swapped them for the one that they already had there. In fact, William may well have had a permanent office in Calcutta for a *New York Times* report of 21 March 1884 refers to the sale of an elephant to William Cross of Liverpool by 'Jamrach of Calcutta'. One confirmation of William Jamrach's Calcutta business comes to us from reports of the loss with significant deaths among the passengers of the S.S. *City of Agra.*The ship foundered off Corunna on 8 February 1897 *en route* from Liverpool to Calcutta and one of the deceased passengers was Arthur Ernest Jamrach who was William's son. The ship's intended route suggests that Arthur was following in his father's footsteps and going to Calcutta on an animal-related mission.

In India was also the civil servant Edward Blyth (Brandon-Jones). Blyth was a correspondent of Charles Darwin, and acted as curator of the Asiatic Society of Bengal's museum in Calcutta between 1841 and 1863. His career offers more evidence of the integration of the exotic animal trade into the broader politics and economics of Empire. Throughout his career Blyth was short of cash and he supplemented his salary by dealing in wild animals. He offered both Darwin and John Gould specimens of Indian birds which he collected alongside the official specimens he took for the museum. Blyth did not have the advantage of premises in London with proximity to the docks that Jamrach had, and so he had to bear in advance costs of shipping and provisioning his finds. He also had to deal through agents in London and had no direct management of his supply chain. When he sent a mongoose to his agent Abraham Bartlett, the celebrated zoo-keeper, for sale to London Zoo it was declined by them. It was then purchased by Edward Cross for £10 (who was mainly a zoo proprietor but who ran a side line

in animal trading). Cross then sold it, more or less immediately, to the zoo for £20. Blyth bought a yak for £25, and the prolific collector Lord Derby was only too pleased to snap it up for the Knowsley menagerie. But Blyth had forgotten to ask for the shipping cost and he was out of pocket and must have been especially peeved when he saw the greater price for which the yak was knocked down at the great auction of the Knowsley menagerie in 1851. Blyth could and did sell nearer to home, as many of the Indian princes were keen on keeping exotic animals and some of the zoos of modern India have their origins in these princely collections. We have seen the price that the Nawab of Oudh offered for giraffes. Blyth made money selling to him and profited again when his menagerie was sold off and tigers were to be had for as little as £2 each. Some of the Indian princes were attracted to South American animals which to them were as exotic as tigers were to the English, and Blyth did attempt to obtain these through his networks for import and sale in India. Blyth was by no means a success in the animal trade but he could double his annual salary with one shipment. This shows what was at stake for the large professional dealers and how the transfer and sale of exotic animals was an important facet of the Imperial economic network.

Blyth's story helps to structure our understanding of the animal trade in Victorian England. His position in India uniquely situated him to take advantage of proximity to some of the more desirable animals, and he would not have been there had it not been for the Empire. However, he was, for the very same reason, remote from the actual trade and could not generate the economies of scale that Jamrach or William Cross could manage. He also had to pay his own shipping costs while the London and Liverpool dealers operated in a world where individual sea captains and sailors took their own risks and so avoided the heavy costs of freight and provisioning. But the India trade was not risk free for Jamrach either. On 5 October 1873 the S. S. *Agra* went down off Galle. On board was a large consignment for Jamrach (priced at £4000). The crew managed to rescue some cobras and an elephant and although a tiger managed to swim ashore it was shot three days later by the government agent.

On 27 October 1857 India made itself felt in a very particular way when a tiger that was being delivered to Jamrach escaped and set off down the road snatching a small boy, John Wade, as he went. Jamrach rescued the boy and recaptured the tiger. The incident made national headlines and the story was reported by most of the English and Scottish provincial newspapers and in Welsh in the *Baner Cymru*. But it was not

so much a tiger escaping in London that created the sensation as the association between that tiger and the events in India on which the British public's eyes were fixed with increasing horror. The loyal sepoys of the East India Company's Bengal army had risen up against British rule and had been joined by units from other parts of India. Europeans, including women and children, had been killed and there were desperate sieges in several cities. In August 1857 *Punch* published a cartoon by Sir John Tenniel, entitled the *The British Lion's Vengeance on the Bengal Tiger*. This showed a lion leaping onto a tiger which is straddling a white woman and her child. *Punch* also reported the Jamrach incident but *The Examiner* of 31 October published a piece entitled 'A Poor Dear Tiger'. In this the newspaper facetiously chastised Jamrach for being more careful of the tiger than the boy and making the point that government policy was paying too much attention to the rights and wrongs of the sepoys' case and the rights and wrongs of the Imperial presence in India and not enough to the business of protecting the British population and planning the military defeat and punishment of the rebels. The escaped tiger was propelled to the heart of political debate about the Empire and the morality of imposing British domination on subject peoples.

The presence of a Bengal tiger, the very symbol of India and, now, of rebellious India in the deepest heart and home of the Empire is, at one level, a statement of the potency of that Empire and its capacity to subjugate and rule its peoples no matter how far away they might be. It is also a statement of the Empire-wide reach of the exotic animal trade. However, once that tiger escapes it becomes a symbol of something very different, especially when it picks up a white child. Jamrach may have thought he was heroically rescuing John Wade and indeed he was. But he was also fighting for the integrity of the Empire. One of the stories which made the reputation of Sir James Outram, one of the commanders of the British forces sent to deal with the rebellion, was that he had, early in his career, killed a tiger with a spear. The symbolic value of this anecdote is clear – if you can subdue a tiger, you can subdue India.

Singapore was also a colony where British traders enjoyed a near monopoly, and it was of course the return from Singapore of Sir Stamford Raffles, bringing with him his second substantial menagerie (the first all went down with his ship which caught fire on his first attempt to come home) that led to the foundation of London Zoo. This was to spark off the mania for zoo building all over England, Scotland and Ireland in the last seventy-five years of the nineteenth century. The zoos were also a statement of Imperial power and could not have survived without the trade routes guaranteed by Empire that kept dealers like Jamrach at

the top of their profession. In 1873 Jamrach's agents were in Singapore and had filled the yard of the Hotel de la Paix with their purchases which included four tapirs, two orang-utans, a panther, an elephant, a bear and various large birds. These formed an informal zoo and could be viewed by appointment. He had two local hunters – the Fernandez brothers – scouring the Malaysian Peninsula for more animals and was planning a shipment of eight each of rhinoceros, tapirs, tigers, panthers as well as numerous birds. With rhinos at more than £1000 apiece, tapirs at £160 and tigers at £300 and panthers at £150 this would have been a significantly valuable cargo and would have compensated for the £4000 Jamrach lost when the S.S. *Agra* went down off Galle (also in 1873) when only an elephant and some cobras survived.

Jamrach employed a worldwide network of agents and this, coupled with the travels of his sons Anton and William, gave him pre-eminence over his rivals. He had full-time agents in Liverpool, Southampton, Plymouth, Deal, Bordeaux, Marseilles, Hamburg and elsewhere. In other words, wherever exotic creatures were most likely to land Jamrach had a man there to watch and buy. Jamrach himself went to St Petersburg in July 1882 and seems to have been involved in supplying up to three thousand African monkeys per year to the monkey theatres which were popular in Germany and Russia at that time. In spite of the risks involved the profits were high. Jamrach left £7150 and 8d so he died a fairly wealthy man as this is roughly half a million pounds at today's rates.

As the century wore on Jamrach became more dependent on the specifically English colonies and was less able to buy animals from Africa where the German dealers, especially Hagenbeck, were increasingly in control. In 1869 the famous naturalist and luminary of the acclimatisation movement, Frank Buckland, recorded an expedition which was led by Lorenzo Casanova on behalf of Hagenbeck. This resulted in what Jamrach himself described as 'the largest consignment of wild animals that ever arrived in Europe'. The expedition did most of its work on the border between Egypt and what is now Ethiopia – the very area that would later be compromised by the Mahdi and his army – and collected thirty-two elephants, eight giraffes, twenty antelopes, sixteen buffaloes, two rhinos, one hippo, twelve hyenas, four lions, four ostriches, twelve hornbills and a miscellany of other birds. The bigger animals walked to the Red Sea while the rest were caged using iron bars which had been transported specially for the purpose. The entourage was accompanied by three hundred Arabs, ninety-five camels and eighty goats which were there to provide milk for the hippo and the rhinos.

After a six week trek across the desert in which Casanova was stung by a poisonous fly and temporarily went blind, two elephants escaped and five were killed 'by accident'. The animals were put on a steamer to Trieste whence they were taken to Hamburg by train. Eventually eleven elephants, five giraffes, six antelopes, one rhino, twelve hyenas, seven hornbills and four ostriches staggered from their carriages. If we apply the prices that Jamrach would have charged in 1879 to this consignment we can begin to understand its value. If everything had survived Hagenbeck would have had goods worth £19,140. As it was his survivors would have fetched at least £6,830 in London. This was big money and even with the attrition rate that was inevitable in the long distance transport of delicate creatures and the subsequent difficulty of their maintenance in captivity (as one can see from the details of Jamrach's loss book cited above) there were fortunes to be made. To illustrate this point another of Hagenbeck's animal catchers Josef Menges offered the following comparison of the cost price of animals at Kassala in the Sudan (their European value is cited in Maria Theresa thalers), (see Table 2.5).

Table 2.5 Comparative value of animals in the Sudan and Europe in 1876

	Kassala	Europe
Elephant	80–100	3000–6000
Giraffe	80–200	2000–3000
Rhinoceros	160–400	6000–12000

Of course, the animals still had to be transported back to Europe and then find a buyer there and, as we have seen, loss rates were very high; nevertheless these figures show very clearly what the potential profit of the animal trade could be (qtd in Rothfels, 'Catching Animals' 232).

 The exotic animal trade brings together the potent ingredients of empire and class – the dealers may have been wealthy men but they were not gentlemen although their patrons were gentlemen and aristocrats who had to visit the lowest slums of London in order to see the goods – and, in that sense, any attempt to make sense of it via a narrative implicates us in the structures of romance. But for the animals the experience was far from romantic. The trade was based on the hard economics of buying and selling, profit and loss, supply and demand, and it undoubtedly contributed – as many Victorian fads did, with pteridomania (the craze for ferns) or the vogue for collecting the life of

seaside rock pools being other examples – to the endangerment of many species. At the same time, the great modern zoological institutions, both museums and zoos, could not have established themselves without the existence of the animal traders and some species (such as Hamlyn's Monkey – *Cercopithecus hamlyni*) first came to be known through their efforts. Above all it is clear that the mechanism of the trade could not have worked had it not been for the background of Imperial commerce and that part of that mechanism was to bring economic advantage to the colonies. The collapse of the trade due to pressure caused by the rise of Germany is an aspect of the Anglo-German rivalry that would, by 1914, lead to catastrophic conflict and the eventual fall of all the Imperial powers. For that reason alone it is worthy of note, although from a wider standpoint the realities of the lives of captured animals and their role in a global trade network is what should detain us as we consider how this history still resonates today.

Notes

1. See Simons, *Tiger* 159–72 for a brief survey.
2. I am indebted to my colleague Professor Tony Cousins of Macquarie University for this insight.
3. See Simons, *Tiger* on all of these issues; Gerzina; and Ritvo, *Noble Cows*.
4. Between 1857 and 1901 some 215 lion cubs had been raised at Dublin Zoo (de Courcey).
5. This was featured in an article in the periodical *The Sphere* on 9 November 1907.

Works cited

Ames, Eric. *Carl Hagenbeck's Empire of Entertainments*. Seattle: University of Washington Press, 2009.

Baden-Powell, Lord Robert. *Lessons from the Varsity of Life*. London: C. Arthur Pearson, 1933. 52–53.

Brandon-Jones, Christine. 'Edward Blyth, Charles Darwin, and the Animal Trade in Nineteenth-Century India and Britain'. *Journal of the History of Biology* 30.2 (1997): 145–78.

Catania, Charles. *Andrea de Bono: Maltese Explorer on the White Nile*. Peterborough: Upfront Publishing, 2002.

de Courcey, Catherine. *Dublin Zoo: An Illustrated History*. Wilton: Collins, 2009.

Crosby, Alfred. *Ecological Imperialism: The Ecological Expansion of Europe, 900–1900*. Cambridge, UK: Cambridge UP, 2004.

Gerzina, Gretchen Holbrook. *Black Victorians, Black Victoriana*. Piscataway: Rutgers UP, 2003.

Jeal, Tim. *Explorers of the Nile: The Triumph and Tragedy of a Great Victorian Adventure*. New Haven, NJ: Yale UP, 2011.

Hagenbeck, Carl. *Beasts and Men*. London: Longmans, 1912.

Henninger-Voss, May, ed. *Animals in Human Histories: The Mirror of Nature and Culture*. Rochester: University of Rochester, 2002.

Hornaday, William. *Our Vanishing Wildlife: Its Extermination and Preservation*. New York: Charles Scribner's Sons, 1913.

Kete, Kathlene, *A Cultural History of Animals in the Age of Empire*. London: Bloomsbury, 2011.

Mackenzie, John. *The Empire of Nature: Hunting, Conservation and British Imperialism*. Manchester, UK: Manchester UP, 1988.

Moore-Colyer, Roland. 'Feathered Women and Persecuted Birds: The Struggle Against the Plumage Trade c. 1860–1922'. *Rural History*, 11.1 (2000): 57–73.

Moss, S. *Birds Britannia*. London: Collins, 2011.

Moyal, Ann. *Koala: A Historical Biography*. Collingwood, Vic.: CSIRO, 2008.

Raffles, Lady Sophia. *Memoir of the Life and Public Services of Sir Thomas Stamford Raffles*. 2 vols. London: James Duncan, 1835.

Ritvo, Harriet. *The Animal Estate: The English and Other Creatures in the Victorian Age*. Cambridge, MA: Harvard UP, 1987.

——. 'The Natural World'. *The Victorian Vision: Inventing New Britain*. Ed. John Mackenzie. London: V&A Publications, 2001. 281–96.

——. *Noble Cows and Hybrid Zebras: Essays on Animals and History*. Charlottesville: University of Virginia Press, 2010.

——. *The Platypus and the Mermaid, and Other Figments of the Classifying Imagination*. Cambridge, MA: Harvard UP, 1997.

Rothfels, Nigel, 'Catching Animals'. *Animals in Human Histories: The Mirror of Nature and Culture*. Ed. May Henninger-Voss. 2002. 182–25.

——. *Savages and Beasts: The Birth of the Modern Zoo*. Baltimore: Johns Hopkins UP, 2002.

Salt, Henry. *Animals' Rights: Considered in Relation to Social Progress*. London: Macmillan, 1894.

Simons, John. *Rossetti's Wombat: Pre-Raphaelites and Australian Animals in Victorian London*. London: Middlesex UP, 2008.

——. *The Tiger That Swallowed the Boy: Exotic Animals in Victorian England*. London: Libri, 2012.

Steele, Murray, and Benbough-Jackson, Michael. 'Liverpool 1886: Selling the City of Ships'. CHARM Proceedings, New York 2011. 182–93. 27 February 2013 http://faculty.quinnipiac.edu/charm/CHARM%20proceedings/CHARM%20 article%20archive%20pdf%20format/Volume%2015%202011/Liverpool,%20 1886.pdf

3
Christian the Lion: An Interview with Ace Bourke

Melissa Boyde

This interview explores the story of a lion cub purchased at Harrods department store in London in 1969 by friends Ace Bourke and John Rendall. The cub's parents, inmates of Ilfracombe Zoo in Devon, had their first litter of four cubs taken from them – two were sold to a circus and two to Harrods 'Zoo', in reality an exotic animal section of the shop. Ace and John, after graduating from university and working to save money to travel, had not long arrived in London from Australia, and on a sightseeing trip around the city, they went to Harrods where they, very unexpectedly, saw two lion cubs in a small cage. The young men sat with them for hours. They found the male cub 'irresistible' and decided to buy him. They called the cub Christian and for the next eight months of his life he lived with them in London.

They worked in a shop on the King's Road, Chelsea, coincidentally named Sophistocat, and while Christian lived in the basement, they lived in an apartment upstairs. A local minister let Christian exercise daily in the large fenced churchyard near World's End. But as Christian grew quickly, the men could not guarantee they could always control him, and although initially he had the run of the shop, he had to spend more and more time in the basement. They sought a long-term solution that would give Christian the best life possible. Through extraordinary circumstances they eventually took him to Kenya where George Adamson of *Born Free* fame gave him the opportunity to take his chance to lead a natural life. Two documentaries were made about Christian's life and return to Africa, and the pride of lions George assembled around him at Kora in Kenya. Ace and John visited a year later, and nearly forty years after that, in 2006, a clip of their reunion

with Christian in Africa was first posted on YouTube and subsequently went viral. Captured on film the real-life moment when Christian recognises Ace and John and runs down the hillside and into their arms triggered an emotional reaction around the world. Christian's life, like the lives of countless animals who find themselves caught in the exotic animal trade, could have taken a completely different path.

Melissa: Department stores, like museums, were a nineteenth-century phenomenon, their rise linked both to modernity and to imperial collecting and consumption. It seems that the presence of imported 'exotic' animals for sale in Harrods in the late 1960s was a lingering trace of that era – the idea that anything and everything from the four corners of the world could be displayed and bought, and that ideas of taste, style and class could be acquired by shopping there.

Ace: Yes, Harrods 'Zoo' as it was then called, was a part of that lingering element from the past, but in the late 1960s it was one of the best known stores in the world, and they did boast that they could provide anything. It sure beat David Jones [a department store in Sydney]. Our fateful first visit was more as tourists rather than shoppers. We were aware of the Zoo, and a friend had told us about someone who had inquired about purchasing a camel and was asked 'Would that be with one hump or two, Sir?'

In the 2009 TV Special *A Lion Called Christian*, vintage footage from the zoo I had never seen was included with rare animals and birds. It was less exotic when we visited in 1969 with dogs, cats and fish etc., and the two lion cubs were there primarily as an attraction in the lead-up to Christmas. It was a shock to think you could actually buy a lion, and that a price could be put on it. It was something we had never thought about, and we later came to realise and acknowledge that we had encouraged and participated in the trafficking in exotic animals by purchasing Christian. The *Endangered Species Act 1973* offered better protection from this trade.

In 2009 while promoting our revised and updated 1971 book *A Lion Called Christian* (See Figure 3.1), we were interviewed in Harrods in what was now more of a pet boutique. There were very few animals, but many totally unnecessary bejewelled accessories for them, miniature four-poster beds, snacks and beauty treatments – I was just horrified. We had just seen similar pet boutiques in Los Angeles. I suppose it means people love their animals – but couldn't that wasted money actually help animals in need?

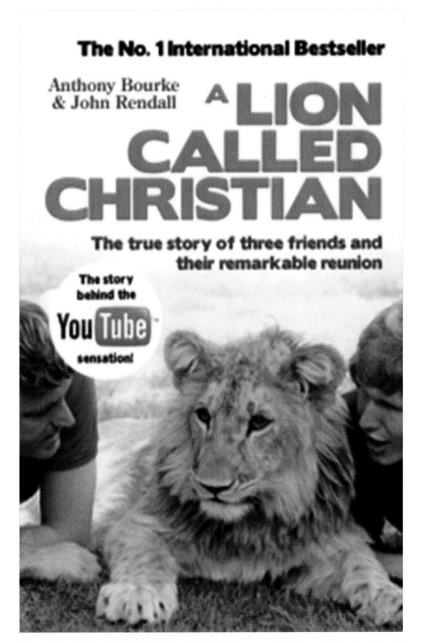

Figure 3.1 A Lion Called Christian (2009), book cover, London: © Derek Cattani/ Born Free Foundation, courtesy of Random House Group

M: Was the acquisition of 'exotic' animals part of having an 'exotic' identity in London in the 1960s?

Ace: I suppose so. The night-club owner John Aspinall had tigers and other animals on his country estate. (Interestingly, his son Damian Aspinall works at returning animals to the wild.) Having an unusual animal in London was probably more 'anything goes' than 'exotic'. But the late 1960s were morphing into another era – leaving the Kings Road and Carnaby Street behind. David Bowie emerged with *Ziggy Stardust*, and Vivienne Westwood and Malcolm McLaren were literally around the corner from us with their shop Sex.

M: Did you buy Christian on impulse?

Ace: Yes, an impulse buy! But we still had weeks to think about it as they wanted Christian on show until Christmas. We were two young travellers, so it was a very impractical idea, possibly fraught with nightmares we couldn't imagine. We realised it was a full time commitment for at least a year but that he would soon out-grow us and we would need to find him a permanent home. We thought we could look after him as well as anyone, and that we would do our best to try and secure the best future for him.

M: The film *Born Free* had been released in 1966, with its story of Elsa the orphaned lion cub who was cared for by Joy and George Adamson until her eventual release into the wilderness in Kenya. Was this film somewhere in your mind and did you envisage Christian's return to the wild right from the start?

Ace: Although both the book and the film were huge hits in the 1960s, neither of us had read the book or seen the film. I've recently read *Born Free*. It was based on George Adamson's diaries and experiences, and unlike Joy Adamson, he received no finan-cial benefit although the book sold millions of copies. However, the story of Elsa the lioness and her return to the wild was well told by Joy, with wonderful photographs. We did meet Joy at her home at Lake Naivasha. She was a very talented but difficult woman. I have noticed that a few people who work tirelessly on behalf of animals don't actually treat humans as well as they should.

It did not occur to us to try and return Christian to the wild. We had never been to Africa, and knew no one there. The com-plexity of the politics and the prohibitive costs would have been beyond us. We were concentrating on avoiding a zoo which was our unspoken nightmare. We thought of wealthy people with

country estates, and the first Safari park outside Africa had opened at Longleat, near Bath. We checked this out as a future option before we actually brought him home.

But by chance one day Bill Travers and Virginia McKenna, who had starred as George and Joy Adamson in the film *Born Free*, came into the shop Sophistocat, shopping for furniture. After meeting Christian they asked if we would consider sending Christian back to Kenya to be rehabilitated by George Adamson.

M: The YouTube clip was taken from film footage that was shot during the time that Christian was with you in London and when you visited Kenya after he was taken there. Without that footage the story of Christian is not likely to have been revived in 2006. What were your reasons for starting to film Christian?

Ace: Bill Travers and others had a film company called Morningstar Productions that had made several animal documentaries. A documentary about Christian's life in London and then his return to Africa would fund the costs of Christian's transportation to Africa, and help pay the rent for the land at Kora allotted by the Kenyan Government to George Adamson for rehabilitating lions. Subsequently, a second documentary followed the progress of Christian and the pride of lions George assembled around him, and this included the YouTube footage of our return to see Christian one year later.

The director was James Hill who had directed the hit television series *The Avengers*. He was terrified of Christian. Morningstar Productions no longer exists, and Bill Travers has died. Virginia McKenna and her son Will Travers continue their work through the Born Free Foundation.

M: How much did the director influence the production? Was it entirely 'real life' or was there a performative element to the filming for the humans, or for Christian, in the documentary?

Ace: We were asked to look 'Kings Roadish' and not cut our hair. I know 70s Retro became cool, but regretfully, yes they are my clothes. I was hopefully moving in a less colourful direction.

We were filmed doing whatever was required to tell the story – some reconstructed, and some as it happened. It was more 'walk over there and pause' rather than acting! On the other hand Christian was a natural, and was described as a 'one take' lion. In his garden he was spooked by the noisy slow-motion camera (the first time a lion had been filmed in slow motion), so we let him chase us to get him going. This was normally something we never

encouraged or allowed. I only had one line of dialogue, but my voice was apparently too plummy and I had to be dubbed by an English actor attempting a broad Australian accent!

M: There are numerous photographs of Christian out and about in London with you and John; did you consciously decide to document Christian's life in London in this way?

Ace: Christian caused a certain amount of attention in London, and photographers loved waiting for a yawn that looked like a snarl. We had a photographer friend Derek Cattani and he came to the shop and built up his own relationship with Christian. A couple of times we went all over town taking photographs. Christian half liked adventure, but like all cats was very cautious, and very much had his own mind about what he would do and what he would not. Everything had to be his idea. We ended up with a great archive of photographs, but the impression this gives of us parading him all over town is a false one. Our time with him would not have been so successful if he hadn't had a very stable environment, and exercise every afternoon.

Christian at home in London

M: How did you communicate with the baby Christian? Was it different to the way one might develop a relationship with a cat or dog?

Ace: No, the same. Love, attention, time, trust. Food of course! Cuddles, pats, hugs and games. Lions are a little more like dogs than other cats, in that they are more gregarious and sociable. As they live in prides, we were part of Christian's family.

M: The basement below the shop Sophistocat where Christian lived: can you describe it for me? Were there windows? How did his behaviour indicate that he was OK with being kept down there?

Ace: It was a very big basement under what were originally two shops, with several rooms. It wasn't mouldy or dingy at all, although I'm not sure if it had windows. We had a large kitty litter tray which he used fastidiously immediately. At first he ran around the shop throughout the day, but as he grew so quickly, his size began to frighten people who could not be expected to respond appropriately, and he had to spend more of the day downstairs. In the basement he had his mattress to tear up and toys to play with, and one of us was always going down to play with him. Like all cats he was happy to sleep if nothing much was happening. His great friend Unity Bevis-Jones came and played with him every day, and

he went to the church garden every afternoon. In the evening he liked to sit in the shop windows and watch the world go by.

M: You mention in the book that Christian had different greetings and played different games and tricks with people such as Unity, his regular visitor. Can you elaborate on this?

Ace: Unity had been an actress in Rome and was in a Fellini movie. She had lived with a lioness in her apartment, despite the hysteria from neighbours. She and Christian adored each other. There is a photograph in our book of her playing wheelbarrows with him, holding his back legs. He also enjoyed tripping her over by tapping her ankles with his paws. She was quite small, and if he was too rough with her she would slip out of the basement door and they would have a conversation like 'I'm not coming back in until you are more gentle with me' or 'I'm not coming back in until you are further away from the door' and he would grunt in reply.

A fan of Christian's emailed me last year saying she had looked at photographs and footage of Christian and noticed I was always talking to him; she asked 'what were you saying?' I then began to look for myself and saw that it was true. I suppose I was saying the sort of things I still say to my cats – and many of us say to our animals – along the lines of 'who is the best looking/cutest/most gorgeous animal in the world?' All compliments were naturally just taken for granted. I think I was also saying 'I know what has caught your eye, and I know you are thinking of chasing it, but I'm not going to let you.' Or just talking of course.

M: How was it that he learned to keep his claws sheathed when playing with you and John?

Ace: Just like with a cat, you just let them know they have clawed you, or snagged your clothing, and that you don't like it. They all have to learn to use and sheath their claws appropriately anyway. We sometimes wore very unattractive but tough boiler suits. Christian learned quickly and would always respond to a tone of displeasure in our voices.

M: It seems to be an indicator of his active involvement in the relationship with you and John?

Ace: I haven't really talked about his extraordinary cooperativeness under these unusual circumstances, and his empathy, which many of the animals in our lives have. He seemed to understand that his behaviour was a factor in the group dynamic.

M: He was figuring it all out?

Ace: It seemed that way. Of course sometimes he was disobedient. I suppose there was the occasional slap – but he was so responsive to the tone of our voices. The worst punishment was just ignoring him or moving away. We tried to create an environment where he could more or less do what he wanted so that we were not always stopping him and restricting him, which only frustrated him. He didn't like being reprimanded and could be offended or huffy, but he would quickly try and win us back all the same. He liked harmony. I am of course being totally anthropomorphic here!

While there was so much that was like any loving human–animal relationship, lions do have immense physical and psychological presence, and very early Christian had the power to inflict great damage. So it was a fascinating game where we never let him know the point where we actually could not control him any longer, which meant we had to pre-empt any likely problematic situations if possible. We were not frightened of him (although very respectful of his power), and we made sure we never exhibited any fear or uncertainty which he could always sense in some people and take advantage of.

When we visited him one year later in Africa, the so-called 'YouTube reunion', we had complete confidence in him, as did George Adamson. We knew he would remember us and that it would not be dangerous for us. We were more worried that he would not be in the vicinity of George's camp, or that he may be a little off-hand or even ignore us!

It took quite a long time for me to realise that part of the attraction of the reunion clip for some people was that they thought we were about to be attacked! Of course it was incredibly exciting seeing him again, but it is similar to when you come home after an extended absence and, for example, your family labrador might run towards you with obvious over-excited enthusiasm. The fact that it was a lion made no difference at all – we didn't think 'OMG that's a lion running towards us'.

M: Because you knew him?

Ace: Exactly. We knew him. That was the key to it all, knowing him. We could tell by his facial expressions and recognise that the noise he was making was one of excitement. He wasn't going to hurt us and we just knew he wouldn't. He had grown so much the danger was he may have knocked us over, but we knew how to brace ourselves.

Interestingly, we were also surrounded by several lionesses who had been captured and did not like humans at all, but in this instance they followed Christian's lead and milled around us, sharing in the euphoria of the moment.

M: Did you grow up with animals at home?

Ace: Always. We just grew up with animals as a normal part of family life. We always had a dog, and I introduced the first cat into the family – a rather scruffy one I found on the vacant allotment next door. We also loved horse riding.

Speaking from my own experience, I do think many of us are now a little too obsessed and dependent on our family animals, probably, like gardening, as a compensation for our increasing alienation from nature.

M: On reflection did you make mistakes with Christian?

Ace: I think we did excellently for two young people. Friends certainly helped us. We led quite independent and full lives, but looked after Christian very well. Lions will always sleep if nothing much else is happening. There were no real incidents or accidents which is really quite amazing. Christian was extraordinary however.

M: Can you describe your perception of Christian's emotional life?

Ace: 'Cheerful, mischievous and courageous' were George's words for Christian, and they came to really love each other. His cheerful disposition (and attractiveness) seemed to make him popular with humans and animals. Christian was trusting, loving and affectionate, cooperative, good-natured and calm, and not neurotic or easily spooked. He was confident. He was fun to be with and playful, a show-off who loved to be the centre of attention. He wanted to be included in nearly everything, although like most cats, the decision to participate had to be his. Of course he could be contrary and we had to be patient and clever with him.

It was only in 2009 when John and I were revising and updating our 1971 book and looking closely at Christian's photographs, that we first used the word 'charismatic' about Christian. How else could a lion get himself from an obscure, run-down zoo in Devon to Harrods in London, have a life in London and a brief sojourn in the English countryside with movie stars, become one of the very few animals to ever actually be returned to Africa to the world expert on lions, and be given – and succeed – at the chance to lead a natural life? Not forgetting – starring in his own movie, and becoming an internet sensation!

Kenya

Ace and John decided against sending Christian to the Longleat Safari Park in England when they revisited it. Their decision was primarily because of Longleat's policy of hiring out animals for film work and even selling on to circuses. After the serendipitous meeting with Bill Travers and Virginia McKenna, George Adamson agreed to rehabilitate Christian. Christian had now outgrown life in London, and while all the complicated and time-consuming arrangements were being made with the Kenyan Government, Ace, John and Christian moved to the country home of Travers and McKenna, where he lived in a large wire enclosure with a gypsy caravan. But after ten weeks there, Christian again outgrew his environment and showed signs of frustration. Reversing the usual practices of capturing and trading wild animals was a complex task but eventually Ace, John and Christian were transported by air to Nairobi, with Christian in a crate in the cargo section. This was a dangerous journey for him as there was not much expertise associated with the safe transportation of animals at that time.

> *M*: How did he react when he first experienced being in Africa?
>
> *Ace*: It took several days to reach George Adamson's camp at Kora in north-east Kenya which we did in two stages. On the first day Christian saw a gombi – an African cow, and he stalked it perfectly – circled around it, crouching low and down wind. Unfortunately, because it had dangerous horns, George said we should stop Christian who was understandably annoyed at being picked up and put in the back of the Land Rover.
>
> He had his thick English coat and found it very hot. For the first few days he just lolled on our camp beds rather lethargically. His colouring provided a natural camouflage, and he instinctively knew how to get thorns out of his paws. It was quite a barren environment (which was why George was allotted the area) and his paws had to be toughened up.
>
> It was so beautiful, unbelievable really, that we were actually in Africa and we were able to just walk with him or sit by the river with complete freedom.
>
> *M*: Can you describe how Christian seemed to settle in at Kora?
>
> *Ace*: He fitted in immediately. George was interested in Christian as a fifth generation European lion, and later said his natural instincts were completely intact – he was just inexperienced. Ironically,

George said out of the many lions he had rehabilitated, Christian was the easiest.

The biggest test was the other lions. The first test was meeting the lion Boy who had been injured and was now ready to be released again. Christian was old enough to be a threat to Boy who could have easily killed him. Their introduction was very frightening and it took several months for Boy to accept Christian. This depressed Christian but he waited patiently. Boy ultimately adored him.

There were wild lions already in the area who were always trying to drive any of George's male lions out of their territory. Christian proved to be courageous and canny to survive the first years and was growing into one of the largest lions George had ever seen. In the end he had to go elsewhere to establish his own territory.

M: Did George Adamson have special qualities that enabled him to live and work so effectively with lions?

Ace: While Joy Adamson could be quite volatile, George was very calm. He had a quiet authority. He managed to create a neutral space where humans and animals interrelated very naturally – the two biggest predators! Given his communication with lions, I suppose these days he would be called a 'lion whisperer'. They loved him. They would passively let him attend to their sometimes bad wounds. In general, the idea at Kora was to minimise human contact as that was dangerous for all concerned. Looking back George probably had too much confidence in all of us. It was nerve-wracking having the huge (and rather troubled) lion Boy wander into our tent, sometimes taking our arms in his mouth. You could not afford to show fear or make quick and unexpected movements. Most importantly, we didn't know Boy and he didn't know us. His eyes were even more opaque and unknowable than Christian's.

With their documentation of their observations of lion behaviour over many years, both Joy and George built an unrivalled and invaluable archive.

M: How did you feel leaving Christian in Africa?

Ace: We left him several times. After the first trip, then a year later in 1971 (the YouTube reunion), and then in 1972. People often ask us how we could have let him go, and comment that we were very generous doing it. I don't know what sort of alternative they imagined. How could we have faced him confined somewhere in England? It would have felt like a complete betrayal. We did not

regret it ever, and we were always so thankful that by a miracle we had returned him to Africa, to George Adamson, to take his chance in a natural, if sometimes hostile and dangerous environment. We just couldn't believe it had all actually happened and been a success. Back in London it was probably a relief that the huge responsibility was over, although life was initially empty without him. He was on our mind as we were writing the book *A Lion Called Christian* (1971) and we were kept informed by letters from George.

The first time we left Christian was still not getting on well with Boy, the dominant male in George's man-made pride of lions, and that was very upsetting. He ran after the Land Rover as we drove away. I cried. He was bigger and more independent each visit, and seemed contented and completely 'at home'. I cried every time we left, but we always thought it was a continuing story and we would be coming back and seeing him.

The wild lions drove Christian from Kora. Although it was very pretty down beside the Tana River, it was a hostile, barren and rather unwanted area that the Kenyan government allotted to George. It had to be away from tourists, villagers, hunters, poachers, etc. There was competition with the local lions for the limited game, and although George had heard him mating, Christian would go away for extended periods in the direction of the more fertile Meru National Park, presumably looking for a territory of his own. If Christian did form his own pride quite far away, he would not have been able to leave them and return to see George and Tony Fitzjohn who had become George's assistant. Tony now continues George's work as the Field Director for the George Adamson Wildlife Preservation Trust (GAWPT).

Christian was last seen in early 1973 heading off in the direction of Meru National Park. Lions live approximately 10–12 years in the wild (up to 18 in a zoo). Through the effective 'bush telegraph' network, no death of an extremely big lion was ever reported. I rather like not knowing what happened to him, and as the years passed I adjusted to the fact that we might never hear of him again.

M: When was the last time you travelled to Africa?

Ace: I have never returned to Africa, although I would love to. Tony Fitzjohn is presently rebuilding George's camp at Kora which was

abandoned after George was murdered by poachers in 1989. Tony recently introduced the first lion for many decades.

John is a founding member of GAWPT and has been an active supporter throughout the intervening years. He lives in London and often travels to Africa.

> M: A recent painting by artist Jiawei Shen entitled 'Eternal Hug' based on a 1970 photograph by Derek Cattani, imagines a present day reunion between Ace and Christian (Plate 1).

YouTube

The YouTube clip of the real-life moment, captured on film, when Ace, John and Christian were reunited after a year's separation, and the subsequent media coverage of Christian's story, reached an estimated 100 million people.

In 2011 Ace was part of a panel at the Global Animal conference at the University of Wollongong, Australia, where the reunion clip was shown followed by questions and discussion. After the conference Ace wrote on his blog:

> one participant expressed annoyance at the 'disconcerting' Whitney Houston backtrack, and that the 'greeting card' sentiments about forwarding the video to 'someone you love', detracted from the human–animal relationship. I was a little taken aback as people are usually so pleasantly uncritical! I said I personally get swept along with Whitney's song 'I Will Always Love You' (actually written by Dolly Parton), and that I didn't mind the footage being co-opted as a general message of love. But I acknowledged the point that was being made, but should have replied, 'without Whitney and the viral "love" nature of the video, would it have reached so many people, and would I actually be sitting here?'

The media attention generated by the YouTube clip led to Ace and John appearing on major talk shows around the world including *Us* in China and the *Oprah Winfrey Show* and *The View* in America. This has given them the chance to generate discussion about the emotional connections between humans and animals, and to help raise awareness about urgent wildlife conservation issues, and the treatment of animals more generally.

M: What was it like appearing on TV talk shows with massive audiences?

Ace: Oprah is such a legend it was an honour to go on her show. She asked some questions, showed the video, a few audience tears were shed. I was very nervous, but an audience of 50 million people is a wonderful chance to talk about wildlife conservation and human–animal relationships.

It was just as important however to appear on television in China, as I wanted to assess their attitudes to animal welfare and environmental issues. The host Wang Lifen was very dynamic and her show *Us* is seen across China. Wang built a wildlife conservation program around us. She effortlessly handled the studio audience, us, and crossed to wildlife experts and the World Wildlife Fund in Switzerland, with different languages and translators. It was encouraging to realise that China was more mindful of conservation issues than one had imagined, and panda numbers, for example, had stabilised. We were told they had increased, but this apparently might have been an exaggeration.

I am especially interested in China and watch with interest how they are trying to balance issues of carbon emissions, global warming, pollution and the destruction of animal habitats with their spectacular economic development and urbanisation. It affects the whole world. I am also very concerned with their appetite for ivory and that the slaughter of so many elephants in Africa is creating an 'extinction vortex'. I did ask Wang Lifen if we could discuss the issue of traditional medicines and the dangers this is presenting to many animal species – like the rhinoceros for example. However she did not raise it during the program and this may have been deliberate as I suspect it is still almost a taboo subject in China, but hopefully not for the next, better educated and urbanised generation.

M: Are there any particular animal welfare or wildlife conservation areas or issues that you are focused on or involved in?

Ace: There are so many people and organisations doing great work on behalf of animals. On my blog I list them and promote them as I am made aware of them, so several years on, it will be quite a useful directory.

I particularly admire Christine Townend who started Animal Liberation in Australia in 1976. Through Working for Animals Inc. Christine and others have, amongst much else, opened animal shelters in Darjeeling and Kalimpong in India, and successfully eradicated rabies from the communities. I loved visiting

the shelters and blogging about their work – and this is a good example of what I like to do.

I am quite often asked to speak at fund-raisers or attend conferences, such as Global Animal. One big change these days is the very interesting and sophisticated work by researchers and academics being done on behalf of animals and issues associated with their treatment and rights, human–animal relationships, and much else. Sometimes I think I'm the light relief amongst some very serious and dedicated people, but that's OK!

M: What do you consider to be some of best ways forward to protect the lives of lions in Africa?

Ace: We are obviously at the tipping point with many species, and the problem is too vast and complex for me to pretend I have the answers. There are 70 per cent fewer lions in Africa today than there were in Christian's time, and this frightening statistic is not confined to lions. I like the concept of trans-frontier conservancy in general, with uninterrupted corridors for the animals. I suspect local villagers need to be much more involved and have more 'ownership'. Animals and protection of their habitats are a valuable resource for their own future which can also provide employment opportunities as park rangers or in tourism. Tourism has been a major industry for many decades. Poaching has to be made less of an option for quick money as it is such a huge threat to animal survival. Another complexity is the divide between animal rights activists and conservationists over issues such as the culling of animals in some situations. As far as I am concerned there is no role for hunters!!!

M: I have heard you say that George Adamson loved and valued lions for their capacity for trust and love. I have also heard you say that you are now scared of lions! Can you shed light on those two contrasting statements?

Ace: I think it is very sensible to be wary of many animals. If you don't know them, you don't know how they will behave. They may be frightened, in a bad mood, ill or injured, or sick of people thrusting themselves at them uninvited. George would never impose himself on the lions – he was just 'living' with them. Animals are not on earth for our amusement or indulgence. As with people, although one signals one is open to friendship, it is quite polite and sensible to wait and just see how things develop. We knew Christian and he knew us – that is the difference.

M: Do you have any thoughts about Kevin Richardson, known as the lion whisperer, an animal behaviourist who enters lion enclosures in South Africa and mixes with the lions?

Ace: I think he is quite a showman and the lions obviously love him. I think however he puts himself in dangerous situations – either out-numbered, or on the ground. You can see the lions sense their alpha male and dominant advantage over him. George 'lived' among lions, and although he loved his morning and evening walks with them, the idea was to minimise animal–human contact.

M: Thinking about lions who perform in circuses – from your experience with Christian and your knowledge of lions in the wild, do you have a view on whether it is possible to have an equal relationship with a performing, trained lion?

Ace: I know nothing about trained animals. Cats never do what I want them to do! It must be elements of fear, domination, rewards – not much of a basis for a good relationship, and I don't like animals performing. Christian was like house training a cat. It was very easy as they are so fastidious and habitual. On our part we tried to create an environment where restrictions were kept to a minimum, and we just kept ahead of frustrations as he outgrew his circumstances.

M: Finally, the experience of living with the young Christian and then releasing him to a life in the wild in Africa happened for you as a young man. Since then you established a career as a leading curator of Aboriginal art in Australia, and more recently colonial art, and recurring throughout your work has been the documentation of family, memory and place. Do you make any connections – philosophical, emotional, insights gained, or whatever else there may be – between your work as a curator and those early experiences with Christian?

Ace: Living in Europe for a few years was probably more of an influence on my career as an art curator. However, spending time in Africa made me think about the legacies of colonialism, and more importantly, how little I knew about Indigenous people in Australia. When I returned to live in Australia I discovered that Aboriginal art and culture is for me probably the most fascinating aspect of the country, and that an inordinate number of Aborigines are arguably the best Indigenous painters in the world.

My experiences with Christian gave me a lifelong interest and concern for wildlife and environmental issues. When asked what I

think the appeal of Christian's clip on YouTube is I usually answer 'love has no boundaries'. However, I choose to think of the dramatic re-emergence of his story for a new global generation as a cry for help – to try and make us realise we are at a tipping point, with the possible extinction of so many animal and plant species in Africa and the world.

4

'Mrs Boss! We gotta get those fat cheeky bullocks into that big bloody metal ship!': Live Export as Romantic Backdrop in Baz Luhrmann's *Australia*

Melissa Boyde

The state of exception, generally understood to be a temporary suspension of the law is typically, as philosopher Giorgio Agamben writes, 'state power's immediate response to the most extreme internal conflicts', brought into play, for example, in civil war, world wars, and the post-9/11 establishment by the Bush Administration of the detention centre at Guantánamo Bay, Cuba. Agamben suggests that the state of exception, since it involves suspending the entire juridical order, 'defines law's threshold or limit' (Agamben, *State* 4). The terms of the state of exception apply to many species of animals who live permanently beyond the threshold of human law. Agamben foregrounds the human–animal distinction perpetuated in much of Western philosophy through his term 'anthropological machine':

> Insofar as the production of man through the opposition man/ animal, human/inhuman, is at stake here, the machine necessarily functions by means of an exclusion (which is also always already a capturing) and an inclusion (which is also always already an exclusion). Indeed, precisely because the human is already presupposed every time, the machine actually produces a kind of state of exception, a zone of indeterminacy in which the outside is nothing but the exclusion of an inside and the inside is in turn only the inclusion of an outside. (Agamben, *The Open* 37)

The live animal export industry – in which animals are first herded, then loaded onto trucks or trains, transported to saleyards, sold to the highest bidder by auction, then reloaded on to a truck and taken, often via feedlots, to a shipping port where they are loaded onto ships destined for countries where they will be killed for food – is one example where animals are both inside and outside of the law. Animal welfare lawyer Malcolm Caulfield points out that the structure of the Australian Commonwealth laws relating to the live export of animals is not only 'irrational and difficult to follow', but that 'key players in the live export chain (particularly the owners of animals once they are on board ship, i.e. the ship's owner and the ship's master) are under no legislative obligations' (Caulfield 135). There is no war, no uprising, no terrorist attack orchestrated by animals to warrant the extreme response of casting them into a state of exception, so why is it in place?

In this chapter I present three stories. One is fiction framed by fact, another is fiction disguised as truth, and the other is autobiographical. I start with the autobiographical.

Story one: country life

Twenty-five years ago at the cattle auction held regularly at Camden Saleyards, just outside Sydney, I purchased a Friesian heifer who, with great originality, I called Moo. She had mooed and mooed day and night until, finally, I went back to the Camden Saleyards to find her a companion. I came across two very young Friesian calves, a male and a female, and, although on a student's meagre income, bid against a butcher for the female calf. When he asserted mid-auction 'she's no good for you, she's only good for veal' I threw caution to the wind. After a few heated minutes, and at what was probably a record price for a few weeks old Friesian calf, I was successful. I paid the money, collected the little calf (who I named Minnie), put her into the back of my old station wagon and drove her home to keep Moo company. My original idea was that Minnie and Moo would eat the grass on the small acreage I had just moved to from the inner city. I knew roughly as much about cows as anyone else who had lived in the city all of their life. Since then I have learnt a bit more.

Story two: fiction framed by fact

The film *Australia*, directed by Baz Luhrmann (2008), begins at a fictional cattle station called Faraway Downs in the Kimberley ranges of

Western Australia. Although the homestead is a constructed set, it is on an actual cattle property called Carlton Hill Station which at the time of filming was owned by Packer family holdings.[1] The central story is the romance between a ruggedly handsome man known only as Drover and a pale, slim British woman, Lady Sarah, which develops during a cattle drove. Lady Sarah arrives in Australia in search of her philandering husband who owns Faraway Downs but finds instead that he has been killed. She also discovers that a ruthless competitor, cattle baron 'King' Carney, plans to steal her husband's cattle in order to create a monopoly on cattle production in the Kimberley. Lady Sarah decides to enlist Drover to help her get the cattle to Darwin and onto the live animal export ships before the Australian Army sign a deal with Carney.

According to Luhrmann the film has at its heart the Stolen Generation.[2] The government policy at the time the film is set, 1939–1942, to remove 'half-caste' children from their families, is figured in the character Nullah, a boy of mixed race (white father and Aboriginal mother), who lives under threat of being taken by force to a mission. After the sudden death of his mother at Faraway Downs, the boy forms a bond with Lady Sarah. When Nullah exclaims to Lady Sarah, 'Mrs Boss! We gotta get those no good fat cheeky bullocks into that big bloody metal ship!', his heritage as a cattle worker is evoked – it is, according to Nullah, in his dreaming. From the cattle industry's earliest incarnations in the nineteenth century an underpaid Aboriginal workforce with intimate knowledge of the land enabled the building up of what has become one of Australia's biggest export industries (May 1; Cox et al).[3] The film's narrative is driven by the cattle drove across sacred Aboriginal land. In a review of the film Aboriginal scholar Marcia Langton writes, 'this long cattle drove across the plains and rivers provides the magical scenes for…the triumph of Aboriginal sorcery, and the build-up of the romantic tension between Drover and Lady Sarah' (Langton 2). Unlike Langton's enthusiastic review of the film, which for her 'sparkles and shines', it was more often panned by critics. A reviewer from the *New York Times* calls it:

> A pastiche of genres and references wrapped up – though, more often than not, whipped up – into one demented and generally diverting horse-galloping, cattle-stampeding, camera-swooping, music-swelling, mood-altering widescreen package. (Dargis)

In the *Guardian* Germaine Greer calls it a 'fraudulent and misleading fantasy' which 'cost the Fox Corporation about $90m (£59m), minus

a hefty tax rebate. The other $40m was contributed by the Australian Tourism Export Council' (Greer).

However, the biggest failure of the film, and of the majority of critics who reviewed it, is the silence on the suffering of animals used in the live export industry which the film portrays. Instead, to underline the heroic nature of Lady Sarah's and the Drover's quest to drove 1500 cattle to the Darwin port and onto the 'big bloody metal ship' is the story that the 'fat cheeky bullocks' will feed the hungry Australian troops fighting on foreign shores in the Second World War.

The history of the cattle industry in Australia reaches back to the earliest days of white settlement. Writing about colonisation and the anti-slavery movement, Deirdre Coleman recounts how the first cattle brought to the colony were five black cows and a bull who had been purchased at Cape Town and had survived the difficult sea voyage to Australia. A few months later, in June 1788, they 'escaped enclosure in search of a better life' and 'regret at their loss reverberated throughout the colony's early years' (Coleman 1). The importance of the cattle as food for the white settlers is indicated by the sentiment expressed four years after their disappearance by the Deputy Governor who wrote, 'Could we once be supplied with cattle, I do not believe we should have occasion to trouble old England again' (Coleman 1). A further three years passed before the mystery was solved when a herd of 60 cattle was found grazing on rich land 20 miles inland from Sydney, near the site of present-day Camden. Coleman points out that the movement from 'loss' to 'abundant recompense' felt by the white settlers when the cows were found and had multiplied 'stands as an allegory of a persistent utopian and Romantic strand of imagining about the shape of new world colonies in the late eighteenth century' (Coleman 1). The area, which became known as Cowpastures, represents the finding of a promised land. But ultimately this was for the humans, not for the cows. Although the Governor ordered the herd to be preserved it was with the view to ensure their multiplication as a future food resource for the colony. The story of the Cowpastures cattle has charm but the question emerges: why are we invested with the magic of this story which has violence underneath?

There is a long history of making links between the cattle industry in Australia and the country's colonisation and later its defence. Historian Dawn May points out:

Throughout the twentieth century the cattle industry has been one of Australia's major export activities.... As well as making an economic contribution, the cattle industry has been perceived as playing

an important role in the defence of Australia. Periodically concern has been expressed about the 'empty north'.... A flourishing cattle industry was seen as the most appropriate way of populating an otherwise unprotected part of the continent. Indeed it was argued that the maintenance of the White Australia policy 'was held to depend more upon the success of the beef cattle industry than on any other industry in the Commonwealth'. (May 1)

The economic and political interests that converge in the so-called frontier lands are reinforced in popular histories and fictions which mythologise the figure of the (most often male) explorer/pioneer/settler/drover/ soldier and render his personal narratives as powerful signifiers of the so-called Australian spirit. But how authentic are representations such as these?

A review of *Australia* in the *Guardian* suggests that the solemn declaration by Drover that '"The only thing you really own is your story"...is quite something, as Luhrmann pinches almost everyone else's story. *Gone With the Wind, Out of Africa, The African Queen, Empire of the Sun* and many others get nicked' (Bradshaw). Another film to add to this list is the classic Hollywood Western *Red River* (1948; directed by Howard Hawks). Faced with financial ruin, and against all odds, the central character (played by John Wayne) droves a herd of cattle from Texas to Missouri – a gruelling epic journey which includes a cattle stampede during which a man gets killed, and the crossing of the eponymous river, before reaching the town of Abilene where the arrival of the large herd is applauded by the locals. The cattle are then loaded into boxcarts to be freighted by rail to their (offscreen) deaths in a Chicago slaughterhouse (Tompkins 117). Writing about the genre of the Western Jane Tompkins comments on how 'with few exceptions...[cattle] are seen only from the viewpoint of their utility for humans: as factors in an economic scheme, as physical obstacles to be contended with in a heroic undertaking, or as the contested prize in an economic struggle' (Tompkins 114). In *Australia* the cattle drove is linked to the men fighting to defend civil liberties and the nation in the Second World War to justify, support and overlook the state of exception in which the cattle exist at all times. The cattle in *Australia*, like those in most Westerns, 'constitute the story's economic base, they are its *raison d'être*...The sacrifice of their lives underwrites everything' (Tompkins 117). 'Good beef for hungry people', as the John Wayne character says (117), in *Australia* becomes 'food to feed the hungry troops'. This is another story, also with violence

underneath, in which the cattle disappear – consumed, off screen, by the humans.

Steve Baker argues that:

> the animal is the sign of all that is taken not-very-seriously in contemporary culture: the sign of that which doesn't really matter. The animal may be other things beside this, but this is certainly one of its most frequent roles in representation. (174)

This kind of representation is common in Westerns where the cattle 'surround the characters, often dominate the screen, pervade the atmosphere with the quiet, massive strength of their bodies, the slow, throbbing presence of their lives. Yet in some profound way they are totally unnoticed' (Tompkins 117). This is true of the depiction of the cattle in *Australia*, for although the animals are central to the narrative they are a present absence; there are no close-ups or shot reverse shots (face of cow, cut to face of human, cut to face of cow) for example which could bring the animal's point of view into the visual narrative. Instead the cattle are mostly shot panoramically, or perhaps more precisely (following Foucault) panoptically. Like the prisons designed to enable observation of inmates with invisible omniscience, the cattle in this film are observed and contained within the storyline by the drover whose very role renders them prisoner. It is a role which embodies what Tompkins suggests is the idealised construction of masculinity in the Western – the ability to 'take pain and give it, without flinching' (121).

A real-life drover in Australian history, known as Boss Drover, 'peerless drover and cattleman, was a great name not so long ago around the campfires of central Australia and the desolate Kimberley region' (Wiley, Introduction). Boss Drover's recollections of the droves he led in the early decades of the twentieth century, unwittingly, provides a history of callous indifference to animals: 'The track to Katherine was very rough but we had plenty of spare cattle, so if a beast became sore-footed we would just cut it out and leave it. And we ate only the very best cuts of beef' (109). Or this incident, in a story about how he broke his leg on a drove: 'One of the cows had calved a couple of days before. We had killed the youngster and she was always trying to get back to it. Each time she broke away I would sool her into the mob again' (11). In the manoeuvre the horse slips and comes down on Boss Drover's leg, breaking it. Although left with a permanent and significant injury and limp, a short while later, undeterred, he heads back to the Kimberleys, 'the back country, the last frontier' (12). Like the John Wayne character

in *Red River*, and like the real-life Boss Drover, in *Australia* Drover is a tough, dusty, strong, silent hero, and the cattle he droves are irrelevant in every way except as part of an amorphous mass of live animals destined in the film to be killed for food. The plight of individual cattle is of no concern.

The film *The Overlanders* (1946), still widely regarded as an Australian classic, creates a view of the drove in which the cattle are valued in economic terms and as food. The film 'began as a propaganda production while the [Second World] war was still going on' (Byrnes), and a caption appearing at the bottom of the opening credits stating 'this film is based on fact but the characters are fictitious' promotes a sense of historical authenticity. The *raison d'être* of the film was 'to publicise Australia's war effort' and the idea for it gleaned from 'an official of the Australian food administration' (Byrnes). There are strong narrative similarities to the cattle story in Australia. In both films the drove is figured as patriotic – the newsreel style opening of *The Overlanders* shows a poster image of a Japanese soldier hovering over the Northern Territory landscape where there are 'one million head of cattle and a population of only 5,000 whites'. A scorched earth policy and droving the cattle south are the strategies that the voice-over declares will save Australia. *The Overlanders* focuses on one of these heroic droves, in which the cattle are driven more than 2500 miles across the country at the wrong time of year in order to deprive the approaching Japanese enemy of food, should they invade northern Australia.

The same year as *The Overlanders* was released the poet Judith Wright writes of the drove through the recollections of an elderly and solitary character in her poem *South of My Days*. Old Dan's story is haunting:

> ...O cold the black-frost night. The walls draw in to the warmth
> and the old roof cracks its joints; the slung kettle
> hisses a leak on the fire. Hardly to be believed that summer
> will turn up again some day in a wave of rambler-roses,
> thrust its hot face in here to tell another yarn –
> a story old Dan can spin into a blanket against the winter.
> Seventy years of stories he clutches round his bones,
> seventy years are hived in him like old honey.
>
> During that year, Charleville to the Hunter,
> nineteen-one it was, and the drought beginning;
> sixty head left at the McIntyre, the mud round them
> hardened like iron; and the yellow boy died

in the sulky ahead with the gear, but the horse went on,
stopped at Sandy Camp and waited in the evening.
It was the flies we seen first, swarming like bees.
Came to the Hunter, three hundred head of a thousand –
cruel to keep them alive – and the river was dust.

In the final stanza Wright suggests this is a mythical history:

> True or not, it's all the same; and the frost on the roof
> cracks like a whip, and the back-log breaks into ash.
> Wake, old man. This is winter, and the yarns are over.
> No-one is listening.
>
> (Wright)

But in 2008 Luhrmann picked up old Dan's mantle and not only rein-
vigorated the myths of the cattleman but romanticised the exportation
of live animals by ship for slaughter in foreign countries. In *Australia*
the arrival of the cattle at the 'big bloody metal ship', a livestock car-
rier to take the cattle in cramped conditions on a journey that will last
for many days only to be offloaded, penned and killed, is constructed,
through the use of triumphant music and cinematic effects, as a
national victory. Unlike Old Dan's memory of the drove – the drought,
the flies, 'cruel to keep them alive' – in *Australia* there is no hint of any
thought for what the cattle might suffer – not even when, for exam-
ple, during a stampede mid-way through the drove cattle appear to
tumble over a cliff. It seems ironic that in a film which seeks to accord
visibility to the suffering inflicted on Aboriginal people through the
effects of white laws and actions which created fear, terror and aliena-
tion from loved ones, the human-created suffering of animals remains
a blindspot.[4]

In this film the cattle are caught in the state of exception which
Agamben describes as 'being outside and yet belonging' (35). Their sta-
tus outside of the law may render them invisible, yet there are signifi-
cant stakes in Australia contingent on their presence.

What are the rationales for keeping animal suffering invisible/irrel-
evant, in this film and elsewhere? And why are so many humans com-
plicit in this suffering? The words of Australian anthropologist William
Stanner, in his famous 1968 Boyer lecture on the omission of Aboriginal
history and culture from Australian history books – what he refers to as
'the great Australian silence', resonate with the current situation for cattle
used for human food and more generally for captive animals worldwide:

inattention on such a scale cannot possibly be explained by absent-mindedness. It is a structural matter, a view from a window which has been carefully placed to exclude a whole quadrant of the land-scape. What may well have begun as a simple forgetting of other possible views turned under habit and over time into something like a cult of forgetfulness practised on a national scale. (Stanner 25)

For animals the partial views of representation, like Stanner's metaphor of the window carefully placed to exclude, has resulted in absences and silences. Clearly the physical capture of animal bodies is not the only issue. It may be as Agamben suggests that 'the openness at stake is essentially the openness to a closedness, and whoever looks in the open sees only a closing, only a not-seeing' (The Open 68).

Story 3: fiction disguised as truth

In 2009 the Australian Livestock Export Corporation Limited (LiveCorp), owned and funded by livestock exporters, presented images and infor-mation on its website of contented animals on green pasture. Images such as a medium close-up shot of a cute lamb on green pasture with the caption 'Nosy Lamb' appeared on their webpage which provided 'facts' for primary school children.[5] LiveCorp perhaps was aware of numerous research findings which show that 'childhood experiences of animals and particularly animal narratives contribute to the formation of attitudes towards animals in adulthood' (Molloy 122). Photographs with cute captions such as 'Nosy Lamb' conceal the realities of what is experienced by the animals in transport vessels, in the feedlots before and after export and in the slaughterhouses that follow. There is no free-dom to graze, there is no grass, there are no family groups left intact. There are cramped metal holding pens, and the food is not green grass but often consists mainly of pellets manufactured as a by-product in ethanol production. Sheep in particular are known to have difficulty making the switch from grass to pellets and the inability of many of them to eat this ship food causes death by starvation.

One of LiveCorp's roles is to promote the idea that the live export industry is concerned about animal welfare. This is crucial to its stake-holders because the lucrative export of live animals is, as Caulfield shows, 'an intrinsically cruel and risky practice' (Caulfield 72). Reports submitted to a government enquiry on live export in the late 1980s vary enormously. The Livestock express fleet submission states: 'offic-ers and crew [take] great pride … in attending to the animals'. Their

account evokes multiplication of an almost biblical, Noah's Ark-like dimension: 'on a recent shipment of 20 days duration we loaded 1425 head of pregnant dairy cattle to South East Asia and the vessel arrived with 1466 head, having had a natural increase of 41 calves during the voyage' (S.C.A. 309–10). This report is, however, in stark contrast to the World Society for the Protection of Animals' submission which documents high levels of animal suffering and death due to poor ventilation, starvation and smothering. One of their examples is a 1986 shipment from New Zealand (on the MV *El Cordera*) of 37,148 ram lambs destined for ritual slaughter in the Hajj Festival in Mecca of which 1,793 lambs died en route (S.C.A. 305). The report from Austrade, the Australian Trade Commission, details inexperienced staff and highly variable conditions at feedlots in the Middle East, and cruel slaughterhouse practices for the Australian cattle which 'most commonly are slaughtered without stunning' (S.C.A. 284).[6] A report from Austrade notes that because they are 'not stunned' and because of the larger size of some Australian cattle the practice can be 'to suspend [the animal] by a chain around one leg, to restrain it while it bleeds to death' (S.C.A. 284).

Twenty years later the conditions and survival rates for the animals have not improved. The RSPCA finds the industry cruel and unnecessary and has called for an immediate halt to the trade to Indonesia (RSPCA). Information the animals advocacy group Animals Australia obtained through the Freedom of Information Act provides details on the mortality rates of animals exported live from Australia. These include the death of 247 cattle on a 25-day voyage to the Middle East (mortality rate of 3.18 per cent) due to pneumonia, leg ulcers (due to falls) and heat stress, particularly in the Friesian cattle (Animals Australia, 'Live Export FOI Reports') and the death of 829 cattle by suffocation when a loss of power caused ventilation failure during a voyage from Darwin to Indonesia (Animals Australia 'Live Export Trade leads to dead end'). Animals Australia's information indicates serious breaches of the Australian Standards for the Export of Livestock (ASEL). In 2002, on its maiden voyage, the apparently streamlined live animal carrier the MV *Becrux* shipped 1995 cattle and 60,000 sheep from Portland, Victoria to Saudi Arabia. Almost half of the cattle and 1400 sheep died after the vessel met extreme temperatures (45 degrees) and humidity in the Arabian Gulf (Animals Australia 'Death Ship Set to Sail again'). In 2006 at least 241 cattle died aboard ship on a journey from Portland and Fremantle (WA) to Israel and a further 200 Australian cattle (some reports suggest up to 500) died in quarantine feedlots after

arrival, and were buried in pits (Animals Australia 'Cattle Deaths'). The list of incidents seems endless.

Despite these facts and figures, LiveCorp saw it differently. In the 2007/08 report the chairman of LiveCorp reports 'extremely high live-stock export success rates with more than 99 per cent of Australia's exported animals arriving fit and healthy at the end of their sea jour-ney' (LiveCorp 1). The total number of cattle exported is reported as 769,890 with a market value of $540 million dollars. Total sheep is 4.08 million with a market value of $287 million and total goats is 84,225 with a value of $9.9 million (4). These figures add up to a total number of approximately 5 million animals exported with a monetary value of approximately $837 million. On these figures the chairman's claim of an export 'success rate' of 'more than 99 per cent' potentially represents the death en route of thousands, possibly tens of thou-sands, of animals. The Australian government report of 'Livestock Mortalities for Exports by Sea' for 2007 lists the total deaths as cattle 747; sheep 37,409 (Australian Government). The many thousands of animals who have died en route in the live animal export trade make the Chairman's claim that the other animals arrived 'fit and healthy' seem questionable.

However, despite all the facts and figures which point to unaccept-able suffering and death of animals used in the live export industry, the industry flourishes and has been rewarded. For 'their significant contri-butions to the Australian livestock industries', two directors of LiveCorp were honoured with 'Membership to the Order of Australia' (LiveCorp Annual Report 7). Most surprising perhaps was that in 2008 'the annual conference of the Animal Transportation Association (AATA) in Dresden, Germany...presented LiveCorp with the International Award for its outstanding contribution to the welfare of animals in interna-tional commerce' (5).

Box office sales of the film *Australia* worldwide reached $211,342,221, despite the reviews, and it is currently the second highest grossing Australian film ever (Australia Box Office). James Packer, consistently at or near the top of Forbes Australian Rich List, sold cattle stations including Carlton Hill, where *Australia* was filmed while the film was screening worldwide, for a reported $425 million.

In 2011 the live animal export industry again hit the spotlight but not as a fictionalised and romanticised representation. In a prime-time television current affairs programme, the Australian Broadcasting Corporation aired footage of the brutal deaths of Australian cattle in an Indonesian slaughterhouse, killed without stunning.[7] The release of

this footage, which clearly showed terrified cattle being beaten to death while other cattle watched helplessly until it happened to them, created a public outcry against the live animal export trade with large numbers of people taking to the streets and creating social media campaigns in protest against the trade. The government responded by implementing a temporary suspension of the trade. But it was reinstated soon after due to pressure from the industry which claimed ignorance of this kind of animal suffering in its trade. Interestingly, however, LiveCorp updated its website and the primary school children page, and Nosy Lamb, disappeared.

Meanwhile at the Camden Saleyards – near the nineteenth-century Cowpastures where the disappearing cows were found, and the same saleyards where I bought Minnie and Moo twenty-five years ago – some of the animals from the film *Australia* were sold at auction. Under the headline 'Australia: see the film, eat the cast' the rural press reported:

> Twenty-five tonnes of…shorthorn bullocks were sold at Camden saleyards yesterday having spent much of the past two years mingling with film stars Nicole Kidman and Hugh Jackman…there were no paparazzi at the sale but the cattle's film credit was announced to the bidders. The bullocks were sold for between $800 and $1050 a head. Some will go to the Sydney Care charity to be served at a fundraiser barbecue on New Year's Eve…and the rest will be exported. (*Camden Advertiser* 12 November 2008)

To return to the autobiographical: my experience is that the most exceptional state for a cow is to be part of the herd started by Minnie and Moo. Minnie and Moo lived to old age and they live on in their offspring and friends, most of whom are themselves now elderly. Local cattlemen and even vets have asked me how long can a cow live – it is so uncommon in Australia for a cow to reach old age. Friends and colleagues who know I have lived with the cows for years ask questions like 'do they know each other?', 'do they know you?' Not long ago Moo's daughter Moulin, who has one eye and is seventeen, fell over in the paddock. I did not see it happen but knew something was wrong because of the bellowing and frantic mooing of the rest of the herd. When I reached her Moulin looked as though she was dead, she was lying perfectly still on her side. Boy, Minnie's grandson, a handsome giant of a steer, was gently pushing her with his head trying to help her up, while the others crowded around her intently looking on. Boy moved back to let me try to get her up. There was palpable relief all

round when eventually she made it back on her feet. Do they know each other? Do they know me?

The 'cheeky bullocks' captured mindlessly in cultural texts such as the partially tax-payer funded, big-budget film *Australia* have been corralled, along with every other nonhuman animal on the planet, into one term, 'The Animal'. The violence thus wrought on each of them – separated from family, cast adrift from their homes, killed when life might otherwise have only been beginning – is evident in the real-life example of the live animal export trade where they are (partially) hidden from view – in sale yards on the edge of towns, in cattle trucks and trains, in unmarked feedlots and behind the closed doors of the slaughterhouses. What is revealed, however, from these obscured realities is the (paradoxical) inhumanity of their fellow animals, The Human, who not only turn a blind eye but who purposefully construct the state of exception which becomes the suffering of animals.

Notes

1. James Packer inherited control of the Australian family company after the death of his father, the media mogul Kerry Packer. As well as considerable media and gambling interests, until a few years ago the Packers had substantial investment in cattle industries (Myers).
2. For more information on the government policy that created the Stolen Generation see Australian Government, 'Sorry Day and the Stolen Generations'.
3. 'Over a period of about 200 years, Australia's beef industry has developed from non-existence to one of the world's leading beef producers. Today, Australia is the world's largest exporter of beef and live cattle' (Cox et al., 22). In 2012 the figures show: 'the off-farm meat value of Australia's beef industry is $11.6 billion'; 'the value of total beef and veal exports in 2011–12 was $4.69 billion' and 'the value of Australia's live cattle exports in 2011–12 was $650 million' (MLA).
4. In making this statement I draw on a non-speciesist perspective as outlined by Peter Singer who advocates that humans make a 'mental switch in respect of our attitudes and practices towards a very large group of beings: members of species other than our own – or, as we popularly though misleadingly call them, animals. In other words, I am urging that we extend to other species the basic principle of equality that most of us recognize should be extended to all members of our own species' (Singer 74).
5. Accessed January 2009. http://www.liveexportcare.com.au/GetTheFacts/KidsCorner/ForPrimarySchoolStudents/.
6. As Animals Australia notes: 'Indonesians prefer traditional slaughter methods...The two primary methods of slaughter for Australian animals are: i) rope casting whereby ropes are tied from a ring in the floor then around the animal's neck and legs to trip it over onto its side for the throat cut; and

ii) restraint boxes that confine the animal in one place so ropes can be tied around the legs and the animal trips over onto its side when it attempts to walk out of the box. Both methods are distressing for the animal and cause a prolonged and cruel death' (Animals Australia 'Live Exports to Indonesia').
7. For a detailed discussion see Fiona Probyn-Rapsey.

Works cited

Agamben, Giorgio. *State of Exception*. Chicago: University of Chicago Press, 2005.
——. *The Open: Man and Animal*. Stanford, CA: Stanford UP, 2004.
Animals Australia. 'Cattle Deaths ship set to sail again'. 6 April 2013. http://www.animalsaustralia.org/media/press_releases.php?release=69.
Animals Australia. 'Death Ship Set to Sail Again'. 6 April 2013. http://www.animalsaustralia.org/media/press_releases.php?release=12.
Animals Australia. 'Live Export FOI Reports'. 10 March 2013. http://www.animalsaustralia.org/media/foi/#foi3.
Animals Australia 'Live Exports to Indonesia: Overview'. 27 March 2013. http://www.banliveexport.com/documents/FactSheet-Overview.pdf.
Animals Australia, 'Live Export trade leads to dead end'. 6 April 2013. http://www.animalsaustralia.org/media/in_the_news.php?article=3956>.
Australia Box Office. 22 March 2013. http://www.boxofficemojo.com/movies/?id=australia.htm.
Australian Government. 'Sorry Day and the Stolen Generations'. 2 April 2013. http://australia.gov.au/about-australia/australian-story/sorry-day-stolen-generations.
Australian Government, Department of Agriculture, Fisheries and Forestry. 'Livestock Mortalities for Export by Sea'. 7 April 2013. http://www.daff.gov.au/animal-plant-health/welfare/export-trade/mortalities.
Baker, Steve. *Picturing the Beast: Animals, Identity, and Representation*. Manchester: Manchester UP, 1993.
Bradshaw, Peter. 'Australia'. Rev. of Luhrmann's film *Australia*. *Guardian* 22 December 2008. 7 March 2013. http://www.guardian.co.uk/film/2008/dec/22/baz-luhrmann-australia-film.
Byrnes, Paul. 'Curators Notes'. Discusses the film The Overlanders (1946). Australian Screen. 10 November 2012. http://aso.gov.au/titles/features/the-overlanders/notes/.
Caulfield, Malcolm. *Handbook of Animal Cruelty Law*. North Melbourne: Animals Australia, 2008.
Coleman, Deirdre. *Romantic Colonization and British Anti-Slavery*. Cambridge: Cambridge UP, 2005.
Cox, Rodney J., Zhang-Yue Zhou, and Jung-Sup Choi. *Beef Supply Chains in Australia: Implications for Korean Beef Industry*. Asian Agribusiness Research Centre: AARC Working Paper Series No. 34. University of Sydney, December 2003.
Dargis, Manohla. 'Oh Give Me a Home Where the Cowboys and Kangaroos Roam'. Rev. of Luhrmann's film *Australia*. *New York Times* 26 November 2008. May 2009. http://movies.nytimes.com/2008/11/26/movies/26aust.html?_r=0.

Greer, Germaine. 'Once upon a Time in a Land, Far, Far Away'. *Guardian* (UK). Rev. of Luhrmann's film *Australia*. 16 December 2008. June 2009. http://www. guardian.co.uk/film/2008/dec/16/baz-luhrmann-australia.

'John McEwen's New Deal 1939'. 18 February 2013. http://guides.naa.gov.au/ records-about-northern-territory/part2/chapter8/8.3.aspx.

Langton, Marcia. 'Faraway Downs fantasy resonates close to home'. 23 March 2013. http://www.theage.com.au/articles/2008/11/23/1227375027931.html

LiveCorp 2007/2008 Annual Report. 6 April 2013. http://ebookbrowse.com/ livecorp-2008-annual-report08-final-pdf-d20338434.

May, Dawn. *Aboriginal Labour and the Cattle Industry: Queensland from White Settlement to the Present*. Melbourne: Cambridge UP, 1994.

MLA Meat and Livestock Australia. 21 March 2013. http://www.mla.com.au/ About-the-red-meat-industry/Industry-overview/Cattle

Molloy, Claire. *Popular Media and Animals*. Basingstoke: Palgrave Macmillan, 2011.

Myers, Paul. 'End of an era as Packer quits bush'. *The Australian*, Business. 3 January 2009. 27 March 2013. http://www.theaustralian.com.au/business/ breaking-news/era-ends-as-packer-quits-bush/story-e6frg90f-1111118463587.

Probyn-Rapsey, Fiona. 'Stunning Australia'. *Humananimalia: A Journal of Human/ Animal Interface Studies* 4.2 (Spring 2013). 84–98.

RSPCA. 'Cruel Cattle Exports to Indonesia Must Halt Immediately'. 10 March 2013. http://www.rspca.org.au/news/cruel-cattle-exports-to-indonesia-must-halt-immediately.html.

Singer, Peter. 'All Animals Are Equal'. *Animal Rights and Human Obligation*. Ed. Tom Regan and Peter Singer. Eaglewood Cliffs, NJ: Prentice-Hall, 1989. 73–86.

Standing Committee of Agriculture (S.C.A) workshop on livestock export research, Melbourne, 22–24 February 1988. Sponsored by Standing Committee on Agriculture. Canberra: Australian Government Publishing Service, 1988.

Stanner, W. E. H. *After the Dreaming: Black and White Australians – An Anthropologist's View*. The Boyer Lectures 1968. Sydney: Australian Broadcasting Commission, 1969.

Tompkins, Jane. *West of Everything: The Inner Life of Westerns*. New York: Oxford UP, 1992.

Wiley, Keith. *Boss Drover*. Adelaide: Rigby, 1971.

Wright, Judith. 'South of My Days'. *The Moving Image*, by Judith Wright. Melbourne: Meanjin Press, 1946.

Plate 1 Jiawei Shen, 'The Eternal Hug', 2013, oil on canvas, 213×167cm, courtesy of the artist

Plate 2 Yvette Watt, *Untitled*, from the 'Animal Factories' series, 2011, gicleé print, 30×138cm

Plate 3 Yvette Watt, *Untitled*, from the 'Animal Factories' series, 2011, gicleé print, 30×145cm

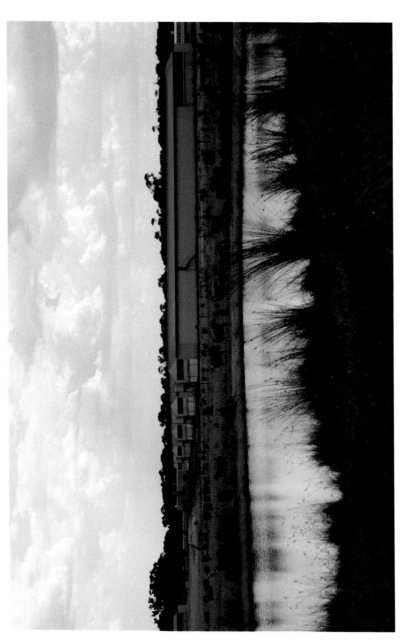

Plate 4 Yvette Watt, *Untitled*, from the 'Animal Factories' series, 2013, gicleé print, 80×120cm

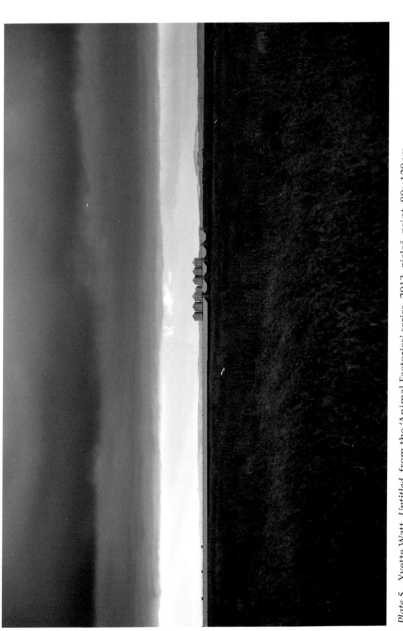

Plate 5 Yvette Watt, *Untitled*, from the 'Animal Factories' series, 2013, gicleé print, 80×120cm

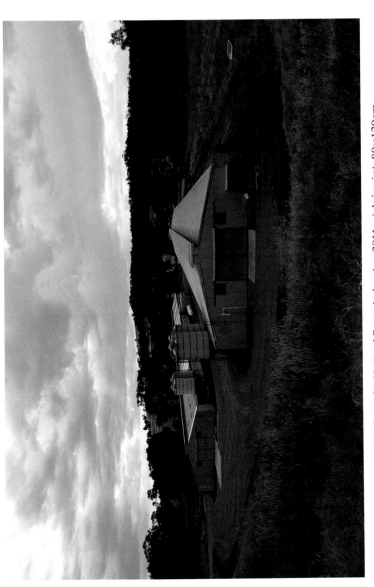

Plate 6 Yvette Watt, *Untitled*, from the 'Animal Factories' series, 2011, gicleé print, 80×120cm

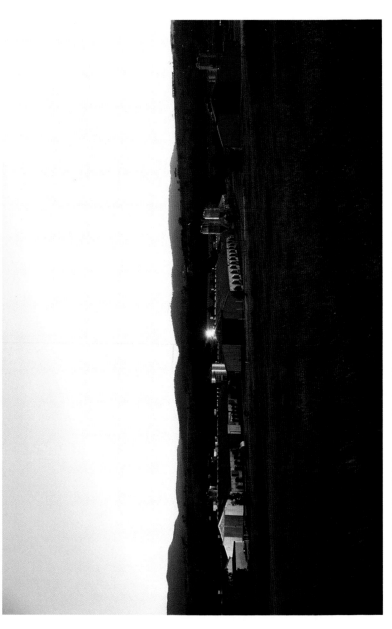

Plate 7 Yvette Watt, *Untitled*, from the 'Animal Factories' series, 2011, gicleé print, 80×120cm

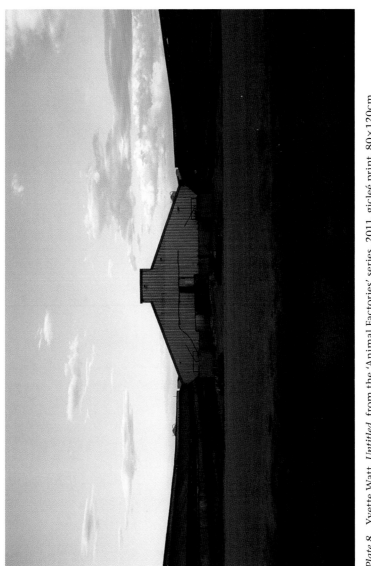

Plate 8 Yvette Watt, *Untitled*, from the 'Animal Factories' series, 2011, gicleé print, 80×120cm

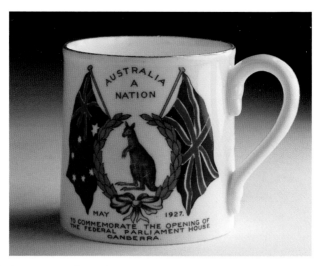

Plate 9 Souvenir cup from the opening of Old Parliament House on 9 May 1927, courtesy National Museum of Australia

Plate 10 Danie Mellor, *Red, White and Blue*, 2008, mixed media, dimensions variable, tallest 105cm, courtesy Caruana & Reid Fine Art

5
Animal Factories: Exposing Sites of Capture

Yvette Watt

Farm or factory?

Several years ago I visited a farm in southern Australia, near my home-town of Hobart, Tasmania. When using the word 'farm' I suspect that the first image your brain might conjure up is one of animals roam-ing in green fields. However, while this farm was surrounded by green fields, the animals being raised there were not allowed the freedom to roam them. In fact, apart from the day when they would be forced into tightly packed crates to be trucked to slaughter, they would never even see daylight. This was a modern meat chicken farm, with the birds raised for one of Australia's biggest poultry companies.

The farm consisted of eight long, windowless sheds, each housing many thousands of birds at various stages of the short 'growth cycle' that ends at a mere six weeks old, well before the birds have reached adulthood. By the time they are sent to slaughter their bodies fill the sheds such that they have almost no room to move.

This was not the first time I had been inside a factory farm; my involvement in animal advocacy has exposed me to many of the horrors inflicted on farmed animals, through text, image and first hand experi-ence. But as I walked away that night, I looked back and was struck by just how much those rows of sheds, lit by spotlights, reminded me of images I had seen of concentration camps, though without the need for guard towers. I was also intensely aware that, while I had just seen, and heard, and smelled, and felt the warmth of the bodies of the thousands of sentient creatures captured inside these sheds, there was no sign of them from the outside.

This experience was the impetus for a project photographing external views of factory farms at various locations around Australia. Ultimately,

I undertook field trips to locations near Hobart and the Tasman Peninsula, Tasmania; outer Adelaide, South Australia; outer Perth, Western Australia; Canberra and regional areas of the Australian Capital Territory and central New South Wales; Mangrove Mountain, New South Wales; and Meredith, Bendigo and the Mornington Peninsula in Victoria.

It was an overwhelming experience to visit and photograph so many factory farms, and yet know that there were hundreds, if not thousands more farms of this type in Australia alone. For example, in one 13-hour day-trip my companion and I travelled over 500 kilometres within a 120 kilometre radius of Adelaide, and photographed 39 farms with a total of 328 sheds – and yet there were many more in the vicinity that we missed, or ran out of time to visit.

Hidden lives and the politics of exemption

The congruities between factory farms and concentration camps that struck me upon leaving the chicken farm that night are more than just physical. In both cases the inhabitants are captured and held against their will, are used and abused at the whim of their captors, and are at the mercy of the politics of the governing power, which in both cases exempts them from the normal moral and legal protections that should be afforded them.

In his 2002 essay in *Borderlands* Dinesh Joseph Wadiwel interrogates the mechanisms that allow humans to treat sentient beings as mere production units within factory farming systems. He brings together Giorgio Agamben's concept of 'bare life' with Michel Foucault's discussion of biopolitics and Carl Schmitt's argument regarding the power of sovereignty lying in processes of exception. In doing so he speaks eruditely of the parallels between modern factory farms and the concentration camps which we most often associate with the Nazi regime. Despite the fact that several Jewish and non-Jewish writers and thinkers[1] have made direct comparisons between Nazi concentration camps and factory farms, the association remains contentious, with a concern that the comparison is at the very least insensitive, if not anti-Semitic. However, Jewish writer Isaac Bashevis Singer's statement that in 'relation to them [animals], all men are Nazis: for the animals it is an eternal Treblinka' (750) is a powerful and oft-quoted observation, and one which Wadiwel uses to emphasise the validity of his argument for the congruities between the spaces of legal exemption that are at work in both concentration camps and factory farms.

Figure 5.1 Yvette Watt, *Untitled*, from the 'Animal Factories' series, 2012, gicleé print, 80×120cm

Around the world, animal welfare legislation consistently provides exemptions for farm animals from treatment that would be in breach of the law if performed on other animals, such as pet cats and dogs. These acts of exception, Wadiwel argues, 'make it possible for a seemingly peaceful society of humans to exercise violence on a massive scale upon nonhuman animal life' (5). The fact that in factory farms such acts of violence and the resulting suffering are hidden from view and are practised on such a vast scale as to be almost incomprehensible is significant – it is so much harder to rally support for invisible victims, especially when the scale of the abuse is so enormous, has legislative support and is seemingly entrenched. This, however, is where the importance of images lies. In the *Animal Factories* project the camera exposes these sites of exemption, capturing in documentary images the grimness of modern industrial farms. The animals are hidden from view, but are visible in our imagination.

Art and animals

There has been a substantial growth of interest in animals and human–animal relations as subject matter for artists and curators in recent years,

as evidenced by numerous exhibitions that have taken animals/human–animal relationships as the key curatorial theme. However, analysis of many of these artworks and exhibitions demonstrate that very few artists foreground the animals themselves, preferring instead to use animals to stand in for someone or something else (see Watt, 'Making Animals Matter' and 'Artists'). Even when animals are foregrounded in artworks, it is rare to see the artist engage with the ethico-political issues of human–animal relations through their artwork. This is exemplified by a comment made by Australian artist Lisa Roet, whose work is based on her long-term interest in primates. Roet states, 'I have my own views on the political aspect of the ape issue, but prefer to keep them separate. Art is not interesting to me when it carries a slogan underneath it' (qtd in Glass 10). A 2004 review of Roet's work demonstrates the support such approaches receive from critics. The reviewer advises readers and potential viewers of Roet's exhibition: 'Don't panic, this is not some heavy-handed animal lover on a socio-political bender...'.[2]

For some time now I have wanted to challenge these kinds of attitudes of artists and art writers and have pursued an interest in the role of art in communicating issues related to the ethics of human–animal relations. The aim has been to produce artworks that engage the viewer with the issues surrounding an animal rights ideology (for want of a better term) in a manner that encourages them to consider their own relationship with animals rather than making simple polemical statements. As such, the relationship between the depiction of animals and how they are understood and hence treated has been a central concern. The resulting artworks rely on a belief in the power of images to aid in effecting change, evoking Jonathan Burt's observation that 'animal imagery does not merely reflect human–animal relations and the position of animals in human culture, but is also used to change them' (15). In addressing the abuse of animals in factory farms, I have chosen not to use images of their suffering. My rationale was to make artworks that cause the viewer to consider the issues through having to *imagine* what these animals endure inside the sheds, and is based on a firm belief in the role images can play in stimulating the imagination of the viewer in order to achieve this end. This matter is addressed by novelist Radclyffe Hall, who comments on why she gave up hunting: 'I could no longer kill for the sake of pleasure... I could in fact no longer ignore the victim, for imagination had led to understanding, and understanding to compassion' (qtd in Kean 182–3). However, I must acknowledge here the importance and power of those images of animal suffering *inside* factory farms, captured in film and photograph by activists in their quest

Figure 5.2 Yvette Watt, *Untitled*, from the 'Animal Factories' series, 2012, gicleé print, 80×120 cm

to expose the hidden horrors of these industrial farms. These images haunt the photographs I have produced for the *Animal Factories* project (See Figures 5.1 and 5.2).

Art and activism

In his essay 'Animal Death in Contemporary Art', Steve Baker poses a question that is highly pertinent to the *Animal Factories* series: 'Can contemporary art productively address the killing of animals?' (70). Implicit within Baker's question is another: Can contemporary art enact social change? While I would not suggest that contemporary art is able to cause change by itself, I do believe that art can be a powerful instrument in the toolkit of social change. Like the multilayered and targeted strategies of advertising – and animal rights campaigns – the production of artwork which directly addresses socio-political issues is one part of a much bigger and more complex picture.

The *Animal Factories* project is based on a firm belief that art can be an important tool for making socio-political comment and can thus aid in instigating change. In her catalogue essay for the 2007 exhibition *Voiceless: I feel therefore I am*, Ondine Sherman, Director and Co-founder

of the animal advocacy group Voiceless, The Fund for Animals, writes of 'the power of a single image to incite public and political action throughout history' (1).[3] Sherman goes on to question the absence of images of animals in factory farms and slaughterhouses, suggesting that this absence allows us to ignore the plight of these animals despite our collusion in their fate. It is ironic then that the *Voiceless* exhibition contained no such images and that none of the chosen artists addressed the issues of farming or meat-eating, even indirectly. Reflecting the 'art and politics don't mix' adage, the curator, Charles Green states in his catalogue essay that the exhibition:

> is not a collective artistic indictment of the lack of compassion with which animals are treated, including by most artists, as part of the so called food-chain; that work is better managed by the legislative and educational work that Voiceless empowers. (3)

Further evidence of the discomfort the art world feels about artwork that addresses the ethics and/or politics of human–animal relations can be found in a review of the *Voiceless* exhibition in the *Weekend Australian*. Here the reviewer spent the majority of the review discussing the issues surrounding meat eating and factory farming, responding more to the catalogue essay by Ondine Sherman and opening address by J. M. Coetzee than to the artworks. He 'outed' himself as a meat eater, going on to state that, 'As an art critic, I don't see it as my job to pontificate in this column on the morality of meat eating...' (Smee). I suggest, however, it is this kind of avoidance of a consideration of the ethics of our relationship with animals that will prove to be a weakness, not just in terms of art and exhibitions on the subject of human–animal relations, but in our society in general. It is worth pondering whether the artists and writers who are so reluctant to address the ethical/political issues around human–animal relations would be so circumspect in addressing issues of gender or race.

Ondine Sherman's request for us to be confronted with pictures of animals that show us the horrors of factory farms and the like is precisely what animal activists do. I openly admit to having entered such sites illegally in the past. In entering the places where these animals are kept hidden, and where often they endure horrific conditions, my aim was to document how the animals are kept and to expose their suffering. These types of images are, for the most part, raw and untransformed, and this is their strength. But at times they can be so shocking as to cause the viewer to turn away and refuse to engage with

the image – and hence the issue. As such, I have chosen to avoid images of animal suffering that might shock or repel the viewer, instead making works that are discomforting and at times confrontational, but which are not shocking, with the desired result being a process by which the viewer is invited to question their own position regarding human–animal relationships.

The photographs produced for the *Animal Factories* project capture images of the farms from publicly accessible vantage points. This is an important matter, as a key aim in the project is to draw attention to these sites, many of which are visible from the road, but which remain invisible to the majority of people passing, who are unaware of what it is they are looking at. Additionally many of these farms are located just off the main roads and so are not seen by many people despite their proximity to towns and cities (see Plates 2–8).

Recently, after looking at the images from the *Animal Factories* series, a colleague who has never previously discussed such issues with me in any depth – other than once taking me to task some years back for comparing factory farms to concentration camps – described an incident he had experienced while travelling in Italy. An Italian friend was driving him through the countryside, when they passed rows of long, low, windowless sheds. He told me how he tried to think what they would be used for, but could not figure it out. Eventually he asked his friend, who told him that they were pig farms. That same evening a former student of mine, on viewing the photographs from the series, recalled a song by Robert Wyatt, titled *Pigs (in there)*, a transcript of which follows. This poetic response to factory farming, which reflects so well my colleague's story, and my work for the *Animal Factories* project, seems a fitting conclusion to this essay.

Well, we're driving, um, driving through Wiltshire, very nice countryside, sky, ground, all that sort of thing, natural marriage for natural resources, and I look out the window (I don't come from that part of the world) and I said, um, what's that over there? This sort of, um, sort of low, grey concrete thing. It was all surrounded by fields, really nice trees, but there was this sort of low – like a sort of large square of concrete like the foundations of a building, that – it had little walls about a foot high or something – it looked like that, maybe two foot high, say three foot high, and in fact it was sort of, the top of it was a sort of flat roof, and I thought, oh that's odd. And then um, I pointed as our car got past it and I said er, what was that? And um, the er, country person that was with me, er, said 'oh, um, that's where they

keep pigs'. And I thought oh, yes, that's where you keep pigs. And the sun was shining down, and er, the grass was green, and it was all very lovely driving country, and then I suddenly, er, thought about what that building must be like from the inside, and thought um, pigs? In there? Pigs? In there? Pigs? In there? Pigs? In there? Pigs? In there? Pigs? In there? Pigs live in there? Pigs? Huddled up in there? Pigs? Huddled up in there? Pigs? In there? In the dark? In there? On a day like this? Living in there? Pigs? In there? Pigs?[4]

Acknowledgements

I am extremely grateful to a number of people who shared their knowledge of the location of farms and provided me with detailed maps and instructions of how to find them, such as Diana Simpson, Patty Mark and Mark Pearson. I owe an even greater debt of gratitude to those people who not only shared their knowledge and researched the best places to go, but who also accompanied me on these trips, including Chris Simcox, Jonathan Hallett and the amazing Alistair Cornell who also supplied me with detailed maps and statistics of our long journey. I also thank Sarah Lynch, who not only accompanied me on two trips, but who so willingly and graciously shared her extensive technical knowledge when it came to using my Canon 5D. Finally, my gratitude goes to Kim O'Sullivan for pointing me in the direction of Robert Wyatt's haunting song.

Notes

1. See for example Isaac Bashevis Singer, J. M. Coetzee, Edgar Kupfer-Koberwitz and Marguerite Yourcenar.
2. http://www.theage.com.au/articles/2004/08/21/1092972829854.html#, accessed 24 January 2013.
3. Sherman, 'Darkness on the Farm'. This essay was also reproduced on the final page of *Photofile* 79 (Summer 2007), which had an animal theme for the issue.
4. Robert Wyatt, *Pigs (in there)* for 1985 LP Animus Artists for Animals and also on the *EPs* album. The song can be heard via the following YouTube link: http://www.youtube.com/watch?v=BcwBH-WnlhM

Works cited

Baker, Steve. 'Animal Death in Contemporary Art'. The Animals Studies Group. *Killing Animals.* Urbana and Chicago: University of Illinois Press, 2006.
Burt, Jonathan. *Animals in Film.* London: Reaktion, 2002.

Glass, Alexie. *Lisa Roet: Uncommon Observations*. Fishermens Bend, Vic.: Thames & Hudson, 2004.

Green, Charles. 'We Are All Animal Now'. *Voiceless: I Feel Therefore I Am*. Exhibition catalogue. Sydney: Sherman Galleries, 2007.

Kean, Hilda. *Animal Rights: Political and Social Change in Britain Since 1800*. London: Reaktion, 1998.

Sherman, Ondine. 'Darkness on the Farm'. *Voiceless; I Feel Therefore I Am*. Exhibition catalogue. Sydney: Sherman Galleries, 2007.

Singer, Isaac Bashevis. *Collected Stories: Gimpel the Fool to the Letter Writer*. New York: Library of America, 2004.

Smee, Sebastian. 'Beastly Goings On'. *The Weekend Australian* 10–11 March 2007, Review Section.

Wadiwel, Dinesh Joseph. 'Cows and Sovereignty: Biopower and Animal Life'. *Borderlands e-journal* 1.2 (2002). 19 February 2013. www.borderlands.net.au/vol1no2_2002/wadiwel_cows.html

Watt, Yvette. 'Artists, Animals and Ethics'. *Antennae* 19 (Winter 2011): 62–72.

——. 'Making Animals Matter: Why the Art World Needs to Rethink the Representation of Animals'. Freeman, Carol, et al. *Considering Animals: Contemporary Studies in Human–Animal Relations*. Farnham: Ashgate, 2011. 119–34.

6
Albatrosses and Western Attitudes to Killing Wild Birds

Graham Barwell

Introduction

In the 1980s I began going on pelagic seabirding trips off the East coast of New South Wales, first from Sydney then from Wollongong. For someone with an existing interest in birds, these offered a way to see wildlife which could not be easily seen from shore. Wollongong is particularly well located for albatrosses in that squid breed just off shore each winter then die after breeding, with their bodies providing a rich food source for a good range of birds and other animals. A feature of the Wollongong pelagic trips, organised by the Southern Oceans Seabird Study Association (SOSSA), is the bird banding activities, primarily involving albatrosses and Wedge-tailed Shearwaters, conducted by SOSSA members. Birds are caught in hand-held nets, brought on board, banded, measured and released, with banding data shared with seabird workers worldwide via the Australian Bird and Bat Banding Scheme.

Seeing albatrosses up close has a powerful emotional impact on those aboard and in my case led to my joining SOSSA and supporting their pelagic trips and efforts to add to existing knowledge about albatrosses and other seabirds. Such close encounters with the briefly-captured birds also stimulated a wider interest in the connections between albatrosses and humans, thus allowing me to combine my intellectual pursuits with practical support for the object of my study.

The regular Wollongong pelagic trips are very well known in birding circles, routinely attracting seabird enthusiasts from around the world, raising the profile of the region and its pelagic birdlife. These trips have had some exposure to a wider global audience via wildlife documentary programmes for television,[1] but the emotional impact of the close encounters with the captured albatrosses is largely confined to those on board the boat.

While such pelagic bird trips are relatively recent, beginning in the 1980s in the case of those off Wollongong, interest in albatrosses has extended well beyond the participants in such activities. A broader worldwide attention to the fate of albatrosses is closely tied to the bird's representation as an index of human impact on the environment, especially the oceans.[2] This interest is marked by international campaigns, treaties and an outpouring of accounts and representations of these species in a variety of media forms: books, magazine articles, documentaries, photo collections on websites, postage stamps, posters.[3] Here the bird is captured in a different sense from physical confinement. Though these examples come from around the world, this interest is particularly noticeable in media in the West, that is, Europe, North America and Australasia.

While an interest in albatrosses is understandable for the settler societies in North and South America, South Africa and Australasia, since the birds inhabit the adjacent seas, the strength of this interest in Europe and elsewhere is striking because the albatross is not a regular part of the North Atlantic avifauna and thus does not carry the historical associations of familiar birds from that part of the world and brought to those societies settled by Europeans. In this respect it is unlike the parrot, known in Europe from at least classical times,[4] or the bird of paradise, which only became known, like the albatross, as Europeans explored beyond the confines of their lands and seas.[5] Both parrots and birds of paradise have been given particular significance by Europeans,[6] and, in some cases, have been as severely affected by human impact as any of the albatrosses, being driven to extinction or near extinction.[7] But they have not achieved the iconic status that the albatross holds today as a symbol of threat posed by humanity to the natural environment.

In the light of these circumstances, a number of questions arise: how did the albatross acquire the significance it has today for Westerners? what has been the relationship between its cultural significance and their behaviour towards it?; are the ways it has been captured in writing and visual media likely to affect people's behaviour? In this chapter I address each of these questions.

What did the bird represent to the first European voyagers?

Not unsurprisingly, the earliest European explorers in the Southern Ocean spoke of the unfamiliar large seabirds they encountered in terms of birds familiar to them. Thus the English seafarer Sir Richard Hawkins

spoke of 'great fowles, as big as Swannes' off southeast South America in late 1593 (71), while the Dutch explorer Willem Schouten, sailing off Cape Horn in 1616, used the same European bird as a point of comparison, writing of 'extreame great Sea-Mewes [sea gulls], bigger of body then Swannes' (22).

As albatrosses became more familiar, reactions to them generally followed one of three patterns. First there was wonder and curiosity, whether at the size of these birds, or at their skilful flight. Thus in 1638 Peter Mundy marvelled at the way the birds he saw off southeast South Africa could fly with hardly any wing movement (3.2: 360), speculating on another voyage in 1655 that this flight pattern, like a ship's ability to sail into the wind, might be related to the curved nature of the bird's wing and the ship's sail (5: 35). Other seafarers remarked on their fearlessness of humans; Schouten noted that these 'birds being unaccustomed to see men, came to our ship, and sat thereon' (22).

Another common reaction was to see the birds as prophetic. Travellers sailing in the South Atlantic felt that the presence of birds indicated their proximity to good westerly winds and a swift passage to the Cape of Good Hope. In 1673, John Fryer speaks of meeting 'those feathered Harbingers of the Cape, ... *Albetrosses*' (1: 51), while William Dampier writes of how English seamen 'have several other signs whereby to know when they are near [the Cape], as by the sea-Fowl they meet at Sea, especially the Albatrosses...' (1: 531). Sometimes the birds were linked to bad weather and their presence was considered ominous, especially the sooty albatrosses. Thus George Shelvocke, whose ship endured continuous foul weather off Cape Horn in 1719, spoke of 'a disconsolate black Albitross, who accompanied us for several days, hovering about us as if he had lost himself', until it was shot by his lieutenant, imagining 'from his colour, that it might be some ill omen' and 'not doubting (perhaps) that we should have a fair wind after it' (72–73).

A third characteristic reaction was to capture the birds as a source of food, even sport, right from the time of the first encounters. As early as 1593, Hawkins reports catching these unfamiliar birds with baited hooks trailed behind the ship: '[by this] manner of Fishing, we caught so many of them, as refreshed and recreated all my people for that day. Their bodies were great, but of little flesh and tender; in taste answerable to the food whereon they feed' (72). Schouten likewise speaks of the ease of catching these birds, remarking how they 'let our men take and kill them' (22). Capturing thus satisfies several human emotions and feelings, none of which relate to the need to protect what is captured.

How did early scientists regard the bird?

During the later seventeenth and the eighteenth centuries, the birds attracted the attention of those whose interests had more of a scientific bent. By the 1680s, the Royal Society's collection of rarities and curiosities included an albatross skull, though there was some doubt as to whether it came from an albatross or a Dodo (Grew 1: 73–74). The catalogue added to the confusion by equating albatrosses with frigatebirds – completely different species which are generally found in tropical seas. The skull's status as a curiosity was reinforced by its inclusion in a plate which also showed an egg with two shells and a bird's nest in the shape of a man's genitals (Grew 2: plate 6). By the mid eighteenth century stuffed albatrosses were available to interested persons in London and, based on those skins, the whole bird was illustrated for the first time by George Edwards (2: 88 and following plate).

Linnaeus drew on the work of Grew and Edwards, in preparing the first formal description of an albatross (1: 132).[8] He named the bird illustrated by Edwards as *Diomedea exulans*, subsequently known in English as Wandering Albatross, though the specific name more strictly translated means 'being an exile' or 'living as an exile'. The name he assigned to the genus is based on that of the Greek hero Diomedes, who played a prominent part in the Trojan War and whose subsequent adventures are related in a number of ancient Greek and Latin texts. Linnaeus gave no reason for his choice of names, but it is likely that he had in mind the story of how Diomedes and his followers were exiled from their homeland after the war ended, and some of them were turned into large birds – in both cases as a result of offending the goddess Aphrodite/Venus. These stories were found in mainstream Latin works which would have formed part of an education in the classics in the eighteenth century: Ovid's *Metamorphoses* (14.466–511) and Virgil's *Aeneid* (11.265–77). In the former, the poet refers to the hero as *profugus*, 'exiled' Diomedes (line 457), and equates with swans the size of the birds the men were transformed into, a point of comparison which had come readily to early European explorers, like Hawkins and Schouten, when they first encountered albatrosses. The implication of heroic attributes implicit in the reference to Diomedes may be in recognition of the bird's size, since Edwards comments several times on this feature, referring to it as 'one of the largest, if not the very biggest, Water-Bird in the World' (2: 88). The notion of exile may refer to the way mariners frequently encountered these birds in the open oceans well away from land.

Naming practices of later scientists sometimes reflect some of the prevailing attitudes to the birds. While some of the names, like those coined by Johann Reinhold Forster in 1785 ('Mémoire'), are based on features of the bird's appearance,[9] others convey more of the associations that went with the bird. Thus in 1850, when Ludwig Reichenbach proposed new names for some albatrosses, he drew on the notion, already well established, of the birds as prophets of some kind. For one genus, he coined the name *Phoebastria*, now applied to the albatrosses of the central and north Pacific, and for another genus the name *Phoebetria*, now applied to the sooty albatrosses of the Southern Ocean. In both cases the names are formed from words associated with prophecy; the first from the Greek word *phoibas* 'a priestess of Phoebus, that is, Apollo/ a prophetess', the second from a feminine form of *phoibētēs* 'a prophet'.[10] The god Apollo, one of whose epithets was *Phoibos*, 'the bright one', was closely linked to prophecy in ancient Greek and Roman religion.

For the sooty albatrosses the name *Phoebetria* is particularly appropriate. When members of the second Cook expedition to the Pacific encountered these birds, both James Cook himself (*Journals* 2: 76) and George Forster (*Voyage* 1: 64) noted that the sailors on the *Resolution* called them *quaker birds*, on account of their sombre plumage. Members of the radical religious group, the Society of Friends, also known as Quakers, during this period were frequently clothed in what they called plain dress, favouring dull colours like brown and grey (Gummere 30; Punshon 129). Despite the connection based on colour, no one on the Cook expedition seems to have associated the birds with prophecy, not even Johann Forster, who assigned the formal name *Diomedea palpebrata* 'the Diomedea with white eyelids' to them ('Mémoire'; Resolution *Journal* 2: 213–14), while referring to them here and elsewhere in his journal as *quackerbirds* [sic] (for example, Resolution *Journal* 2: 189–90, 218). The only evidence of the significance of the birds is that some of the sailors on the ship somewhat fancifully proposed that the albatrosses they encountered in the Southern Ocean contained the souls of the dead captains of vessels sailing to and from the East Indies, now being punished with harsh conditions after their years of sailing in more pleasant conditions (G. Forster *Voyage* 1: 134; Sparrman 44).

The connection with prophecy was left to Reichenbach to make, presumably based on the longstanding notion of albatrosses as prophetic as regards weather or proximity to certain locations, and on links between Quakerism and Christian prophecy. This kind of connection between the sooty albatrosses, prophecy and Christian religious figures

continued to be made in the later nineteenth century and into the twentieth. For example, Elliott Coues explained the name *phoebetria* as relating to the bird's 'weird presaging' (*Coues Check List* 125), while Robert Cushman Murphy spoke of its 'fanciful appearance of a cowled monk' and how the combination of white eyelids (suggesting aston-ishment) and sombre plumage was responsible for the association with prophecy (1: 498–99).

The relationship between attitudes to particular creatures and their destruction

Regardless of who one was, a characteristic part of European engage-ment with these birds involved their destruction. Early encounters, like those of Hawkins (71–72) in 1593 or Schouten (22) in 1616, are marked by the men noting how the birds are easy to kill, while the scientific study of the birds generally began with killing them to obtain speci-mens. But the attitudes people had were complex and involved a range of emotional responses, often within the one individual. Admiration and wonder might extend to a superstitious view of the bird's omi-nous nature or seeing it as a means of providing entertainment for those aboard ship; an inquisitive approach might combine an attempt to understand the bird through capture and detailed study with a prac-tical desire to put its flesh to use as meat for dinner. Joseph Banks, in his journal entry for 5 February 1769, gives an example of the latter. Having noted on 3 February that he had been successful in shooting and collecting several seabirds, including albatrosses, during a period of calm west of Cape Horn, he remarks two days later, that, recover-ing from a slight bilious attack he was 'well enough to eat part of the Albatrosses shot on the third, which were so good that every body commended and Eat heartily of them tho there was fresh pork upon the table'.

While the birds might have been an unproblematic source of food and sport for Hawkins and his crew in the sixteenth century, attitudes in the eighteenth century could be more nuanced. A fictional account of an English shipwreck survivor, Phillip Quarll, offers an analysis of his thinking about killing wild animals for food. Despite having scru-ples over killing creatures which Nature has placed on an island out of the reach of humans, he decides to go ahead, offering a justifica-tion based on the Book of Genesis: 'were not all Things created for the Use of Man? Now, whether it is not worse to let a Man perish, than to destroy any other Creature for his Relief? Nature craves it, and

Providence gives it; now, not to use it in Necessity, is undervaluing the Gift, and despising the Donor' (Longueville 191). After he shoots a bird which has been raiding his fish supply, he is pleased with his marksmanship but,

> having taken Notice of the Birds Beauty, he had a Regret for its Death, tho' he might in time have rue'd its living.... 'Tis true, said he, I have by killing this admirable Creature, preserv'd what is much better for my Use; but then, I have destroy'd that as was certainly made for Nature's Diversion, such Variety of Colours, so regularly plac'd, and wonderfully order'd.... (Longueville 199)

While Phillip Quarll was a fictional character, the kind of thinking he exhibits could be found among living people, who might deplore what seemed to them senseless killing or scrutinise their own motives. On the second Cook expedition, for instance, George Forster, who described himself as having, unlike some of those on board, a 'heart not yet buffeted into insensibility', deplored the disappearance of a swallow he had rescued, which he thought due to 'some unfeeling person, who caught it in order to provide a meal for a favourite cat' (*Voyage* 1: 39). The published report of this incident caused another member of the expedition, William Wales, to remonstrate, declaring as cruel and unwarranted the suggestion the bird was fed to someone's cat (2: 708). Forster responded by saying he was positively assured it went to a cat (*Reply* 2: 768). Yet another member of the expedition, Anders Sparrman, wrote of his emotions following the shooting of some ducks for the table. He confessed that the feeling of the warm blood of the dying birds running over his fingers 'excited me to a degree I had never previously experienced while shooting in Sweden or New Zealand' (31–32). Reproaching himself for being 'a harsh and callous tyrant to nature', he 'acknowledged that hunting resembled not a little the murder and cruelty of the New Zealand savages' (32).

Characteristic attitudes in the nineteenth century

Sparrman's recognition of and concern over the savage impulse within him were not shared by most people travelling into the Southern Ocean in the nineteenth century. Writers of journals and reminiscences of their travels often comment on the practice of passengers on ships shooting indiscriminately at seabirds, commonly showing themselves to be out of step with prevailing attitudes. Louisa Meredith, writing of

her passage to Australia in 1839, speaks of the shooting of the abundant Cape Petrels, or 'passenger's friend':

> Had the *sobriquet* been 'passenger's *victim*,' it had been far more appropriate, for it appears the universal custom – shame on those who make it so! – to massacre these poor harmless and really beautiful birds for the mere wanton love of destruction. Every one possessed of a gun, powder, and shot aids in the slaughter, or at least does his worst; and besides the killed, I have watched many and many a poor wounded bird, disabled from flying or procuring food, float helplessly away to perish in pain and starvation, because some heartless blockhead had no other resource to kill time than breaking its leg or wing. (25)

Sometimes the practice engaged those aboard in debate over its merits. Alfred Fell, sailing in the South Atlantic in 1841 en route to New Zealand, wrote of such an occasion:

> Shooting on the poop. A beautiful bird called the Cape hen, in great abundance, flying about the vessel, as well as some albatross, a noble looking bird measuring 12 and 14 feet from tip to tip of the wings. We had an interesting discussion at lunch, whether it was justifiable to shoot these birds merely for wantonness and amusement, when it is impossible to reach them after they are dead. I had only Mr. Otterson and Mr. Barnicoat on my side of the question, so it was agreed by the sportsmen that they were justified to continue the sport if only for practice. (55)

Fell's reservations seem to be based on the shot birds not being captured for human use, since, only ten days later, he remarks that one of the sailors caught a beautiful albatross on a fishing line baited with pork: '[a]fter being led round as a raree-show it made a capital dinner for all the sailors' (62).

The Reverend William Scoresby commented caustically on the 'sport' of shooting albatrosses, describing it as a 'useless infliction of injury and suffering on these noble looking birds' where there was no chance of getting them for museum specimens or other purposes (91). The shooters' motives were perhaps 'want of consideration' (91) or following the example of others (91–92). His remonstrances were met with claims that the birds are savage, they attacked fallen birds of their species, and that an albatross had attacked a boy who had once fallen overboard. Scoresby remarks the same could be said of dogs (92).

Like Scoresby thirty years earlier, James Froude pondered on the motivation for the behaviour of passengers, whose

> chief anxiety was to shoot these creatures, not that they could make any use of them, for the ship could not be stopped that they might be picked up, not entirely to show their skill, for if they had been dead things drifting in the wind they would not have answered the purpose, nor entirely, I suppose, from a love of killing, for ordinary men are not devils, but from some combination of motives difficult to analyse. (67)

He remained puzzled by the way people could both admire the birds and yet shoot them just the same: 'We have a right to kill for our dinners; we have a right perhaps to kill for entertainment, if we please to use it; but why do we find killing so agreeable?' (67–68).

Representation and cultural significance of albatrosses in the nineteenth century and their effects on attitudes and behaviour

In the first half of the nineteenth century albatrosses had a certain cultural significance: they were prophetic, a bird of good or bad omen; they were noble, a notion based on their size, their flying skill and to some extent on the whiteness of some species and age ranges; they were faithful; they embodied the souls of departed sailors.[11] Of these, the first two are attested to most widely. These notions circulated by word of mouth, in the accounts of travellers, explorers and others, and in naming practices.

But it was Samuel Taylor Coleridge's poem, 'The Rime of the Ancient Mariner', first published in 1798, that seems to have had the greatest effect on attitudes towards albatrosses.[12] This poem ascribed to the bird a number of the qualities which were already widely current. It was a friendly companion in the polar region (lines 71–78) and was harmless (401) and a bird of good omen (71–74 gloss), despite the sailors' claiming that it affected the weather (91–102). But the major emphasis of the poem was on the terrible consequences of the Mariner's thoughtless killing of the bird, after it had accompanied them for part of their journey from the polar regions to the tropics, where they are becalmed. The crew are in two minds about the virtue of the Mariner's action, but eventually blame him for their privations and tie the dead bird round his neck as a sign of his guilt. All except the Mariner die of thirst. He

returns home through the help of favourable spirits which intervene, but he is forced to wander and retell his story whenever he is overcome by feelings of guilt.

The poem was republished a number of times in Coleridge's lifetime and subsequently went through many editions during the nineteenth century.[13] Though it had not been particularly successful when first published, its popularity began to grow and its influence soon became apparent on writers and readers, either through their making direct reference to it or showing obvious familiarity. Thus Louisa Meredith wrote that en route to Australia she never saw a great albatross without thinking of Coleridge's poem (26), while the American novelist Herman Melville, writing in 1851, recognised the powerful connection between Coleridge and the perception of albatrosses, but denied that his awestruck response to the bird was produced by the poem (1: 236–37). Outside the English speaking world, the French poet Charles Baudelaire in 1842 began his poem on the albatross by remarking on sailors' removing albatrosses from their natural element by bringing them on board for entertainment. Equating the bird's plight with his situation as a poet who flies on wings of imagination but whose work is subject to scorn, his link to Coleridge is evident in the suggestion in the last verse, added in 1859, that the flying bird 'se rit de l'archer' 'mocks the archer down below'. As the century progressed, Coleridge's influence extended very widely and he is frequently cited by those writing about their experience of albatrosses at sea, like James Froude (66–68). This extends to scientific writing. The writer of a check list of North American birds noted how the significance of the prophetic nature of the birds can be 'felt by one who reads Coleridge's "Ancient Mariner", or himself goes down the deep in ships' (Coues, *Coues Check List* 125).

Coues was not averse to shooting birds, but only if they were to be captured and used in a way which he considered acceptable, such as for the table or for scientific purposes, but not collection for the sake of it (*Handbook* 15). For scientific work, he recommended that between 50-100 specimens be collected, unless the bird was particularly abundant (*Handbook* 19). Game shooting on a large scale had been part of western life for a long time, particularly among the well-heeled, such as British aristocrats, who spent large sums of money on the practice whether in breeding animals or staffing or holding shooting parties. Lovers of these kinds of blood sports did not distinguish wholly wild birds from those which had been reared in captivity for shooting, except that the latter were owned by particular individuals. Wild birds on the other hand were available to anyone, though the depredations

resulting from unchecked shooting on wild bird populations had not become as evident in the nineteenth as they did in the twentieth century. John James Audubon, writing in the 1840s of Passenger Pigeons in the United States in the first half of the century, spoke of their 'astonishing' numbers (26) and his experience of their slaughter, but confidently asserted that it would be wrong to assume they were decreasing (30). They became extinct in the early twentieth century.

Audubon's remarks on the unlikeliness of extinction through such destruction imply that these practices and common attitudes towards living things were being questioned. Coleridge's poem had a role in these debates. For instance, students at Cambridge University in February 1829 debated which would be more effective in reducing cruelty to animals: 'The Rime of the Ancient Mariner' or the Cruel Treatment of Cattle Act of 1822 (Cambridge Union Society qtd in Haven et al. 65, item 465).[14] Later in the century Frederick Thrupp published an attack on blood sports using Coleridge's work as a starting point.

Coleridge's representation of albatrosses had wider effects, producing ways of seeing things which were not overtly connected to the poem. The notion that killing an albatross brings bad luck seems to derive from him. It was not part of eighteenth-century discussions of the bird, including the incident which inspired the poem, Shelvocke's report of the killing of a dark-plumaged albatross (72–74), and the written accounts of the three Cook expeditions. Indications of the belief seem to come mainly from the twentieth century (for example, Lowes 257, 516–18 n83; Simmons 37–40) and it is generally agreed that Coleridge's poem is the origin (for example, Armstrong 214; Jameson 68–77; Tickell 2000: 374). Then of course there is the common metaphorical meaning of an albatross as a burden. The earliest example in print given in the *Oxford English Dictionary Online* dates from 1883 ('Albatross', n, def. 1b). In that citation the poem and metaphor are linked explicitly.

Despite its effects on cultural attitudes towards albatrosses, Coleridge's poem did not affect the way the birds were commonly treated, whether by those aboard ships, field ornithologists collecting in the manner Coues had recommended,[15] or most especially by those who saw the birds as a resource to be harvested. These latter activities began in the nineteenth century and the massive depredations of the feather trade have been well covered elsewhere.[16] In many cases the destruction was so great that populations of the birds were nearly exterminated, such as Short-tailed Albatrosses in the North Pacific in the early twentieth century or Shy Albatrosses in Tasmania in the nineteenth century. The birds and their eggs were also valued as a source of food or for

other purposes, such as fashion items like muffs, for smoking accessories (Green 9) or for albumen for the photographic industry (Safina, *Eye* 147–52). In no case did the close encounter with captured birds produce a reaction sufficiently strong to produce a change of behaviour. In a familiar pattern of human interactions with the natural world, exploitation was tempered only when the resource had been severely affected or exhausted and governments were persuaded to provide some sort of legislative protection to the surviving populations of birds.

Recognition of human impacts on albatrosses

Attempts to protect albatross populations via legislation began in the early decades of the new century. In 1909 Laysan Island, west of the main Hawaiian group and the main breeding site for Laysan Albatrosses, became a bird sanctuary as a result of a presidential decree (Safina, *Eye* 150). Australian authorities in 1920 refused to renew the commercial lease under which the natural resources of Macquarie Island had been exploited (Terauds and Stewart 65). In New Zealand the passage of the Animal Protection and Game Act of 1921–22 brought protection for most albatross species, followed by some extensions in 1931 (Robertson, *Questions* 9). Short-tailed Albatrosses on the Japanese island of Torishima gained protection in 1933 and were declared a national monument in 1958 (Safina, *Eye* 184–86). The establishment of government departments with responsibility for wildlife protection was part of this same process. Thus the Division of Economic Ornithology and Mammalogy, the forerunner of the US Fish and Wildlife Service, came into being in 1885, the US National Parks Service in 1916, while in 1931 the NZ Department of Internal Affairs began the activities which led to the establishment of its Wildlife Service in 1945.

But the enactment of legislation and the establishment of enforcement agencies did not mean that exploitation immediately stopped. Because of the remoteness of the breeding islands, it was difficult, if not impossible, to police the regulations effectively. Poachers continued to raid breeding colonies in the western islands of the Hawaiian group for eggs, meat and feathers (Safina, *Eye* 150–51), and the killing and eating of birds remained a feature of people's experiences of the Southern Ocean. L. Harrison Matthews, who wrote a book about his time with sealers and whalers on South Georgia and South Orkney in the late 1920s, dedicated it to 'bird lovers, especially those who love them piping hot, well browned and with plenty of bread sauce' (ix).

Despite the continuance of older attitudes, the twentieth century saw the arrival of individual advocates, protectors and activists on behalf of albatrosses. An example of such a person is Lance Richdale, who had a major role in the successful establishment of a colony of Northern Royal Albatrosses on one of the main islands of New Zealand, not far from a major city. The birds had been attempting to breed on Taiaroa Head, near Dunedin, since late 1919, when the first known egg was laid (Richdale 1939: 468–69). It was fried and eaten by a local resident. Subsequent annual nesting attempts regularly failed, mostly as a result of human disturbance or predation, until 1936 when a chick hatched but did not survive long. Richdale saw an albatross for the first time in November of that year. The following year, after the destruction of yet another egg, Richdale determined to take steps to protect the incubating birds. He did this by literally living beside the nest and making 'a special point of being present all day every Saturday and Sunday' (Robertson, 'Lancelot' 194). As a result of Richdale's efforts, the birds were not molested and the chick fledged and left the nesting site in September 1938 (Richdale 482). The local branch of the Royal Society of New Zealand had also been part of the protection effort, but Richdale's passionate activism was remarkable for the period. This activist impulse extended beyond devoting himself to the protection and study of individual birds: he published the results of his studies in the scientific literature of his day and inspired young people as educator in local schools. Paying regular visits as an agriculture adviser, he was known as the Nature Study man and always took the children outside the classroom. The positive effects of his teaching were a consequence of his approach and personality: 'A quiet, friendly listener, no dramatics, no films, no posters, no books, just using nature itself, a good experience' (letter from a former pupil quoted in Robertson, 'Lancelot' 195).[17]

Richdale's combination of activism, scientific work and publication with school education had a powerful effect on those who came into contact with it, but his writing, being aimed at the scientific community, and his educative effort, being confined to local schools, did not greatly affect the public at large. However, in the latter part of the century, some writers, including would-be activists, did attempt to engage with wider audiences, especially young people. Two contrasting examples from the 1980s will suffice.

Around 1980, David Barton, a trawler operator out of Eden, in southern New South Wales, published a twenty page booklet, detailing the life history of a male Wandering Albatross born on Macquarie Island

in 1902, a chick of the last pair breeding on the island. Barton recounts the bird's wanderings, successful breeding with successive females, being banded by Australian scientists and captured by humans on three further occasions, when the band details are read and sent to banding authorities in Canberra. Finally he is shot aged 73 by a man with a shotgun from the shore (location not given), 'in a futile effort to impress a young boy' (5), the man's son, who is disturbed by the bird's death:

> 'I wish we didn't shoot him Dad,' he said. 'He seemed to know me, and he looks so beautiful.' His father, not now the exultant hunter, but simply the confused father of a confused boy, said nothing, but turned and walked away across the granite rocks, oblivious to the crashing seas and the great dead bird. (5)

Information about the author in the booklet indicates that birds are captured, banded and photographed on his trawler (16), and this, together with the detail of the band number of the shot albatross, suggests that the life history may have been based on an actual bird. The booklet was published by a small press in Geelong, Victoria, and is unlikely to have had a wide distribution, so the author's conservation message will have had little effect on the Wandering Albatrosses of Macquarie Island whose numbers had risen during the century then decreased from 68 pairs in 1968 to 5–7 in 1979–82 (Marchant and Higgins 268).[18] Further north from David Barton in Eden, but still in New South Wales, efforts to learn more about albatrosses had been in progress for many years prior to publication of his booklet. Members of the NSW Albatross Study Group, the forerunner of SOSSA, had begun capturing and marking Wandering Albatrosses off Bellambi near Wollongong and Malabar near Sydney in the 1950s.

A book with a wider readership, but with a less overt conservation ethos, is Deborah Savage's *Flight of the Albatross*.[19] Here the focus is on the experiences of the heroine, Sarah Steinway from New York City, who, in the course of a stay of some months on an island in New Zealand, rescues an injured Wandering Albatross and nurses it back to health with the help of a mysterious Maori woman, Aunt Hattie. This mission of healing is associated with Sarah's falling in love with a local Maori boy, whose future may include becoming a teacher and lifting a nineteenth-century curse which has extended from the island to all New Zealand. Despite the author's background as a scientist in natural history museums, she chooses to concentrate on the human relationships in keeping

with the interests of her young adult audience. Thus the source of the injuries the albatross suffered is left rather vague, being a consequence of an encounter with a fishing net (42–43). Its recovery is central to the story but its significance is more to do with Sarah herself than anything else. In the film adaptation of the novel, a German – New Zealand co-production (*Flight of the Albatross*), the fishing net as a source of injury is retained, but the symbolic equivalence of Sarah, now a German girl, to the bird is lost. Neither the film nor the novel is concerned with addressing any of the threats the birds face from the fishing industry, particularly from long-lining.

Like those who try to engage youthful readers, writers in the fantasy genre have attempted to reach a more general readership. Two examples of such works from Australasia indicate the ways such writers address environmental issues including albatrosses. Ian Irvine published his novel *The Last Albatross*, the first of his Human Rites trilogy, in Australia in 2000. Set in the dystopic world of 2010, characterised by environmental terrorism, extreme global climate change and violent technological upheaval, the novel offers a newspaper report of the official extinction of the Wandering Albatross as symptomatic of the extent of the destruction of the natural world (16). The bird's demise is explained as the result of the effects of long-line fishing. In a new edition of the novel, published in 2008, the extinction date has been moved back to 2020 but the circumstances are otherwise the same (25). The New Zealand novelist, Witi Ihimaera, who does not usually write in the fantasy genre, blends Maori mythology concerning the battle of the birds with a young adult romance and an environmentalist message in a modern New Zealand setting in his work *Sky Dancer*. Here Toroa, the albatross, along with the mollymawks, features as one of the leaders of the seabirds who have been permitted by Tane, the generative god, to resume their ancient battle with the landbirds, who had not sacrificed to Tane after their earlier victory. The environmental destruction the novel emphasises tends to relate to the lands and forests rather than the consequences of human, especially European, impacts for albatrosses, who tend to be portrayed as scouts and warriors (for example, 18, 211, 259).

The recognition of the power of images

In the latter part of the twentieth century, conservation issues were attracting wider attention in a number of developed countries. Some writers had had a significant effect on raising awareness of such issues, for example Rachel Carson, whose examination in *Silent Spring* of the

effects of pesticides and pollution on the natural world, especially birds, appeared in 1962. It was non-fictional works such as this which tended to move people, resulting, in the case of Carson's work, in bans on the agricultural use of pesticides like DDT in a number of countries. Fictional works did not have such a powerful influence.

Grassroots political campaigns on conservation issues became more common as the century progressed, accompanied by the rise of political parties under names like the Greens or of activist groups advocating conservation and protection of the natural environment. These issues gained traction with young city dwellers particularly, and were addressed, to a greater or lesser extent, by major political parties as the voting power these groups could harness became more obvious. Such groups were often media savvy and did not confine themselves to the written word in order to influence the wider voting public. This process is readily evident in Australia, for instance. In the late 1960s and early 1970s early proponents of a green agenda ran an unsuccessful campaign to prevent the Tasmanian Hydro Electric Commission building a series of dams around Lake Pedder, flooding a much larger area than the lake then covered.[20] The publicity for this campaign was assisted by photographs taken by Olegas Truchanas. Their next campaign opposed the building of a dam on the Gordon River in south-west Tasmania, which would severely affect the Franklin River, whose catchment was relatively undisturbed by human impact. Aside from conventional political activism, opponents of the dam made very effective use of images, especially photographs, in raising political awareness of the issue outside Tasmania. Some of these were by Truchanas, but it was his protégé, Peter Dombrovskis, who produced a series of images of the Franklin River[21] which were highly influential in the 'No Dams' campaign leading into the 1982 Federal Election, which the Federal Labor party won. Soon after their victory they made good on their commitment to prevent construction of the dam. The photographs which helped crystallise public awareness of the beauty of the Franklin River gorge offered emotionally powerful instant visual images of the landscape, affecting people in other states whose views would not be swayed by economic or social issues particular to Tasmania.

The potency of attractive full colour images has been recognised by wildlife activists worldwide, so it should be no surprise that they should be used as part of the efforts to raise awareness of the effects of human activities on the wildlife of the southern oceans. That such concerns commonly focus on the figure of the albatross is evident from the range of representations and accounts of the bird mentioned in

the Introduction. It cannot be mere coincidence that the albatross has become such an iconic figure. It seems likely that this has occurred for several reasons. One is that the bird has always been seen as noble in some way or other, a master of its element, a free and wild spirit. These notions have been around in western nations certainly, for many centuries. But the combination with that other cultural significance of the bird, as a prophet, makes it a particularly resonant figure for a twenty-first century audience. Even if it is not spelt out in the imagery or its textual accompaniment, the fundamental implication of the material is the warning the bird offers of the consequences of unthinking human impact on the wildlife of the oceans. This outpouring of concern shows no sign of decreasing, though there are some signs that there may be grounds for what Terence Lindsey describes as 'cautious optimism' (112) regarding the fate of albatross populations in regard to the dangers posed to them by long-line fishing. Their populations may be more resilient than suspected, but it is still impossible to predict a favourable outcome with any certainty.

Conclusion

My own experience is testimony to the emotional effects produced by direct encounters with captured birds, even if that encounter is quite brief. In the wider world, where such opportunities are unavailable, people experience the bird captured in a different way. Here, the combination of iconic powerful images in a variety of media with longstanding cultural understandings of the prophetic significance of albatrosses is still likely to provoke a potent response, especially in audiences in developed nations. Such responses may arise in those who have had no direct contact with the birds or where the bird plays no significant part in the local avifauna. Just how far this will go in changing behaviour remains to be seen, but it is undeniable that the awareness of the birds' plight is more widespread than thirty or forty years ago, and the concerns felt worldwide have led to some changes in fishing practices.[22] These changes were produced by a combination of factors, rather than being a direct consequence of the exposure of the fishing industry to material indicating a contemporary understanding of the significance of albatrosses. Nevertheless a change in practice, like changes in attitudes to pesticides, pollution and the destruction of wilderness in the twentieth century, comes about partly as a result of the effects of stories, images and other forms of emotive communication on those who may be in a position to agitate for changes in attitudes of governments, authorities, companies

and other such entities. In this regard the figure of the albatross, captured in writing and visual media, has played a significant role.

Notes

1. The makers of the BBC series *The Life of Birds* shot a sequence featuring the writer and presenter, David Attenborough, off Wollongong on the boat used for these trips ('Fishing').
2. Throughout this chapter I refer to the 'albatross' as a generic singular for the members of an internationally threatened family of birds. The number of species constituting this family varies, depending on the taxonomic treatment adopted. A recent study of the family accepts 21 species (Brooke), an arrangement followed by the most recent field guide (Onley and Scofield). Other authorities favour 22 species; for example, the Agreement on the Conservation of Albatrosses and Petrels.
3. As examples of this phenomenon from the mid 1990s on, see BirdLife International's 'Save the Albatross' campaign; the international Agreement on the Conservation of Albatrosses and Petrels which came into effect in 2004; books and magazine articles by Carl Safina; Alex Terauds and Fiona Stewart; Enrique Couve and Claudio Vidal; Terence Lindsey; Tui de Roy, Mark Jones and Julian Fitter; Peter Ryan; the National Geographic Society's DVD *The Photographers: Frans Lanting and Robb Kendrick*; Chris Jordan's online slideshow; an Australia Post stamp of 2007; and Pamela Branas's poster of 1995.
4. For instance, the Greek writer, Diodorus Siculus, writing his *Library of History* in the first century BC, refers to the parrots of Syria (bk 2 ch. 53).
5. The first European to encounter these birds was Juan Sebastian Elecano, who commanded the Spanish round the world expedition after the death of Ferdinand Magellan. In 1521 in the Moluccas, he was given several dried skins as presents for the King of Spain (Frith and Beehler 30).
6. For the significance of parrots, see Paul Carter's book, and for birds of paradise, the account by Clifford Frith and Bruce Beehler (30–31).
7. Among parrots, notable examples are the Carolina Parakeet *Conuropsis carolinensis* in the United States (extinct), the Paradise Parrot *Psephotus pulcherrimus* in Australia (extinct), the Kakapo *Strigops habroptus* in New Zealand (fewer than 150 alive) and Spix's Macaw *Cyanopsitta spixii* in Brazil (no wild sightings since 2000). Birds of paradise are threatened, but not in immediate danger of extinction (Frith and Beehler 27).
8. Linnaeus also cites the work of Eleazar Albin among his sources, but Albin offered little new information, copying Grew's description of an albatross skull without acknowledgement (76; cf. Grew 1: 73–4), though he did provide the first illustration of a feathered albatross head (fig. 81).
9. Forster's names include *Diomedea chrysostoma* 'the albatross with a yellow bill', known in English today as the Grey-headed Albatross, and *Diomedea palpebrata* 'the albatross with white eyelids', now known as the Light-mantled Albatross.
10. See the relevant entries in Liddell and Scott's dictionary ('phoibas' and 'phoibētēs'). For the transcription of the Greek diphthong *oi* as *oe*, see

Nybakken (58). For a fuller discussion of the genus names, see Barwell, 'What's in a Name?'.

11. The notion of nobility seems to have come readily to the minds of those who wrote about their encounters, for example, Robinson in 1832 (700), Fell in 1841 (55), Gould in 1838 (2: 427), and especially Melville, who emphasised the connection between nobility and whiteness in 1851 (1: 236–37n). Their habit of following ships was considered a mark of a faithful companion (Cook, *Journals* 2: 76; Cook, *Voyage* 1: 38; Guillemard iv).

12. For a much more detailed account of Coleridge's poem and its effect on perceptions of albatrosses, see Barwell, 'Coleridge's Albatross'.

13. Full details of the various versions of the poem are given in the edition by J. C. C. Mays.

14. The act had been introduced by Richard Martin and supported by the anti-slavery campaigner William Wilberforce. It was designed to regulate the treatment of farm animals.

15. Thomas Parkin, for instance, travelled to and from Australia, collecting as he went, passing on some of his specimens to leading scientists of the day, like Osbert Salvin. On one day on the voyage out he noted that shooting parties who went out on calm seas in small boats bagged 31 birds of a wide variety of species (1: 68).

16. Useful summaries are given by Robertson (*Questions* 12–13), Tickell (357–70), Safina (*Eye* 80–1, 147–52, 181–8), and Brooke (150–2). A recent book by Sarah Stein covers the workings of the plumage trade in detail with a focus on ostrich plumes.

17. Neville Peat's recent biography of Richdale gives a full account of his dedication to seabirds and its impact on all those who came into contact with him.

18. The Wandering Albatrosses of Macquarie Island remain a matter of concern. They were included in a postage stamp issue on threatened wildlife from Australia Post in 2007.

19. The book was first published by Houghton Mifflin in the US in 1989. Australian and New Zealand editions appeared in 1990. It was translated into German as *Der Flug des Albatros* in 1990 and into French as *Le Vol de l'Albatros* in 1991.

20. William Lines gives a detailed account of this and the subsequent Gordon-below-Franklin campaigns (58–61, 114–19, 197–216).

21. The most famous was a shot of Rock Island Bend by Peter Dombrovskis where the swirling waters of the river contrast with the sheer rock walls of the gorge with precariously perched vegetation beneath a misty sky. This picture has all the elements of classic nineteenth-century dramatic landscape painting celebrating the natural attributes of wilderness, so it works on the strength of its use of classical tropes as well as its sheer beauty. Lines notes that this image was reproduced more than a million times in advertising at the time of the 1982 election (216).

22. Chapter 17 in Tickell's book (357–70) gives a good overview of the threat posed by human activity and the changes that have occurred in fishing methods as a result of concern for the birds.

Works cited

Agreement on the Conservation of Albatrosses and Petrels. 1 Feb. 2013. http://www.acap.aq.

'Albatross, n'. *Oxford English Dictionary Online.* Dec. 2012. Oxford UP. 31 Jan. 2013. http://www.oed.com/.

Albin, Eleazar. *A Natural History of Birds.* Vol. 3. London, 1738.

Armstrong, Edward A. *The Folklore of Birds: An Enquiry into the Origin and Distribution of Some Magico-Religious Traditions.* The New Naturalist. London: Collins, 1958.

Audubon, John James. *The Complete Audubon: A Precise Replica of the Complete Works of John James Audubon Comprising* The Birds of America *(1840–44) and* The Quadrupeds of North America *(1851–54) in Their Entirety.* National Audubon Society 75th Anniversary Edition. Vol. 3. Kent, OH: Volair, 1979.

Australia Post. 'Wandering Albatross'. $1.30 postage stamp. Threatened Wildlife Series. 2007. Image: 1 Feb. 2013. http://www.birdtheme.org/scripts/family.php?famnum=17.

Banks, Joseph. *The* Endeavour *Journal of Joseph Banks 1768–1771.* Ed. J. C. Beaglehole. 2 vols. Sydney: Public Library of NSW, 1962. *South Seas: Voyaging and Cross-Cultural Encounters in the Pacific (1760–1800).* Ed. Paul Turnbull and Chris Blackall. National Library of Australia and Centre for Cross-Cultural Research, Australian National University. 31 Jan. 2013. http://southseas.nla.gov.au/index.html.

Barton, David. *Wangeera: The Story of a Wandering Albatross (Diomedea exulans).* Geelong, Vic.: Marine History [1980].

Barwell, Graham. 'Coleridge's Albatross and the Impulse to Seabird Conservation'. *Kunapipi: Journal of Postcolonial Writing and Culture,* 29.2 (2007): 22–61.

——. 'What's in a Name?: What Names for Albatross Genera Reveal about Attitudes to the Birds'. *Animal Studies Journal,* 1.1 (Oct. 2012): 67–82. 4 Feb. 2013. http://ro.uow.edu.au/asj/.

Baudelaire, Charles. 'L'Albatros'. *The Complete Verse.* Ed., introd. and trans. Francis Scarfe. Vol. 1. London: Anvil Press, 1986. 59.

BirdLife International. 'Save the Albatross'. *BirdLife International.* 1 Feb. 2013. http://www.birdlife.org/action/campaigns/save_the_albatross/index.html.

Branas, Pamela. *The Endangered Species No. 3: The Wandering Albatross.* Silkscreen poster. Richmond, Vic.: Red Planet, 1995. Image: 1 Feb. 2013. http://search.slv.vic.gov.au/.

Brooke, Michael. *Albatrosses and Petrels across the World.* Bird Families of the World 11. Oxford: Oxford UP, 2004.

Carson, Rachel. *Silent Spring.* Boston: Houghton, 1962.

Carter, Paul. *Parrot.* London: Reaktion, 2006.

Coleridge, Samuel Taylor. 'The Rime of the Ancient Mariner'. Vol. 1 *Poems (Reading Text)* of *Poetical Works.* Ed. J. C. C. Mays. 3 vols. (6 parts). The Collected Works of Samuel Taylor Coleridge 16. Bollingen Series 75. Princeton, NJ: Princeton UP, 2001. Part 1: 365–419.

Cook, James. *The Journals of Captain James Cook on His Voyages of Discovery.* Ed. J. C. Beaglehole. 3 vols. and portfolio. Hakluyt Society Extra Ser. 34–36. Cambridge: Cambridge UP, 1955–67.

——. *A Voyage towards the South Pole and round the World Performed in His Majesty's Ships the Resolution and Adventure in the Years 1772, 1773, 1774, and 1775*. 2 vols. 1777. Australiana Facsimile Editions 191. Adelaide: Libraries Board of South Australia, 1970.

Coues, Elliott. *The Coues Check List of North American Birds*. 2nd edn. Boston: Estes and Lauriat, 1882.

——. *Handbook of Field and General Ornithology: A Manual of the Structure and Classification of Birds with Instructions for Collecting and Preserving Specimens*. London: Macmillan, 1890.

Couve, Enrique, and Claudio F. Vidal. *Albatrosses/Albatros of the Southern Ocean/ del Oceano Austral*. Punta Arenas: Fantastico Sur, 2005.

Dampier, William. *A New Voyage round the World.…* 3 vols. London, 1697–1703.

De Roy, Tui, Mark Jones and Julian Fitter. *Albatross, Their World, Their Ways*. Collingwood, Vic.: CSIRO, 2008.

Diodorus Siculus. *Diodorus of Sicily*. The Loeb Classical Library. Vol. 2. Trans. Charles H. Oldfather. Cambridge, MA: Harvard UP, 1935. 5 Feb. 2013. http://penelope.uchicago.edu/Thayer/E/Roman/Texts/Diodorus_Siculus/2B*.html.

Dombrovskis, Peter. *Morning Mist, Rock Island Bend, Franklin River, Tasmania, 1979*. 1979. National Library of Australia, Canberra. 4 Feb. 2013. http://www.nla.gov.au/apps/cdview?pi=nla.pic-an24365561.

Edwards, George. *A Natural History of Birds.…* 4 parts. London, 1743–51.

Fell, Alfred. *A Colonist's Voyage to New Zealand under Sail in the 'Early Forties'*. Exeter: Townsend; London: Simpkin [1926].

'Fishing for a Living'. *The Life of Birds*. Writ. and pres. David Attenborough. Episode 5. 1998. DVD. BBC, 2001.

Flight of the Albatross. Dir. Werner Meyer. Footprint Films and New Films International, 1995.

Forster, George. *A Voyage round the World*. 1777. Ed. Nicholas Thomas and Oliver Berghof, assisted by Jennifer Newell. 2 vols. Honolulu: U of Hawai'i P, 2000.

——. *Reply to Mr Wales's Remarks*. 1778. *A Voyage round the World*. Ed. Nicholas Thomas and Oliver Berghof, assisted by Jennifer Newell. 2 vols. Honolulu: U of Hawai'i P, 2000. Appendix C. 2: 754–83.

Forster [Johann Reinhold]. 'Mémoire sur les Albatros'. *Mémoires de Mathématique et de Physique Présentés à l'Académie Royale des Sciences par Divers Savans, et Lus dans ses Assemblées* 10 (Paris, 1785): 563–72 and plates 13–15.

——. *The* Resolution *Journal of Johann Reinhold Forster 1772–1775*. Ed. Michael E. Hoare. 4 vols. Hakluyt Society 2nd ser. 152–55. London: Hakluyt Society, 1982.

Frith, Clifford B., and Bruce M. Beehler. *The Birds of Paradise*: Paradisaeidae. Bird Families of the World. Oxford: Oxford UP, 1998.

Froude, James Anthony. *Oceana: Or, England and Her Colonies*. New edn. London: Longmans, Green, 1886.

Fryer, John. *A New Account of East India and Persia, Being Nine Years' Travels, 1672–1681*. 1698. Ed. William Crooke. 3 vols. Hakluyt Society 2nd ser. 19–20, 39. London: Hakluyt Society, 1909–15.

Gould, John. *Handbook to the Birds of Australia*. 2 vols. London, 1865.

Green, J. F. *Ocean Birds*. London: R. H. Porter, 1887.

Grew, Nehemiah. *Musaeum Regalis Societatis: Or, A Catalogue and Description of the Natural and Artificial Rarities Belonging to the Royal Society* 2 parts. London, 1681.

Guillemard, Arthur G. 'Preface'. *Ocean Birds.* By J. F. Green. London: R. H. Porter, 1887.

Gummere, Amelia Mott. *The Quaker: A Study in Costume.* 1901. New York: Blom, 1968.

Haven, Richard, Josephine Haven and Maurianne Adams, eds. *Samuel Taylor Coleridge: An Annotated Bibliography of Criticism and Scholarship.* Vol. 1 1793–1899. Boston: Hall, 1976.

Hawkins, Richard. *The Observations of Sir Richard Hawkins.* 1622. Ed. James A. Williamson. Argonaut Press 13. 1933. Amsterdam: N. Israel; New York: Da Capo, 1970.

Ihimaera, Witi. *Sky Dancer.* Auckland: Penguin, 2003.

Irvine, Ian. *The Last Albatross.* East Roseville, NSW: Simon and Schuster Australia, 2000.

——. *The Last Albatross.* [New edn.]. Pymble, NSW: Simon and Schuster Australia, 2008.

Jameson, William. *The Wandering Albatross.* Foreword by Robert Cushman Murphy. Drawings by Peter Shepheard. 1958. New York: William Morrow, 1959.

Jordan, Chris. *Midway: Message from the Gyre.* 2009. 1 Feb. 2013. http://www.chrisjordan.com/gallery/midway.

Lindsey, Terence. *Albatrosses.* Australian Natural History Series. Collingwood, Vic.: CSIRO, 2008.

Lines, William J. *Patriots: Defending Australia's Natural Heritage.* St Lucia, Qld: U of Queensland P, 2006.

Linnaeus, Carolus [Carl von Linné]. *Systema Naturae per Regna Tria Naturae Secundum Classes, Ordines, Genera, Species, cum Characteribus, Differentiis, Synonymis, Locis.* 10th ed. 2 vols. Stockholm, 1758–59. *Biodiversity Heritage Library.* 31 Jan. 2013. http://www.biodiversitylibrary.org/bibliography/542.

Longueville, Peter. *The Hermit: Or, the Unparalleled Sufferings and Surprising Adventures of Mr. Phillip Quarll, an Englishman.* 1727. Introd. Malcolm J. Bosse. Foundations of the Novel. New York: Garland, 1972.

Lowes, John Livingston. *The Road to Xanadu: A Study in the Ways of the Imagination.* Rev. edn. 1930. London: Pan-Picador, 1978.

Marchant, S., and P. J. Higgins, co-ordinators. *Handbook of Australian, New Zealand and Antarctic Birds.* Vol. 1 *Ratites to Ducks.* Melbourne: Oxford UP, 1990.

Matthews, L. Harrison. *Wandering Albatross: Adventures among the Albatrosses and Petrels in the Southern Ocean.* London: MacGibbon with Reinhardt, 1951.

Mays, J. C. C., ed. *Poetical Works.* By Samuel Taylor Coleridge. 3 vols. (6 parts). The Collected Works of Samuel Taylor Coleridge 16. Bollingen Series 75. Princeton, NJ: Princeton UP, 2001.

Melville, Herman. *Moby-Dick: Or, The Whale.* 1851. 2 vols. New York: Russell and Russell, 1963. Vols 7–8 of The Standard Edition of the Works of Herman Melville. 16 vols.

Meredith, Louisa Anne. *Notes and Sketches of New South Wales During a Residence in that Colony from 1839 to 1844.* 1844. Penguin Colonial Facsimiles. Ringwood, Vic.: Penguin, 1973.

Mundy, Peter. *The Travels of Peter Mundy in Europe and Asia, 1608–1667.* Ed. Richard C. Temple. 5 vols. Hakluyt Society 2nd ser. 17, 35, 45–46, 78. 1907–36. Nendeln: Kraus, 1967.

Murphy, Robert Cushman. *Oceanic Birds of South America: A Study of Species of the Related Coasts and Seas, Including the American Quadrant of Antarctica Based on the Brewster-Sanford Collection in the American Museum of Natural History.* 2 vols. New York: Macmillan and The American Museum of Natural History, 1936.

National Geographic Live! The Photographers: Frans Lanting and Robb Kendrick. DVD. Washington, DC: National Geographic Society, 2008.

Nybakken, Oscar E. *Greek and Latin in Scientific Terminology.* Ames, IA: Iowa State UP, 1959.

Onley, Derek, and Paul Scofield. *Field Guide to the Albatrosses, Petrels and Shearwaters of the World.* Helm Field Guides. London: Helm, 2007.

Ovid. *Metamorphoses.* With English trans. by Frank Justus Miller. 2nd–3rd edn. Rev. G. P. Goold. 2 vols. The Loeb Classical Library. Cambridge, MA: Harvard UP; London: Heinemann, 1977–84.

Parkin, Thomas. 'Log of a Voyage Round the Globe in the Years 1890–1891'. Ms. 2 vols. Alan E. Bax Collection. Sydney University Library, Sydney.

Peat, Neville. *Seabird Genius: The Story of L. E. Richdale, the Royal Albatross, and the Yellow-eyed Penguin.* Dunedin: Otago UP, 2011.

'Phoibas' and 'phoibētēs'. *A Greek-English Lexicon.* Comp. Henry G. Liddell and Robert Scott. 9th edn. Rev. Henry Stuart Jones and Roderick McKenzie. With supplement. Oxford: Clarendon, 1968.

Punshon, John. *Portrait in Grey: A Short History of the Quakers.* London: Quaker Home Service, 1984.

Reichenbach [H. G.] L[udwig]. *Avium Systema Naturale: Das natürliche System der Vögel mit hundert Tafeln grösstentheils Original-Abbildungen der bis jetzt entdeckten fast zwölfhundert typischen Formen.* Dresden and Leipzig, 1850.

Richdale, L. E. 'A Royal Albatross Nesting on the Otago Peninsula, New Zealand'. *Emu* 38.5 (April 1939): 467–88.

Robertson, C. J. R. 'Lancelot Eric Richdale 1900–1983'. *A Flying Start: Commemorating Fifty Years of the Ornithological Society of New Zealand 1940–1990.* Ed. B. J. Gill and B.D. Heather. Auckland: Random Century, 1990. 194–95.

——. *Questions on the Harvesting of Toroa on the Chatham Islands.* Science and Research Series 35. Wellington: Department of Conservation, 1991.

Robinson, George Augustus. *Friendly Mission: The Tasmanian Journals and Papers of George Augustus Robinson 1829–1834.* Ed. N. J. B. Plomley. 2nd edn. Launceston: Queen Victoria Museum; Hobart: Quintus, 2008.

Ryan, Peter. 'It's Not Love, Actually'. *Africa Birds and Birding* 13.4 (Aug.–Sept. 2008): 42–9.

Safina, Carl. *Eye of the Albatross: Visions of Hope and Survival.* New York: Holt, 2002.

——. 'On the Wings of the Albatross'. Photographs by Frans Lanting. *National Geographic* 212.6 (Dec. 2007): 86–113.

Savage, Deborah. *Flight of the Albatross.* 1989. St Lucia, Qld: U of Queensland P, 1990.

Schouten, Willem. *The Relation of a Wonderfull Voiage….* Trans. W[illiam] P[hillip]. London, 1619.

Scoresby, William. *Journal of a Voyage to Australia and round the World for Magnetical Research*. Ed. Archibald Smith. London: Longman, Green, Longman and Roberts, 1859.

Shelvocke, George. *A Voyage round the World by Way of the Great South Sea....* 1726. Bibliotheca Australiana 71. Amsterdam: N. Israel; New York: Da Capo, 1971.

Simmons, George Finlay. 'Sinbads of Science: Narrative of a Windjammer's Specimen-Collecting Voyage to the Sargasso Sea, to Senegambian Africa and among Islands of High Adventure in the South Atlantic'. *National Geographic Magazine*, 52 (1927): 1–75.

Sparrman, Anders. *A Voyage Round the World with James Cook in H.M.S. Resolution*. Trans. Huldine Beamish and Averil MacKenzie-Grieve. Introd. and notes by Owen Rutter. 1944. London: Hale, 1953.

Stein, Sarah Abrevaya. *Plumes: Ostrich Feathers, Jews, and a Lost World of Global Commerce*. New Haven: Yale UP, 2008.

Terauds, Aleks, and Fiona Stewart. *Albatross: Elusive Mariners of the Southern Ocean*. Sydney: Reed New Holland, 2005.

Thrupp, Frederick. *The Antient Mariner and the Modern Sportsman*. London, 1881.

Tickell, W. L. N. *Albatrosses*. Mountfield, Sussex: Pica, 2000.

Virgil. *Eclogues, Georgics, Aeneid, Appendix Vergiliana*. With English trans. by H. Rushton Fairclough. Rev. G. P. Goold. 2 vols. The Loeb Classical Library 63–64. Cambridge, MA: Harvard UP, 1999–2000.

Wales, William. *Remarks on Mr. Forster's Account of Captain Cook's Last Voyage round the World, in the Years, 1772, 1773, 1774, and 1775*. 1778. George Forster. *A Voyage round the World*. Ed. Nicholas Thomas and Oliver Berghof, assisted by Jennifer Newell. 2 vols. Honolulu: U of Hawai'i P, 2000. Appendix B. 2: 699–753.

7
Capturing the Songs of Humpback Whales

Denise Russell

25°0′S, 153°0′E, Hervey Bay, Australia, a long way out to sea, a distant soft moan triggers an unexpected response. Several humans fall to their knees and place their ears on the empty hull shells of the aluminium boat. We smile, cry and call out in wonder. We hear a whale singing.

We were trainee marine researchers in the 1990s. By the time I started doing actual research in Hervey Bay from 2000 my responses were more 'systematic', taking GPS measurements, hydrophone recordings, photographic records of tail flukes that distinguish one whale from another, collecting skin samples for DNA analysis to match to the photographs, recording behavioural data and measuring ecological parameters – but the joy has never left me. Nor has the curiosity. What are these sounds that the whales make conveying? The research teams I have worked with do not pretend to have the answer. However, scientists working elsewhere with whales believe that they have captured the meaning of certain vocalisations.

Western scientists have attempted to capture the nature of animal thinking for some decades by working out a system of communication accessible to human and animal. We can talk to the animals and they can talk to us even if not in our native language, with the exception of the African Grey parrot who can even do that in a way that is not simply mimicking (Pepperberg). Bonobos, the closest ape to humans, can learn symbolic and sign languages. Some have acquired an understanding of approximately 3000 words in this way (Challis). Bonobos can convey a great deal to humans by use of a symbolic language concerning their needs, wishes, thoughts and feelings that are sometimes quite abstract and not simply requests for food or cuddles. They can also lie (Savage-Rumbaugh; Segerdahl et al.). These studies raise ethical questions as the animals are physically captive. Also they capture an aspect of human culture more than animal culture, the ability of humans to

teach animals and birds systems of communication which humans use. Yet they nevertheless provide some insight into animal lives. According to Donna Haraway taking human–animal relations seriously 'draws us into the world, makes us care and opens up political imaginations and commitments' (Haraway 300).[1] The task of this chapter is to look at the possibility of being drawn into the world without the handicap of domination in a way that would also have Haraway's aims in mind. It involves exploring possibilities not presently imagined. So instead of humans developing a way of communicating with whales, I want to look at some aspects of whale/whale communication and ask whether we might learn firstly to acknowledge that whales have a cultural life and secondly to project imaginatively how we might gain insights into this life, how we might capture it in understanding while keeping our distance. This is a type of cultural capture, but more respectful than the work with birds and apes, as it does not require the physical capture of animals. The whales in question are unconfined and are not encouraged to learn our languages.

The underpinnings of cognition

Whales have a large and complex brain. In the last few years, spindle neurones have been found in the brains of humpback, fin, killer and sperm whales (Coghlan). Previously these neurones had only been identified in humans and great apes. They have been linked to a range of cognitive abilities in humans and play a central role in intelligent behaviour and adaptive responses to changing conditions and cognitive dissonance (for example, dealing with contradictions). They are most active when humans are engaged in difficult tasks or experiencing intense emotions. Following on from this finding, it is quite reasonable to assume that these whales have a range of cognitive abilities.

Humpback whales

The main focus here is on humpback whales as they not only emit a complex array of variable sounds but they also 'sing' – they produce a patterned range of sounds lasting thirty minutes or so. If we want to begin to understand the minds of whales it might be easier to start with the songs rather than tackling more vexed questions about the variable vocalisations which are not as yet the subject of research papers. While some other whales share this singing ability, they are more difficult to study as their range is less linked to coasts, living or migrating in the

open ocean. Some key questions here are: Given that only males sing, is the purpose of the whale song to attract females and ward off males? Could they aid social cohesion? Do they express feeling? Is knowledge imparted? Given that humpbacks have the biological base for high-level cognitive skills it is not unreasonable to suggest that the whale songs and the variable complicated sounds they make are meaningful exchanges. Could they constitute an oral tradition in a similar way to human oral traditions broadly conceived that can be construed as a part of their culture? According to the poet Heathcote Williams in his epic poem *Whale Nation*:

> Webs of cetacean music stretch around the globe;
> Lyrical litanies on the bio-radio
> That draw on an oral tradition of submarine songs
> From a living memory bank, founded fifty million years ago.
>
> (Williams 17).

So says the poet, what about the scientist?

Taking into account advancements in understanding the underlying biology of the whale brain, these questions about meaningful whale/whale communications do not seem out of place. While the focus here is on humpback whales I draw into the discussion some of the findings concerning other whales and dolphins, their ability to vocalise either by singing or otherwise and the current insights we have into the nature and function of these vocalisations, especially if these findings might help to understand the humpback whale songs.

Humpback whales are highly migratory, a feature some researchers think is important in decoding the songs (Cerchio et al. 312; Mercado et al. 93; Au et al. 1104; Smith et al. 468). They live in different waters in summer from winter, often hundreds of kilometres apart. The whales who share the migration route constitute a population; a population of several thousand humpbacks travel up and down the east coasts and the west coasts of Australia and between the Hawaiian Islands and Alaska.

Humpback whale songs

In a report of a major study of the songs of Northern Hemisphere humpback whales the marine biologists Salvatore Cerchio et al. state that:

> the structure of humpback whale song [is] an ascending hierarchal series of units, phrases, themes and songs...A 'unit', analogous to a

note, is a signal that appears aurally continuous. Units have fundamental frequencies ranging from 30 Hz to greater than 10,000 Hz. [The range for a healthy young human is 20–20,000 Hz.] Different units are organized into distinct, stereotyped patterns, termed 'phrases', with 2–20 or more units, and lasting approximately 5-30 seconds. Several distinct phrase types are usually found in a whale's repertoire, each characterizing a different 'theme'. A theme is typically a repetitious series of similar phrases... A 'song' consists of several different themes sung in a consistent, cyclical order. ... Songs are usually repeated without pauses, and a group of consecutive songs is a 'song session'. (Cerchio et al. 314)

While all humpbacks vocalise a great deal it is only males who have been found to sing a song. Insofar as these whales have been studied globally all the males in one population share a song which is different from the song which male humpbacks in other populations sing. The songs progressively change during the winter. Singing is uncommon in the summer. For the whales migrating along the Australian east coast the changes occur when they are in Queensland waters. When they are in Antarctica in the summer little singing occurs. The changes are gradual but they accumulate over several seasons so that songs recorded 4–5 years apart are very different (Cerchio et al. 314). Changes can occur in all the structural levels: in units, phrases, themes and songs. With individual whales which have been studied, their songs change over the years, so that at any given time a male's song more closely resembles the songs of whales around him than his own songs from previous years or months. It is a similar story for the Alaskan/Hawaiian whales. They mate and give birth in the Hawaiian Islands in winter though neither event has been directly observed. As Au et al. point out, 'most singing by humpbacks takes place on the winter grounds, although singing also occurs, but not as widespread, during the northbound migration and in the summer feeding grounds' (1104).

These findings cannot be explained by genetics. Whales with the same genetic structure have different songs and the evolution of the song is too quick. Songs may change slowly from year to year but genetic change occurs over a much longer time scale. Nor can an explanation appeal to environmental factors since, at least during the last few decades when the songs have been studied, the environment has changed little. There has been an increase in average water temperature of less than one degree which is unlikely to be detectable by the whales given that yearly changes can be much greater and, in any case, would not

explain why the songs change. Neither genes nor environment would make sense of the complexity of the patterns in these songs. So the findings suggest that some sort of cultural transmission is going on. The songs are learnt by the males in a particular population and passed on to other males. This idea is supported by an extraordinary change that was reported in the year 2000. The song of the Australian east coast humpbacks in the Pacific Ocean was rapidly and completely replaced by the song of the Australian west coast population from the Indian Ocean (Noad et al.). The study began in 1995, and hydrophone recordings were made during 1995 and 1996 of 1,057 songs sung by the east coast humpbacks in the Great Barrier Reef, Queensland. In 1996 the song pattern changed slightly. However:

> 2 singers out of 82 were singing a new, completely different song. In 1997 the new song became more common. Most of the 112 singers produced either the old or the new song, but three used an intermediate song containing themes from both types. By the end of the 1997 southward migration almost all males had switched songs, and in 1998 only the new song was heard. The new song was nearly identical to the song of humpback whales migrating along the west coast of Australia in 1996. The very low incidence of the new song in 1996 off the east coast and the fact that the songs of the two populations evolved independently after 1996 is consistent with the new song being introduced by movement of a small number of singers between populations in 1996. (Noad et al. 537)

This could have happened in Antarctic waters where both populations spend time in summer. Instead of returning up the west coast, two of the males may have joined up with the east coast population and taught the whales in that population the new song.

How do we understand what is going on here? A widely accepted definition of 'culture' in this field is 'information or behaviour acquired from conspecifics through some form of social learning' (Boyd and Richerson 77). The finding from the Noad study provides evidence of cultural transmission of the songs, but the questions concerning what the function of the songs might be remains unanswered.

There are few scientific papers written on humpback whales songs but those that exist usually assume that the song is a form of sexual display (Cerchio et al. 312; Mercado et al. 93; Au et al. 1104; Darling et al. 1051; Smith et al. 467). Noad's study goes down this track as well, saying 'it is

not known whether... [the song's] main purpose is to repel other males or to attract females' (Noad et al. 537), assuming it must be one or the other. The basis for this is that the males sing in the winter in locations where whales breed. It is uncommon for them to sing in summer when they are in locations where they eat. Australian humpbacks rarely eat out of Antarctic waters except for the occasional consumption of bait-fish if they happen to come across them. I suggest that this seems to be a very slight basis on which to posit narrowly sexual interpretations of the songs. While it is true that the east coast humpbacks breed in the north, i.e. further north of Hervey Bay, believed to be in the Whitsunday Islands, there are many recordings of whale songs in Hervey Bay – a place where whales stopover briefly on their southern migration and mating behaviour has not been observed even though the whales have been extensively studied in this area. In the more northerly areas which are thought to be the breeding grounds, there have been few studies con-ducted. A similar picture is emerging for northern hemisphere hump-back whales. There are an increasing number of humpback whale songs recorded out of breeding areas and even in feeding areas (Pacific Whale Foundation, personal communication).

Songs as mating calls?

Bird, frog and insect scientists seek to establish that a song is a form of sexual display by looking at the context in which a song is used, its effects on an audience and correlations with the mating system. Very little work along these lines has been done with whales. In a paper published in 2008 in the journal *Animal Behaviour,* the zoologists Joshua Smith et al. argue that the songs of the male humpbacks are mating tactics. They acknowl-edge that to date no copulation has ever been observed in this species (Smith et al. 468). If we adopt this scientific methodology of the birdsong research then the only other strand of argument that supports the conclu-sion that a song is a type of sexual display is the effect on the audience, the animals of the same species who are listening to the songs.

The study, led by Smith, was conducted at Peregian Beach on the Sunshine Coast in Queensland, Australia, during the southward migra-tion in 2002, 2003 and 2004. They tracked interactions between sing-ing and non-singing whales acoustically and visually and monitored them over a 15km radius at the study site. The singing was picked up by an array of 5 hydrophones deployed off the coast. Researchers deter-mined the positions of singers using acoustic software looking at the

arrival times of the selected sounds at the 5 hydrophones. Visual track-ing of all whales moving through the study area was conducted from the peak of a hill set back 700 metres from the beach. Volunteers staffed this watching post from 7.00 a.m. to 5.00 p.m. They were in touch with the research station on the beach exchanging visual and acoustic data. Some visual tracking also took place from a boat. Identification photos were taken. The tail fluke is different in every humpback. Of course a whale has to put this fluke up for the photographer to take a photo but they are often very active. Skin samples were taken using an arrow fired from a cross-bow. These were sent for genetic analysis to determine sex. The researchers hoped to be able to work out which whales were male and which female and the interactions between the whales.

The methods used had difficulties and limitations as most field stud-ies of whales do. They were able to identify 13 singers as male and six escorts as male. Escorts are whales associating with a mother and calf. Four single whales closely associated with one calf were female. Smith's team used these findings to work out the sex of un-biopsied animals. This was a risky inductive leap. However from other studies it is fair to assume that singing humpbacks are male and adults most closely associated with calves are female. These are the most important sex determinations for the findings.

The ethics of firing arrows into whales' sides should be questioned, given there are more whale-friendly methods to obtain samples. In 2003 and 2006 I was part of a research team studying humpback whales in Hervey Bay, Queensland, led by Walter and Patricia Franklin from the Oceania Project and Southern Cross University in Australia.[2] Non-invasive methods were used to obtain samples of skin and excreta. We used a colander attached to a long pole and would hover behind active whales and pick up skin samples which they rub off during their encoun-ters with other whales. In addition, if we were very lucky, we picked up whale excreta in the scoop. These samples were then sent to a laboratory for DNA analysis and links were made to the identification photographs and reports of whale behaviour, both of which we acquired during the week-long voyages. The Project has been going since 1992 and there are five voyages a year. The early studies were mainly photo-identification but current research involves much more with a growing interest in whale songs. What this research team demonstrates is that it is possible to capture the important skin DNA without using invasive methods.

Separate from these issues, Smith's study did come up with some results of interest, but not in the way the authors intended. The researchers considered singers to be singing in the presence of other whales when

they sang for a minimum of 15 minutes as part of a group. (A group was defined as two or more whales.) They wanted to determine whether singers actively joined or were joined by other whales. They identified 114 singers. They used the word 'association' for the circumstance where a singer was already with other whales. The term 'interaction' was used when singers actively join or were joined by other whales. Forty-eight did not associate with other whales. Sixty-six whales did associate with others. That constituted 58 per cent. Mostly these 66 associated with lone whales (27) or unescorted mother/calf pairs (20). Singers who did interact with other whales were nearly equally likely to approach these other whales or be approached by them.

The authors make a great deal of this result, saying that the whales were more likely to interact with a mother/calf pair than lone whales or other groups. However the sum of all the non-mother/calf interactions is greater than the interactions with the mother/calves. Singers joined other whales in 26 instances and were joined by other whales in 24 instances. Singers joined the mother/calf pair on their own in 10/26 interactions, or 39 per cent. So in 16/26, or 61 per cent of cases, they did not join a mother/calf pair (without an escort). The authors concluded on the basis of the 39 per cent result that singing is part of a reproductive strategy for males. But this leaves no explanation for the 61 per cent result – a majority finding which has not been analysed.

Another curious feature of this study is the number of lone whales who joined the singers: 22/24 interactions, 92 per cent, a highly significant result. Many of the lone whales were male. The sex of the others was unknown. How does this fit the reproductive hypothesis that what is going on is a male acoustic display aimed toward the females? The authors attempt to get around this finding as follows: 'the song may inadvertently act as a cue to other males about the potential presence of a female and … lone males that join singers may be prospecting for a female' (Smith et al. 475). This is an ad hoc explanation to try to save the hypothesis that the song has a function in mating behaviour. The researchers say:

> Given the possibility that males escorting females with calves are capable of being reproductively successful, we suggest that song may play a role in the solicitation and coordination of mating behaviour of females, possibly by conveying certain attributes of a singer to a female such as fitness. (Smith et al. 474)

However their own results contradict this claim. No mother/calf pairs joined the singers, whether they were with an escort or not, so if the

whale song is part of a reproductive strategy it seems to be totally unsuccessful. Noad's study, mentioned previously, also reveals how researchers of animal behaviour commonly assume that the male song is a sexual display and as such its main purpose is to repel other males or attract females. This study by Smith and his team comes up with exactly the opposite finding: there is no evidence of female attraction towards the singer and no evidence of male repulsion against the singer. This does not, however, lead the authors to drop the sexual display hypothesis.

What can we conclude from Smith's study? The authors began with the hypothesis that the humpback song is a sexual display and they tried to force their findings into it. A narrow perspective on whale behaviour is operating here. If it does not relate to feeding it must relate to breeding. A narrow perspective on the audience is working here too. The researchers only consider associations and interactions within 1200 metres of the singing whales. However whales do not have to approach each other to hear these songs that travel great distances underwater depending on the undersea topography. For instance, if the singers are near sound reflecting layers their song could potentially travel the circumference of the earth and certainly the breadth of the Pacific Ocean (Williams 116). Finally, Peregian Beach is on the southern migration path for humpback whales and a long way south of the areas thought to be used for breeding. Pairs do not stay together for long. So are we to imagine that the male woos the female at Peregian Beach, migrates well over a thousand kilometres to the Southern Ocean to feed in summer and back again, tracking an additional distance of hundreds of kilometres further north to eventually mate months later? This seems far-fetched and a long way from capturing what is really going on. It seems to be much more likely that a different explanation of the song is needed.

In another account of 167 singer interactions collected from 1997 to 2002 off Maui, Hawaii, there is a very similar finding and a similar contortion of the result. The singers sang until they were joined by non-singing males in 89 per cent of the cases. In two cases, after the singing, the two male whales 'provided mutual assistance in mating' (Darling et al, 1051). The authors say that they (the researchers) 'recognize that access to females and mating are the ultimate objective of male behaviour patterns described here' (Darling et al. 1096). On what basis does this recognition rest? Two cases? It is not a recognition, it is an assumption. Darling et al. acknowledge that 'a preponderance of data now suggests that the whales that join singers are all males' (1080), and I believe that is what needs to be explained. If the scientists conducting these studies and commenting on them could reconsider the reductionist

assumption that whale songs must be related to mating other possible interpretations may emerge.

Another feature of the whale song that has been given almost no attention in the whale song literature is the posture of singers. They generally position themselves with their heads down and their tails up, at an angle of 0° to 75° from the vertical (Au et al. 1109), within 40–50 metres of the surface, with both flippers outstretched (Martinelli 5). This posture has also been witnessed by the Oceania Project researchers. Roger Payne suggests that the upside-down posture is to allow blood to flow faster to the brain to assist in the difficult process of recalling all the elements of the song. Zoomusicolgist Dario Martinelli reflects on this but notes that humans often strike particular poses when they sing 'to exploit their vocal resources' but also to make them look good: 'eyes closed, hand on heart, the gestures of rock stars' so why should whales not be exhibitionists as well (Martinelli 5). A related finding is that when the humpbacks are singing in this position they have been observed lifting their very large flippers 'forward, then back, in rhythm with phrases of the song' (Earle 5). Approaching this phenomenon from a zoomusicologist's point of view, Martinelli says:

> the lifting of the flippers may be a) a percussive element; b) an attempt to rhythmically frame the song; or c) an attempt to produce further sounds (like splashes) to include as part of the song. On the other hand, this pattern can be interpreted as a mere game, i.e., quite simply, an attempt to make the whole thing more amusing and rich. (9)

He goes on to suggest that the humpback whale songs are similar to folk songs of oral traditions in that 'each community has its own repertoire, but this latter is flexible and mixable with others, up to not only including new songs, but also to providing more or less evident modifications of old ones' (12). A thirty minute recitation of a piece as complex as a whale song would make a very long folk song indeed but that is not a good reason to rule out the speculation. Also human recitations can exceed thirty minutes. Some ballad singers sing for several hours (Lord).

Is there any support for this idea in the scholarly reflections on oral tradition in language studies? Two issues of the journal *Oral Tradition* published in 2003 surveyed the field. It is clearly very diverse and can only be brought together by highly generalised statements such as: oral tradition 'refers to all verbal art that comes into being and is transmitted without

texts' (Foley 1). Beyond that, authors stress different functions: the social: 'oral traditions are embedded in social contexts and serve social functions' (Fine 47); the cognitive: oral tradition involves 'the oral transmission and communication of knowledge, conceptions, beliefs, and ideas, and especially the formalization and formulation of these into...practices, and representations that foreground elements that favour their replication. The formalized verbal products of oral tradition range from lengthy epic poems, songs...to proverbs' (Anttonen 116); and the emotional: oral tradition is 'an expression of an intense emotional bond between performer and source' (McKean 49). All of these statements could apply to the whale songs. We do not know but we cannot rule this out. One liberating aspect of dismissing the mating interpretation is that all of these avenues are now open to explore.

Another point of likely relevance from the 'oral tradition' literature is the stress that some authors place on the audience. Thomas Dubois argues that we need to pay attention to the audience in order to understand the rich complexity of oral tradition. In particular we should focus on the skills of the audience as well as the skills of the performer (Dubois 256). During 2000, 2001 and 2012 I was on different research boats in Hervey Bay, this time studying the whale song using hydrophones. We found that when one whale started to sing the rest of the sea was quiet. Even the dolphins ceased their constant chatter. We also noticed a marked drop in humpback whale activity when a song started. Why did the cetaceans want or need to listen to these songs? Did the ocean go quiet because the non-singing cetaceans were listening?

There is clearly something quite complex going on with the whale songs in terms of their detail, the feats of memory and the cultural evolution. It may well be true that where the whales are has something to do with singing but this might be quite unrelated to breeding. The Australian east coast whales have been recorded singing in the Great Barrier Reef and nearby waters. The Reef area in winter is beautiful. There is plenty of light. There is warm water. There are few storms or very heavy winds. The whales have a great deal of free time as they do not need to catch food. They gorge themselves on krill in the Antarctic waters which sustains them for the months ahead. Krill are not present in the north. The whales mix freely together with little concern about predators. The main predators are humans and killer whales. Humans have stopped killing these whales in winter but recently the Japanese threatened to do so in summer in the Southern Ocean. Killer whales are in very small numbers off the Australian east coast but the numbers are increasing. An explanation that sees the singing as a meaningful

performance, perhaps akin to an epic poem rather than a sexual display could have some plausibility. In any case alternative explanations to feeding and breeding should be contemplated for such complex behaviours. Perhaps studies like the two main ones led by Smith and by Darling will inadvertently prompt us to move out of the narrow scientific lens in trying to understand the whale song and broader scientific interpretations could be developed.

Other humpback whale vocalisations

Apart from the whale song, humpback whales emit other sounds of a variable nature. Echolocation is the use of high frequency clicks to investigate the world around the animal – many different animals use this technique. It was uncertain until recently whether humpbacks used echolocation. However research by Peter Beamish ascertained that they do. He tested the navigational skills of humpback whales in the dark. After building a maze in a Newfoundland bay for a humpback rescued from a fishing net, he blindfolded the whale with rubber drain plungers. 'Before being set free…the humpback whale managed to navigate the maze' (Encyclopedia of Earth). Such opportunistic science can be contrasted with the whale rescued from fishing nets and crab traps in Californian waters. A rescue team untangled the net by diving in the water and moving closely around the whale. They worked for hours with knives and eventually freed her. James Moskito, one of the rescue divers, said that she then swam in what seemed like joyous circles. She came back to each diver, one at a time, and nudged them, pushing them gently around. Moskito says 'It felt to me like it was thanking us, knowing that it was free and that we had helped it' ('Daring Rescue of Whale'). Moskito cut the rope out of her mouth and said her eye was following him the whole time, and that he will never be the same: 'I never felt threatened. It was an amazing, unbelievable experience' ('Daring Rescue of Whale'). Who has learnt more from their encounters with a rescued whale – the scientist with the drain plugs or the divers allowing the whale to interact with them?

A personal magical experience on one trip occurred when I was enjoying an evening drink on a research boat moored off Fraser Island which borders Hervey Bay. It had just become dark and we idly dropped the hydrophone in the water. We heard whale sounds getting louder and louder, then a whale surfaced calmly beside the boat, engaged us visually, letting us reach and touch her head. When you look into the eye of a whale it is easy to believe that there is a high level of intelligence

behind there, but whether we are intelligent enough to find it is another matter. That whale is why I write this chapter. Meetings, says Haraway, 'make us who and what we are in the avid contact zones that are the world' (Haraway 287).

Vocalisations in whales other than humpbacks

There has been some scientific research on vocalisations with cetaceans other than humpbacks. Is there anything in this literature which might give us leads in understanding the humpback whale song? Researchers from Cornell University have used hydrophones as part of the Sound Surveillance System originally developed by the US. Navy to track singing blue, fin and minke whales as well as humpbacks. Working out of the US. Navy's Joint Maritime Facility in Cornwall, England, Christopher Clark and his team have obtained recordings of thousands of acoustical tracts of singing whales of the different species: 'We now have the ability to fully evaluate where they are and how long they sing for... We now have evidence that they are communicating with others over thousands of miles of ocean. Singing is part of their social system and community' (*Science Daily*). These reports, however, stay at this level of vagueness. No details are provided, so it is impossible to work out if this research provides useful information.

Sperm whales have not only caught the interest of scientists but of poets. The Australian poet Les Murray speaks for the sperm whale in the poem 'Spermaceti', saying 'My every long shaped cry re-establishes the world, and centres its ringing structure' (Murray 390). Scientific papers are starting to talk about the vocalisations of sperm whales, and something interesting has emerged even though it does not relate directly to whale songs. Females live in tropical or sub-tropical waters with their immature offspring. Males leave when they are about six years old and go to cold, polar waters, only returning to the female group in their late 20s. In a report of research published in 2006 in the *Canadian Journal of Zoology*, Marianne Marcoux and others state: 'Male and female sperm whales emit sharp, impulsive, broadband clicks. They produce several types of clicks with an assortment of repetition rates ranging from 220 clicks per second to 1 click every 5–7 seconds' (Marcoux et al. 610). The whales utter sounds which have been called 'codas': short stereotypically patterned series of 3–40 clicks which are thought to function in communication. Codas are principally produced during periods of social behaviour but are also heard in small numbers during foraging dives (Marcoux et al. 610).

Codas have also been detected in male sperm whales in the Mediterranean Sea uttered at the end of a series of echolocation clicks. However in the Marcoux study the codas were recorded almost exclusively in mature females and they were not attached to other clicks: 'The codas were either part of a coda exchange among whales or heard without other vocalizations' (Marcoux et al. 611). Fifty-four per cent of the codas were recorded when there were no mature males interacting with the females. Given the enormous possible range of sperm whale sounds, what about the wider audience? The authors state that there were no mature males even within a few tens of kilometres from the females. Seventy-three per cent of the codas were recorded when there was no calf in the group. The conclusion is that 'coda production can neither be solely related to male attraction nor the care of calves'. They point out that the codas which ranged from 9–11 minutes were often heard in exchanges between socialising females, and the non-randomised order of the codas in exchanges may suggest a type of conversation (Marcoux et al. 612).

Sceptics wishing to reduce the sounds to breeding may point out that sperm whale sounds can be heard well in excess of a few tens of kilometres. However the observations about the exchanges and ordering of the codas between the females counteract the view that they were directed at distant males. It is possibly noteworthy that the key author on this paper is female while most whale researchers are male. It is also of note that she is one of the few scientists who have acknowledged that whale vocalisations may be disconnected from breeding but she still assumes a narrowness of interpretation.

If the exchanges are a type of conversation, what are the whales talking about? Marcoux and her team suggest that they would be communicating about defence from predators and care of calves with the assumption that these issues are likely to be on their mind. However no research has been done on these links, and 73 per cent of the codas occurred with no calves present. While it is true that sperm whales share calf care it seems odd to postulate that they would be talking about care of the calves in the absence of calves. Sperm whales are extremely large but they are attacked by the smaller killer whales and when this occurs they form a large circle, usually heads in. As a result the killer whales can only bite their tails. In relation to whale songs it would be interesting to know whether this is the only time they form a circle, as Martinelli points out the importance of the circle in human dance, observed also in the chimpanzee round dance and in the 'quadrille' dance of cranes (Martinelli 7). Perhaps some of the sperm whale codas

were about defence from attack but in the absence of specific research it is just a prejudice against imagining the communications to be more complex to say that codas are to do with child care and defence. Sperm whales also emit whale songs but these have not been so extensively studied as they have in the humpback whale. The positive outcome of this research by Marcoux and her team is that it allows us to think beyond the reproductive hypothesis.

Killer whales also have large and complex vocal repertoires but have not been recorded singing. The research on these animals may not directly impart an understanding of the whale song but some of this research does reinforce ideas about the cultural nature of cetacean communication. Once it is agreed that some communications are learnt rather than biologically fixed it is easier to move beyond the limits of a scientific focus on sounds as mating calls.

The sounds of killer whales consist of clicks, whistles and pulsed calls. They are capable of producing two different signals simultaneously, for example whistles and echolocation clicks. It is believed that the clicks are mainly used for echolocation. The pulsed calls may be discrete or highly variable. Russian researchers on killer whales state that 'discrete calls are used to maintain contact between group members, especially when animals are dispersed, for example during foraging' (Russian Orcas Homepage). There has been no success in classifying the highly variable calls. These calls 'include complex, intergrading signals ranging from low frequency rumbling and squeaks to high frequency squawks of different duration' (Russian Orcas Home Page). Long-term investigations of killer whale acoustic behaviour in Canada, Alaska, Norway and Russia showed that 'each group had its own unique repertoire of discrete calls, stable during tens of years and passing from mother to offspring by vocal learning'. These repertoires have been called 'vocal dialects' (Russian Orcas Homepage). This is of interest in my pursuit of leads in understanding the whale song just in so far as it shows that other species of whales are capable of vocal learning. Also it shows that there are communications unique to populations which directs us away from some sort of biological explanation concerning what is going on.

Beluga whales have the most complex range of sounds of all whales but little is known about these vocalisations. There is a report by a sixteenth-century Dutch traveller claiming that belugas 'like to hear music played on the lute, harp, flute and similar instruments' (qtd in Rothenberg 102). Rothenberg recently tried playing the clarinet to beluga whales in the Shedd Aquarium on the shore of Lake Michigan. The whales vocalised back with the same pitch and phrasing and

then later in a manner which Rothenberg describes as 'complementary, rhythmic engagement' (Rothenberg 107–08). He also played the clarinet in the presence of wild belugas and heard the same mimicking responses. Rothenberg mentions the work of Russian scientists studying beluga sounds. They have made progress in classifying the different types of sounds but interpretations have been difficult. Roman Belidov, one of the scientists on the project, said: 'Beluga sounds are a very complicated subject for investigation... Perhaps we will one day be able to know as much about their meaning as we do about orca sounds, but I have some doubts... Everything is very elusive in beluga signals' (Rothenberg 128).

Bottlenose dolphin communications

One of the difficulties in gaining further insights into whale songs is that we cannot do experiments. We can make recordings, observations of behaviour and perhaps it is not too ridiculous to suppose that we might be able to work out some way of communicating with whales in a meaningful way. This has already been achieved with a close relative of the humpback whale, the bottlenose dolphin. These experiments were unethical as the dolphins were kept in holding tanks, a most rigorous form of capture. They have not been funded for some years but they did generate a very large number of research papers, many more than other dolphin communication studies before or after. It would be a double shame if the findings were ignored along with the suffering of the animals. In this outline of the studies I hope to reveal something of the dolphin's cognitive capacities. If dolphins have these abilities without the presence of spindle neurones then it seems likely that the minds of humpback whales are even more complex.

Dolphins use sounds seemingly continuously. With echolocation they investigate their environment and stun prey. It is precise. One study revealed the ability of a bottlenose dolphin to detect the presence of a water-filled sphere of diameter 7.6 cm over distances of up to 110 metres (Simmonds). Some of the key findings of the experiments are as follows.

1 *Ability to communicate about self*

Visibility under water is sometimes very poor. Dolphins do not use vision as we do to recognise others. Instead they emit a 'signature whistle'. These are individually distinctive whistles that each dolphin develops in the first few months of his or her life. This is something that dolphins learn. The whistles differ from those of their parents, but

are similar to other sounds present in their environment at birth. Baby dolphins babble sequences of whistles that become more organised as they mature. These whistles can be heard up to 25 km away in calm seas (Simmonds 104). They are used to keep in touch. Recordings have been made of these whistles in both free and captive bottlenose dolphins. There are only minor differences in different space/time locations for the same dolphin (Watwood et al. 1379).

2 Capacity for vocal mimicry

Bottlenose dolphins have no trouble in copying sounds heard in their holding tanks and repeating them later, for example mimicking a variety of computer-generated sounds using a whistle mode of vocalisation. Experimenters played the sounds that the dolphins had mimicked in the presence of various objects, for example a ball or a hoop. The dolphin learnt to link the sound to the object, 'in effect, the dolphin gave unique vocal labels to those objects. In a test of accuracy and reliability of labelling, correct vocal labels were given in 91 per cent of 167 trials comprised of five different objects presented in random order' (Richards and Wolz).

3 Communication about objects

In another study a male and a female bottlenose dolphin were given a food reward if they were able to jointly solve a problem. They were housed in the same tank but physically separated by a net drawn between them. Then they were separated by an opaque screen. To receive the reward each dolphin had to select the correct paddle from a pair located in their part of the tank and both dolphins had to select correctly for either to receive the reward. The correct paddle was signalled by an out-of-water cue light. If flashing a response on the left-hand paddle of the pair was correct and if steadily lit, a press on the right was required. They both had training sessions with the lights and paddles and then the light was removed from the male's tank. An opaque screen was placed across the tank. The male could not see the light. In order to press the correct paddle, the male was dependent on information being passed to him by the female. She was heard to vocalise at the start of the trials. The male responded to the correct paddle nearly flawlessly trial after trial. This has been taken to indicate that the dolphins can transmit information involving the right response. This skill required the creation of acoustic symbols to represent something arbitrary – the state of the light or what to do with the paddle (Bastion).

4 Understanding artificial languages

Numerous experiments were conducted by Louis Herman and his team at the University of Hawaii with bottlenose dolphins in holding tanks. The following broad outline of the findings is taken from Herman's book *Cetacean Behavior.* Subsequent papers fill out more details (Herman et al., 'The Bottlenose Dolphin'; Herman, 'Vocal, Social and Self-imitation'; and Pack et al., 'Dolphins'). The research involved electronically generated sounds and also sign language. To briefly mention the first, objects and agents in the tank and the adjoining environment and the actions concerning them were all mapped onto a set of unique sounds. When the dolphin was presented with a string of sounds this was an instruction to manipulate her world. Her ability to understand the language was then assessed by her ability to respond correctly to instructions, and by her ability to form concepts and generalisations appropriate to the sounds.

One of the dolphins named Kea was able to remember long strings of sounds, able to generalise old learning into new contexts and to acquire and use rules and concepts in her responses. In one experiment, Kea learnt to associate particular sounds with a ball, a ring and a cylinder. When she touched the correct object a coded 'yes' was played, if incorrect a coded 'no'. The playing of 'no' quickly interrupted an approach to an incorrect object or any other behaviour.

After learning these three names there was quick generalisation to balls of different sizes, etc. Then she learnt sounds for 'touch', 'fetch', 'place in mouth'. After learning some verbs there was an immediate generalisation of response for example 'mouth ball' generalised to 'mouth hand', 'mouth disc' on the first appearance of these things. After being trained to touch with the jaw she quickly picked up the understanding of touching with other body parts. Words (sounds) were presented in syntactical arrangements. Kea followed instructions almost flawlessly for all combinations. Names of trainers were taught and Kea learnt to follow instructions to bring the ball or other objects to particular trainers. At this point in her training, Kea was abducted by two pool workers and released into the ocean.

Training followed with more bottlenose dolphins. Phoenix and Ake had 80 per cent correct responses with 700 two word instructions. Most of the errors were object errors when there were a large number of objects in the pool. Action errors were very rare. For both dolphins new nouns taught were used correctly with old verbs, and new verbs with old nouns, with no additional training, for example the noun 'water'

was learnt in one training session. Then two word sentences using, for instance, 'go over', 'go under' were understood in combination with water immediately in the next session. Phoenix was trained with three word sentences: direct object, verb and indirect object for example 'ball-fetch-hoop' meaning 'fetch a ball to the hoop' and 'hoop-fetch-ball', i.e. the hoop is to be retrieved and taken to the ball. Phoenix seemed to understand reversal of order by performing the required action correctly. Phoenix performed well above chance.

Over 1000 unique imperative sentences of two to five words in length were used in these trials. The dolphins quickly picked up an ability to understand a sentence when a new word was inserted into a syntactic slot of a familiar syntactic form, for example having displayed an understanding of 'Hoop fetch surfboard' meaning take the hoop to the surfboard, and an understanding of a new object sound, for example disc, they showed an understanding of the novel sentence 'disc fetch surfboard' with a high level of accuracy. Combinations of instructions were quickly followed, for example, Phoenix understood the instructions 'pipe tail touch' as 'touch the pipe with your tail', and she understood 'pipe over' as jumping over the pipe. When given the combination 'Pipe tail touch pipe over' she swam to the pipe, touched it with her tail and then jumped over it without any new training. The dolphins responded in curious ways to commands that made no sense in the artificial language or were impossible to perform. Sometimes they re-arranged reality, for example, when asked to jump over an object that had drifted to the side of the pool, they would first drag the object to the middle and then jump. This action originated with the dolphins. Phoenix understood 'ball toss' as toss the ball. There was a sound linked to a stream of water entering the pool. When asked to 'stream toss', Phoenix made up an action – moving his head rapidly through the stream in a manner similar to tossing a ball. Herman concluded from these studies that dolphins are capable of a range of language skills.

The experiments were objectionable. The dolphins were taken out of their social world, placed in concrete tanks, unable to swim freely. They became angry and sick. Funding was cut to the projects led by Louis Herman in 2000 after continuing for thirty years. Nevertheless the experiments were valuable in showing the abilities of dolphins, and opening our minds to the abilities of humpback whales. The main difference between dolphins and whales is simply size but humpbacks do have a *more* complex brain structure as mentioned above. Some recent research, again ethically objectionable, has revealed the existence of

abstract conceptions of novelty and numerosity in bottlenose dolphins (Killan et al.). The dolphin studies are useful in allowing us to open up questions about cetacean communication with a very open mind about what we might discover rather than trying to force a narrow interpretation without justification. This applies to whale songs too. We should admit that we have not captured what they mean but marvel at the possibility that they may be communicating thoughts and emotions or other experiences that may match or move beyond our capabilities. Haraway writes about Crittercam, a project linking National Geographic with marine zoologists. Humpback whales were fitted with cameras to film their social hunting behaviour. When the cameras were taken off the whales, bits of skin adhered which were tested for DNA. This led to the discovery that the whales in the hunting group were not close kin. Haraway expresses delight at this result:

> The close teamwork over years would have to be explained, ecologically and evolutionarily, in some other way. I know I should suppress my pleasure in this result, but I raise my Californian wine glass to the extrafamilial social worlds of working whale colleagues. My endorphins are at high tide. (Haraway 261)

I feel the same way about the intriguing issue of whale songs. To find sufficient grounds to dismiss the main theory about the meaning of these songs which regards them as mating calls, opens the door to much more complex and interesting interpretations. Also when we look at the research findings concerning sperm whales, orcas and dolphins discussed above, it is clearly not absurd to imagine the whale songs to be communications on a high level of abstraction which may even involve thought processes unknown to humans. My aim has been to try to capture whale songs in whale cultures. That the result here is to say what they do not mean could be viewed as a negative one but it is a liberating standpoint to develop further understanding. The first recording of whale songs, produced for the public in 1970, is the best selling natural history record of all time (Burnett 629); and as Graham Burnett notes:

> The humpback also holds the title for the single largest one-time pressing in the history of the recording industry: *National Geographic* ordered ten and a half million copies of humpback whale song on plastic cards that were tipped in to every copy of their January 1979 issue. (629–30)

Humans want to listen to these songs. If we look and listen with an open mind, we might get closer to capturing their meaning.

Notes

1. Unfortunately Haraway does not believe that such care and commitments mean that hunting and meat eating should be shunned. Such violence against animals is permissible for her if done with respect. I cannot agree. Unless we need to perpetrate such violence in order to survive then it should be deplored.
2. Two of their publications relating to their work on whale songs are a CD of actual songs (The Oceania Project); and a work detailing the research process (Harris). See the Oceania Project website for further details of the expeditions (www.oceania.org.au).

Works cited

Anttonen, P. 'The Perspective from Folklore Studies'. *Oral Tradition* 18.1 (2003): 116–17.

Au, W. W. L., A. A. Pack, M. O. Lammers, L. M. Herman, M. H. Deakos, and K. Andrews. 'Acoustic Properties of Humpback Whale Songs'. *Journal of the Acoustic Society of America* 120.2 (2006): 1103–10.

Bastion, J. 'The Transmission of Arbitrary Environmental Information Between Bottlenosed Dolphins'. R. G. Busnel, ed. *Animal Sonar Systems,* vol. 2. Jouy-en-Josas, France: Laboratoire de Physiologie Acoustique, 1967.

Boyd, R., and P. J. Richerson. 'Why Culture Is Common, but Cultural Evolution Is Rare'. *Proceedings of the British Academy* 88 (1996): 77–93.

Burnett, D. G. *The Sounding of the Whale: Science and Cetaceans in the Twentieth Century.* Chicago: University of Chicago Press, 2012.

Cerchio, S., J. Jacobsen, and T. Norris. 'Temporal and Geographical Variation in Songs of Humpback Whales. *Megaptera novaeangliae:* Synchronous Change in Hawaiian and Mexican Breeding Assemblages'. *Animal Behaviour* 62 (2001): 311–29.

Challis, S. 'Do Bonobos Have a Language? Can Apes Be Taught Human Language?' 2010. 12 December 2012. http://stevechallis.net/Bonobos.php

Coghlan, A. *Whales Boast the Brain Cells That 'Make Us Human'.* 2006. 12 December 2012. www.newscientist.com/article.dn10661-whales-boast-the-brain-cells-that-make-us-human.html.

'Daring Rescue of Whale off Farallones'. 2005. 29 January 2013. www.sfgate.com/bayarea/article/Daring-rescue-of-whale-off-Farallones-Humpback-2557146.php.

Darling J. D., M. E. Jones, and C. P. Nicklin. 'Humpback Whale Songs: Do They Organize Males during the Breeding Season?' *Behaviour* 143 (2006): 1051–101.

DuBois, T. A. 'Oral Tradition'. *Oral Tradition,* 18.2 (2003): 255–57.

Earle, S. A. 'The Gentle Whales'. *National Geographic* 1551 (1979): 2–25.

Encyclopedia of Earth. *Whale Communication and Culture.* 12 December 2012. http://www.eoearth.org/article/Whale_communication_and_culture.

Fine, E. C. 'Performance Praxis and Oral Tradition'. *Oral Tradition,* 18.1 (2003): 46–48.

Foley, J. M. 'Editor's Column'. *Oral Tradition* 18.1 (2003): 1–2.

Haraway, D. J. *When Species Meet*. Minneapolis: University of Minnesota Press, 2008.

Harris, T. G. *A Whale's Song: The Humpbacks of Eastern Australia*. Lismore, NSW: University of Southern Cross Whale Research Centre, 2003.

Herman, L. *Cetacean Behavior: Mechanisms and Functions*. New York: Wiley, 1980.

——. 'Vocal, Social and Self-imitation by Bottlenose Dolphins'. C. Nehaniv and K. Dautenhahn, eds. *Imitation in Animals and Artifacts*. Cambridge, MA: MIT Press, 2002.

——. D. Matus, E. Herman, M. Ivancic, and A. Pack. 'The Bottlenose Dolphin's (*Tursiops truncates*) Understanding of Gestures as Symbolic Representation of Body Parts'. *Animal Learning and Behavior* 29 (2001): 250–64.

Killan, A., S. Yaman, L. von Fersen, and O. Güntürkünm. 'A Bottlenose Dolphin Discriminates Visual Stimuli Differing in Numerosity'. *Learning & Bevhavior* 31.2 (2003): 133–42.

Lord, A. B. *The Singer of Tales*. Cambridge, MA: Harvard University Press, 1960.

Marcoux, M., H. Whitehead, and L. Rendell. 'Coda Vocalizations Recorded in Breeding Areas Are Almost Entirely Produced by Mature Female Sperm Whales (*Physeter macrocephalus*)'. *Canadian Journal of Zoology* 84 (2006): 609–14.

Martinelli, D. 'Zoomusicology and Musical Universals: The Question of Processes'. *TRANS Revista Transcultural de Música* 12 (2008). http://www.sibet-rans.com/trans/a95/zoomusicology-and.

McKean, T. A. 'Tradition as Communication'. *Oral Tradition* 18.1 (2003): 49–50.

Mercado, E. I., L. M. Herman, and A. A. Pack. 'Song Copying by Humpback Whales: Themes and Variations'. *Animal Cognition* 8 (2005): 93–102.

Murray, L. *Collected Poems*. Melbourne: Heinemann, 1994.

Noad, M., D. Cato, M. Bryden, M. Jenner, and K. Jenner. 'Cultural Revolution in Whale Songs'. *Nature* 408/6812 (2000): 537.

The Oceania Project. 'Songlines: Songs of the East Australian Humpback Whales'. CD. 2006.

Pack A., and L. Herman. 'Dolphins (*Tursiops truncatus*) Comprehend the Referent of Both Static and Dynamic Human Gazing and Pointing in an Object Choice Task'. *Journal of Comparative Psychology* 118 (2004): 160–71.

Pepperberg, I. M. 'Grey Parrots Do Not Always "Parrot": Phonological Awareness and the Creation of New Labels from Existing Vocalizations'. *Language Sciences* 29 (2007): 1–13.

Richards, D., and J. P. Wolz. 'Vocal Mimicry of Computer-Generated Sounds and Vocal Labeling of Objects by a Bottlenose Dolphin, *Tursips truncates*'. *Journal of Comparative Psychology* 98.1 (1984): 10–28.

Rothenberg, D. *Thousand Mile Song: Whale Music in a Sea of Sound*. New York: Basic Books: 2008.

Russian Orcas Homepage. *Killer Whale Acoustic Behavior*. 2010. 21 September 2010. http://www.russianorca.com/Orcas/sounds_eng.htm.

Savage-Rumbaugh, S. *Kanzi: The Ape at the Brink of the Human Mind*. New York: Wiley: 1994.

Science Daily 'Secrets of Whales': Long-distance Songs Are Being Unveiled'. 2005. 12 December 2012. http://www.sciencedaily.com/releases/2005/02/050223140605.htm.

Segerdahl, P., W. Fields, and S. Savage-Rumbaugh. *Kanzi's Primal Language: The Cultural Initiation of Primates into Language.* New York: Palgrave Macmillan, 2005.

Simmonds, M. 'Into the Brains of Whales'. *Applied Animal Behaviour Science* 100.1-2 (2006): 103–16.

Smith J., A. Goldizen, R. Dunlop, and M. Noad. 'Songs of Male Humpback Whales, *Megaptera novaeangliae*, Are Involved in Intersexual Interactions'. *Animal Behaviour* 76 (2008): 467–77.

Watwood S., E. Owen, P. Tyack, P. and R. Wells. 'Signature Whistle Use by Temporarily Restrained and Free Swimming Dolphins, *Tursiops truncatus*'. *Animal Behaviour* 69 (2005): 1373–86.

Williams, H. *Whale Nation.* London: Jonathan Cape, 1988.

8
The Dog and the Chameleon Poet
Anne Collett

Prologue

I have never had any desire to 'own' a dog, or indeed, any 'pet'. This does not mean that I do not entertain the possibility of a companionate relationship between dog and human, or that I cannot see the possible value to each in such a relationship, but four children seemed more than enough to cope with. My children were given as great a measure of freedom and choice as could be afforded them without danger to themselves – a difficult line to determine and tread. When they begged for a pet, I eventually capitulated and two mice were purchased, with run and cage and wheel, and with the assurance that they were both female. I felt uncomfortable, but told myself there would be benefits to my children (I had my doubts about the mice) in learning to care and take responsibility for the care of another being. Given my abhorrence of caging, the mice were given plenty of 'controlled' rein/reign in the house which seemed to work okay – okay that was until the baby mice came along. (I discovered, after the fact obviously, that sexing mice accurately is notoriously difficult and unreliable.) The mice kittens generated enormous excitement and great delight. Then the neighbouring children came to visit.

With the entrance of the neighbour's children, chaos and disaster followed. A kitten mouse was squashed and my children were devastated – guilty for the breach of care on their part and anguished over the death of a being much loved and in which they had taken great delight. The response of my eldest son, who at that time would have been about 10 years old, gave me pause for thought. He declared on discovery of the death he had inadvertently caused to a being he loved (he had not squashed the mouse himself), that 'he would never love anything so much again'. I was shocked as much at the strength of his

131

feeling, as by his unexpected response – so much love felt for a mouse – but never to love again was an extreme reaction to an extreme situation. Love does not differentiate by species boundary, and it does not require or expect reciprocity – love is love, given freely and 'mindlessly'. It may seem an obvious thing to state, but love deeply, intensely felt, is an affective response to the world and an enormously powerful one.

Introduction

Why do I begin with this anecdote? In part because I want to talk about human–animal relations in terms of love, that is, in terms of a Romantic notion of Imagination and the associated role of the poet as an agent of change, as raised in works by J. M. Coetzee and Michelle de Kretser; and I want to think about what kind of capture this 'love' might involve. But also because, having little experience with the lives of animals except as I glimpse them in the wild, or on occasion in zoos and on farms, or as I have described as 'pets', I feel my contribution to current (academic) debate about human–animal relations to be somewhat fraudulent, particularly given the very real and important desire of this book to stress relationship between theory and practice, ideal and real, words and deeds.

In his work *Corporal Compassion* (2006) Ralph Acampora asserts that 'the ethos of corporal compassion' has 'at least as much to do with concrete, lived experience as with theoretical activity' and stresses that, 'if it is to refire latent yet abiding feelings of biophilia, post-humanism must engage with actual animals' (133). Acampora draws on Michael W. Fox's understanding of bioethics – that a 'trans-situational attitude of respect and reverence for all life comes from embracing the ethic of equal concern (equalitarianism) for animals, environment, and people alike. No one is first. What must come first from us is compassion' (Fox qtd in Acampora 133). Acampora then moves on to align himself with ethicist and animal rights advocate Elisa Aaltola, who asserts that 'to respect the welfare of an animal we have to pay attention to it as something more than an abstraction: we have to see the content of its characteristics and understand its interests, instead of marvelling from a distance at the form its [theoretically etherealized] "difference" takes' (qtd in Acampora 133).

Whilst agreeing with Aaltola and Acampora that actual change in human relations with the nonhuman animal in the 'real' world is not only the desired endpoint of philosophy and literature that speaks to this ideal, but that the materiality – the real lives – of animals, must

inform philosophy and literature, I wish in this chapter to discuss the extent to which literature might encourage its human readers toward a bioethics in which 'no one is first' and which might also increase our capacity for compassion and our willingness to extend compassion to nonhuman animals. I want not only to consider the role that literature might play (and has played), but how, or by what means, literature can effect change. Martha Nussbaum quotes Henry James 'on the task of moral imagination' of which he observes: 'The effort really to see and really to represent is no idle business in face of the constant force that makes for muddlement' (qtd Nussbaum, 'Finely Aware' 148). That 'muddlement' has surely been compounded over the course of a century of huge change and increased complexity. The question is: how might literature assist us in that effort to see more clearly? Thus Nussbaum, taking James as her guiding light, observes:

> We live amid bewildering complexities. Obtuseness and refusal of vision are our besetting vices. Responsible lucidity can be wrested from that darkness only by painful, vigilant effort, the intense scrutiny of particulars. Our highest and hardest task is to make ourselves people 'on whom nothing is lost.' This is a claim about our ethical task, as people who are trying to live well. (148)

In concert with James, Nussbaum claims that 'the work of the moral imagination [later rephrased as 'moral attention and moral vision'] is in some manner like the work of the creative imagination, especially that of the novelist' (148). In this both she and James are in agreement with Percy Bysshe Shelley, with the exception that he privileges poetry over the novel.

In the discussion that follows I draw on literary Romanticism to assess what a theory of humanist aesthetics might still have to offer a posthumanist aesthetics, given that both stress an essential relationship between aesthetics and ethics. The literary texts I have chosen to aid my discussion present a Romantic thesis as a place to start, even if they ultimately find it insufficient to carry the weight of a posthumanist ethics and posthumanist desires.

Romanticism: the aesthetics of a humanist ethics

In his *Defence of Poetry* Shelley held that '[t]he great secret of morals is love; or a going out of our own nature, and an identification of ourselves with the beautiful which exists in thought, action, or person, not our

own' (Shelley, 'Defence' 642). It is no coincidence that the ultimate fate of the Mariner who shoots the albatross in Samuel Taylor Coleridge's *Rime of the Ancient Mariner* turns upon the moment he recognises the beauty of the living world in the form of water-snakes. Surrounded by dead men, the Mariner discovers he is not as alone as he believed himself to be: 'O happy living things!' he declares,

> ... no tongue
> Their beauty might declare:
> A spring of love gushed from my heart,
> And I blessed them unaware.
> ...
> The selfsame moment I could pray;
> And from my neck so free
> The Albatross fell off, and sank
> Like lead into the sea.
> (Part IV, Stanzas 14 & 15, p. 55)

The Mariner is 'saved', primarily that he might tell his tale, to all who will listen, and even those who would prefer not to listen cannot evade capture: the unwilling Wedding Guest is held by 'the glittering eye' of the Mariner. Brought to a standstill by the force of the Mariner's emotional intensity, 'he listens like a three years' child', and 'cannot choose but hear' (Part I, Stanzas 4 & 5). Clearly the poem is in part a 'defence' and example of the power of story to command attention and with that attention, a hearing. (The fact that Coleridge was the son of a preacher, was something of a proselytiser himself, and indeed was known in his later years as 'the Highgate oracle', is not unrelated to his belief in, and advocacy of, story as a means of encouraging self-reflection and bringing about change in attitudes, values and behaviour.) The moral of *The Rime* is encapsulated in a simple stanza that comes toward the conclusion of the long poem:

> He prayeth best, who loveth best
> All things both great and small;
> For the dear God who loveth us,
> He made and loveth all.
> (Part VII, Stanza 23, p. 65)

The tale the Mariner is 'forced' to tell is affecting and effective in the mode of Romantic literature, that is, the story is designed to move its

audience to feel remorse for their lack of a generous, all-embracing love, and to encourage them toward the pursuit of a better life – to become better human beings. In the introduction to *Animal Stories: Narrating Across Species Lines* (2011), Susan McHugh highlights some of the ways in which animal narratives 'appeal to the power of affect to defy the regimes that benefit from separation, isolation, and fragmentation of our lives and theirs' and observes that 'story forms serve as spawning grounds for forms of species and social agency' (McHugh 19). This posthumanist understanding and advocacy of story as creative of community across borders, aided by the literary power of affect, derives its ethical aesthetic from a humanist ideal. For the Romantics, Imagination was held to be pivotal to the possibility and process of betterment described and desired in Coleridge's *Rime* and McHugh's animal narratives.

In his *Defence*, Shelley avers that to be 'greatly good' a 'man' 'must imagine intensely and comprehensively; he must put himself in the place of another and of many others; the pains and pleasures of his species must become his own' (642). It is immediately apparent that Shelley's thesis (unlike Coleridge's *Rime*) is 'exclusive' – being both sexist and speciesist – but this does not annul the claims it makes for the important affective and effective quality of literature and the literary imagination. He moves on to assert that '[t]he great instrument of moral good is the imagination', that poetry 'enlarges the circumference of the imagination' and that it 'strengthens the faculty which is the organ of the moral nature of man' (642). We could also add 'genreist' to Shelley's 'faults', given that he privileges the claims of poetry over those of other forms of literature. In conclusion he makes the large (and rather self-aggrandising claim) that 'Poets are the unacknowledged legislators of the world' (660).

What is important about this claim, in relation to a posthumanist discussion of aesthetics, is the Romantic view that literature not only could (by its very nature), change the world, but that it should. The Romantic aesthetic was not one that hived literature off from the 'real world'; it was an aesthetic that insisted on the capacity and the necessity of 'poets' and poetic craft to establish and maintain relationship to the social, political and material world. Which brings me to the need advocated by Nussbaum and Aaltola to 'pay attention', to be morally attentive to self and to that which is not-self. As Cary Wolfe explains it in his answer to the question 'What is Posthumanism?', posthumanism does not ask us to look less at what it is to be human when we move our gaze to that which is not-human, but rather it 'requires us to attend to that thing called "the human" with *greater* specificity, *greater* attention

to its embodiment, embeddedness, and materiality, and how these in turn shape and are shaped by consciousness, mind, and so on. It allows us to pay proper attention...' (Wolfe 120) And indeed, I would make the same claim for disciplines in the inter- or multi-disciplinary field of Animal Studies. It is more important, rather than less, that in entering this field, I pay attention to my disciplinary training in English Literature and Literary Theory, and more particularly, Postcolonialism and Romanticism; that I attend with greater rather than less specificity to the material that is central to my field of enquiry, in order to add to the number of careful, detailed and attentive ways of seeing, understanding and possibly achieving a posthumanist world.

To this end, what follows is an examination of the debate about the usefulness of a Romantic aesthetic in a literature that wants to extend the ethic of that aesthetic from a postcolonial perspective that concerns itself, in Nussbaum's words, with 'the pursuit of global justice that require[ed] the inclusion of many people and groups who were not previously included as fully equal subjects of justice', to a 'truly global justice' that 'looks across the world for other fellow species members who are entitled to a decent life' – those 'with whose lives our own are inextricably and complexly intertwined' (Nussbaum, 'Beyond Compassion' 319). South African-born Australian J. M. Coetzee's *Disgrace* (1999) and Sri Lankan-born Australian Michelle de Kretser's *The Lost Dog* (2007) are postcolonial novels that engage in this debate about the relationship between a humanist and a posthumanist ethic; and whose plots and characters are 'moved', by which I mean moved forward toward their denouement, and moved as in undergoing an emotional shift, because their lives are 'inextricably and complexly intertwined' with the lives of 'other sentient beings', namely, dogs.

Disgrace

Although Coetzee is a writer whose work can be understood to speak for the local, even when it appears not to do so, that work also speaks to 'the world' and the nature of humanity – the self in the world, the self in history, the self in time. The deliberateness of this multiple placement is apparent in an interview, when he responds to David Atwell's observation about 'chronicity South African style'. Coetzee replies: 'I am not surprised that you detect in me a horror of chronicity South African style':

> ...time in South Africa has been extraordinarily static for most of my life. I think of a comment of Erich Auerbach's on the time-experience of

Flaubert's generation, the generation that came to maturity around 1848, as an experience of a viscous, sluggish chronicity charged with eruptive potential ... But that horror is also a horror of death ... Historicizing oneself is an exercise in locating one's significance, but is also a lesson, at the most immediate level, in insignificance. It is not just time as history that threatens to engulf one: it is time itself, time as death. (Attwell in Coetzee, *Doubling the Point* 209)

Here Coetzee locates himself in the geographical, historical and political realm of South Africa – specifically a South African 'time', but he is also at pains to locate himself in the larger philosophical realm of being (and non-being). Reading Coetzee in Australia and by an Australian is clearly quite a different experience to reading Coetzee in South Africa as a South African. This has changed somewhat post-*Disgrace*, given Coetzee's relocation to Australia. Nevertheless, location does matter.

Coetzee's 1999 novel, *Disgrace*, was read by me, but probably also by many other Australians, not so much for what it had to say about post-apartheid South Africa, and the particular historical, social and political situation of the late 1990s, but for what it had to say more generally about living in 'the world', and more specifically, living in the postmodern, posthumanist world in the last days of the twentieth century. It was a book that addressed the big questions of sex, race, religion, speciesism, history, art and what it meant to be human, or indeed, to be humane: what it means to live (and to write) with integrity. I cannot recall a book that generated so much discussion and excited disputation: it was as if we had been transported back to seminar rooms of the 1970s when the value of literature and the value of the discussion generated by literature was assumed: we might have debated the relative value of different types of literature, but that literature had social, personal, and human value was indisputable.

The question that arises out of a discussion of Romanticism and its impact upon the novel and an understanding of Coetzee's answer to the question 'How to be a good person?' (as voiced by Lucy in *Disgrace*) or 'How best to live a life?' (as voiced by Elizabeth Costello in *The Lives of Animals*) is whose Romanticism? In that first reading of *Disgrace*, it seemed to me that although David's identification with the egotism of Byron and Wordsworth is undermined and replaced by identification with first a woman (Byron's rejected lover, Teresa) and then a (crippled) dog; not all that Romanticism stood and stands for is lost in that dissatisfaction; and perhaps a particular aspect of Romanticism is symbolised in David's 'come down'.

Reflecting on his life toward the end of the novel, a displaced David (a character who speaks and thinks in third person, that is, through his author) observes: 'The truth is, he has never had much of an eye for rural life, despite all his reading in Wordsworth. Not much of an eye for anything, except pretty girls; and where has that got him? Is it too late to educate the eye?' (218). The more pertinent, or perhaps more appropriate, question to ask might have been 'Is it too late to educate the heart?' This sentiment is echoed some years after *Disgrace* by Coetzee's character Elizabeth Costello, who remarks in her 'lesson' on 'The Philosophers and the Animals': '[i]f principles are what you want to take away from this talk, I would have to respond, open your heart and listen to what your heart says' (*The Lives of Animals* 37).

Central to the Romantic ethos is a belief in the rejuvenative, creative quality of the Imagination – imagination primarily conceived as empathy: not the egocentric imagination of Byron or Wordsworth but that of Keats – the chameleon poet. In a letter addressed to Richard Woodhouse (dated 27 October 1818), Keats speaks about what he understands the 'poetical Character' to be:

> As to the poetical Character itself (I mean that sort of which, if I am any thing, I am a Member; that sort distinguished from the wordsworthian or egotistical sublime; which is a thing per se and stands alone) it is not itself – it has no self – it is everything and nothing… it lives in gusto, be it foul or fair, high or low, rich or poor, mean or elevated… What shocks the virtuous philosop[h]er, delights the camelion Poet…. A Poet is the most unpoetical of any thing in existence; because he has no Identity – he is continually in for[ming?] – and filling some other Body. (Keats, *Letters*, 226–7)

Perhaps it is to this aspect of Romanticism that Coetzee subscribes; certainly it is in this guise that I am enabled to think about the place and significance of David's association and identification with the dogs in this novel, traces of which can be found throughout Coetzee's later work. Before moving on to think about the role the chameleon poet plays in Coetzee's discussion of aesthetics and ethics in a postcolonial and posthumanist world, I want to consider Michelle de Kretser's novel *The Lost Dog* – a novel that demands to be read 'post-*Disgrace*'.

The Lost Dog

In 2008 I was a judge for a major literary prize in Australia, and among the books to be considered were Coetzee's latest novel, *Diary of a Bad*

Year, and Michelle de Kretser's third novel, *The Lost Dog.* It was this novel that reminded me of Coetzee's earlier work, and my unfinished business with 'the dogman'. Although *The Lost Dog* moves back and forth between India and Australia, it is its location at a very particular time in Australian history that seems pertinent to points of contact with Disgrace:

> In the same spring as the towers fell, boats making their way to Australia foundered on the treachery of currents and destiny. People looking for sanctuary drowned. They might have been found; they might have been saved. But what prevailed was the protection of a line drawn in the water.
> Night after night, images of the refugees appeared. Tom...felt the convergence of public and private dread...
> Spring came apart under the weight of rain, death-laden spring. Fear put out live shoots in Tom. Instantly identifiable as foreign matter, he feared being labeled waste. He feared expulsion from the body of the nation. (251–2)

This is Australia on the brink, Australia at the point of change after the sluggish chronicity of the Howard years.[1] Like *Disgrace, The Lost Dog* is a story of displacement and loss, a story about disgrace and grace, a story about un-belonging and the desire to belong, for which the lost dog and his recovery is the central symbol and the narrative drive around which the history of the 'coloured' ('mixed-race') protagonist, Tom, circles. This central dog–human relationship is paralleled with Tom's desire for Nelly (also of Asian descent), where here too there is a kind of loss and recovery; so in effect Nelly is also symbolised by the dog. But I would make the claim that James Ley makes of Coetzee's employment of the dog in *Disgrace*: 'By appearing in a fictional narrative, by intervening in the action at key moments, animals inevitably assume a symbolic role. But what I want to suggest is that they are also acting, in an important sense, as symbols of themselves' (Ley 66). The dog in de Kretser's novel is both a symbol for something else and a symbol, that is, representative, of itself.

Tom, being not-white, and the dog, being not-human, share an otherness, recognised by Tom, and emphasised by the narrator: when Tom seeks help from his neighbour to find the lost dog, the man he approaches is characterised in terms of his treatment of dogs: 'The man who came out of the door raised his voice over the racket of dogs who lived a dog's life on the end of a chain. "Help you?"' (30).

The chain is later (metaphorically) attached to Tom as he leaves the neighbour's property thoroughly 'unhelped': 'Tom walked back up the hill into the dirty light of day that had gone on and on, despair dragging through him like a chain' (31). 'Can't blame a bloke that shoots a stray first and asks questions later', remarks Tom's neighbour, to which the narrator responds, 'Tom had seen those helpful blue eyes in schoolyards: "What about you fuck off back to the other black bastards?"' (31).

The fear Tom feels for the lost dog is also a fear for himself; he and the dog share an otherness, and yet it is a singularity of otherness where knowledge of the other is just a myth, a hope; any understanding between them must be worked for – worked for hard, and with no surety of result:

> Over the years, Tom recalls, with patient repetition and bribes of raw flesh, he had taught the dog to fetch. But when he picked up the ball and threw it a second time, Tom would feel the dog's gaze on him. He tried to imagine how his actions might appear from the dog's point of view: the man had thrown the ball away, the dog had obligingly sought out this object the man desired and dropped it at his feet; and behold, the man hurled it away again. How long could this stupidity go on?
>
> 'Anthropomorphism,' Karen would have said...But what was apparent to Tom in all their dealings was the otherness of the dog: the expanse each had to cover to arrive at a corridor of common ground. (27)

Tom tries to convince himself that the dog does not suffer, does not feel the kind and quality of fear that humans do because:

> Animals...do not live in time, they are not nostalgic for the past, they do not imagine a better future; and so they lack awareness of mortality. They might fear death when it is imminent, but they do not dread it as we do.
>
> So Tom Loxley reasoned, and tried to believe. (75)

But he is not successful, perhaps because so much of his self is bound up with the dog and the dog's fate. Reflecting on the work of Werner Marx, Acampora suggests that 'an ethos of compassion becomes cross-specific when mediated by symphysical awareness of animal vulnerability (comparing, for example, the specifically human concept of death with

a generically animal perception of pain)', and that an 'earthly standard' for ethical conduct is:

> discoverable in the capacity for compassion, which manifests itself pre-eminently through one's encounter with mortality. Basically, the pattern suggested is that confrontation with death and dying produces a sense of life's transience, contingency, and dependence; this feeling, in turn, breeds an affection of solidarity with those beings who share the condition of mortality. (Acampora 129)

Again, the link to *Disgrace* is evident, and clarified in Wendy Woodward's work on animal subjectivities in South African narratives. She writes:

> Coetzee represents the dogs in the clinic as having emotions and Lurie as responding to the dogs who become subjects with consciousness, foresight and fear who sense the 'shadow of death' upon them ... Whether an animal is able to have a sense of his or her impending death is controversial. It is an indication of Lurie's acknowledgement of nonhuman animal subjectivity that he becomes 'convinced the dogs know their time has come.' (Woodward 137–38)

Tom is softer, less intransigent than David – in fact there is little commonality; but like David, as the narrative progresses and the search for that which has been lost becomes more difficult to sustain, Tom comes to recognise the amplitude of what has been lost, and moves increasingly toward a 'cross-specific' ethos of compassion. He recognises that capture – that is the presumption of ownership of the dog, and of himself – is not only an outrage, it is also an absurdity. Tom recalls that the dog 'belonged' to his wife, as he did also, 'The presumption of it struck Tom now: that one should speak of ownership in relation to nerved flesh' (111). Slowly, slowly, after the purchase of the dog for his wife, Tom recognises that:

> the animal spoke to a need that was his alone ... The dog was handsome, sweet-natured. It was easy to love such a creature. Nevertheless, his core was wild. In accommodating that unruliness, Tom's life flowed in a broader vein ... It was not an aversion to disgust, which is an aversion to anything that reminds us we are animals. But the dog unleashed in Tom a kind of grace; a kind of beastliness. (204)

Tellingly, in his desperate search for the dog, inspired by a desperate love, Tom's dog ways of being and knowing are marshalled: he sniffs the air (50); at one point, he is described by de Kretser as standing still, ears straining (51). Tom employs all he knows about 'being dog' in order to find the dog, but nevertheless he is unsuccessful – the dog eludes him. Even the chameleon qualities of the poet, the ability to inform another's being or to take on the colouring and characteristic of the desired other, do not yield result. The other is too intransigent – too impermeable. It will not be captured.

After days of searching it is not Tom who finds the dog, but the dog who finds Tom, aided perhaps by the unstinting faith of Tom's mother (who remarks 'Saint Anthony never fails', 316). Tom reflects that 'while the dog had persisted in his painful effort to re-join him, he had persuaded himself the dog was dead. What he meant was that he was unworthy of grace...' (320). Here again is resonance with *Disgrace*. When Ley argues persuasively for an 'ontological independence' in Coetzee's fictional dogs, and claims that 'in light of this ontological independence... Coetzee's fiction uses animals to suggest the possibility of a form of empathetic connection between human and animal that is, temporarily at least, capable of short-circuiting humankind's divided nature' (Ley 66), he proves his claim with examples of a number of significant instances when a dog reaches out to a human at a moment of great need. Ley insists that 'in each case, the dogs' unanticipated actions interrupt the self-involvement of the protagonists' suffering', that 'the tangibility of the gesture draws them out of their solipsism', and that 'the implied affinity between human and animal, however modest or fleeting, undercuts their [the human's] sense of absolute despair' (69).

The dog's bestowal of 'grace' in de Kretser's novel is a significant moment of reaching out by nonhuman animal to human that shifts the perspective and understanding of possible relationship. Tom 'surrenders' himself to the dog, to use a Barbara Smutts word: 'I use the word "surrender" intentionally', she writes, 'for relating to others (human or nonhuman) in this way requires giving up control over them and how they relate to us. We fear such loss of control, but the gifts we receive in turn make it a small price to pay' (Smutts 118). Tom comes to understand that his relationship with the dog is quite other than what he had imagined it to be – roles are reversed, and Tom discovers that it is not the dog who was lost, but himself.

At this moment of recognition, Tom is deeply humbled – grateful that the dog has found him, and ashamed of his lack of belief

in the dog and his underestimation of the dog's capacity for love; but although Tom might feel 'unworthy of grace', grace, as Derek Attridge explains in relation to a discussion of *Disgrace*, is not earned or deserved, 'it just *comes*': 'Grace is a blessing you do not deserve, and though you may seek for grace, it comes, if it comes at all, unsought' (Attridge 180). De Kretser would seem to be in agreement: she describes 'Grace, rocking along Tom's fibres': Grace 'murmured of wonders that exceed reason. It whispered of the miracle of patient, flawed endeavour. It butted and nuzzled him, blindly purposeful as a beast' (320). Grace might not be earned but it seems that persistent, patient loving is rewarded (at least in fiction). But 'Love without limits', Tom reflects:

> was reserved for his own species. To display great affection for an animal invariably provoked censure. Tom felt ashamed to admit to it. It was judged excessive: overflowing a limit that was couched as a philosophical distinction, as the line that divided the rational, human creature from all others. Animals, deemed incapable of reason, did not deserve the same degree of love. (287)

But love knows no bounds – species bounds or otherwise. Love is a state of mind, a way of living in the world that the Romantics associated with the power of Imagination and the capacity to feel.

The chameleon poet

In December 1817, Keats writes to Benjamin Bailey:

> The Imagination may be compared to Adam's dream – he awoke and found it truth. I am the more zealous in this affair, because I have never yet been able to perceive how any thing can be known for truth by consequitive reasoning... Can it be that even the greatest Philosopher ever arrived at his goal without putting aside numerous objections. O for a Life of Sensations rather than of Thoughts! (Keats 67)

Here reason, the highest truth of the enlightenment, the discourse of philosophers and scientists, and that which has long differentiated human beings from the so-called lower and lesser animals, is devalued and replaced (in a hierarchy of desirable human attributes) by feeling. And more, in a letter to his brothers a month later, Keats makes his

claim for the higher truth of the poet, the poet being the most imaginative of beings, the most capable of feeling. Keats writes:

> ...and at once it struck me, what quality went to form a Man of Achievement, especially in Literature, and which Shakespeare possessed so enormously – I mean Negative Capability, that is, when a man is capable of being in uncertainties, mysteries, doubts without any irritable reaching after fact and reason... (Keats 71)

'At the Gate', Elizabeth Costello (a character who appears in a number of Coetzee's literary works) puts the case of her life and her 'belief':

> She sighs. 'Of course, gentlemen, I do not claim to be bereft of all belief. I have what I think of as opinions and prejudices, no different in kind from what are commonly called beliefs. When I claim to be a secretary clean of belief I refer to my ideal self, a self capable of holding opinions and prejudices at bay while the word which it is her function to conduct passes through her.'
> 'Negative capability,' says the little man. 'Is negative capability what you have in mind, what you claim to possess?'
> 'Yes, if you like. To put it another way, I have beliefs but I do not believe in them. They are not important enough to believe in. My heart is not in them.' (*Elizabeth Costello* 200)

One way of interpreting this refusal of belief is to understand 'belief' (rather than 'faith') as a barrier to an all-encompassing love. When Elizabeth declares that her heart is not in her beliefs, she gives precedence to the heart over the head. When Tom, in de Kretser's novel, thinks about the importance of love, and the means to prevent his precipitation into a state of fall, it is not only as a human being, but as a writer that he thinks. He is, like Coetzee's David, an English academic – in this case a man engaged in writing a book on Henry James: not a writer of fiction, but a writer nevertheless, and a man who values literature and the author capable of its highest expression. What is the characteristic so highly valued by an ethical aesthetics advocated by humanist and posthumanist alike? Is it not the capacity to think and feel oneself into other lives?

Writing about Coetzee's Elizabeth Costello, Attridge stresses that she is presented 'very much as a *novelist*' and that part of the burden she experiences is 'the burden of feeling one's way into other lives, including the lives of animals' (202). Costello's lesson on 'The Philosophers and the

Animals' in which she speaks of a *'sympathy,* that allows us to share at times the being of another' (Coetzee, *The Lives of Animals* 34–35), draws on Keats's notion of the chameleon poet. Here, through this fictional 'lesson', Coetzee offers us a way by which we might approach relationship with the other – that way being our capacity to sympathise, and that 'other' being all which distinguishes itself from 'self'. *'Other modes of being...* Are there other modes of being besides what we call the human into which we can enter', asks Elizabeth Costello, 'and if there are not, what does that say about us and our limitations?' (Coetzee, *Elizabeth Costello* 188).

Other modes of being

The enlarged capacity to sympathise, or more, to empathise, to imagine oneself as fully as one can in the position of another, might be the only way we have to create real relationship with that which is not self. This is to go beyond *Disgrace*, where Coetzee baulks at the possibility of 'knowing another'. Lucy's cry against David's desire to 'help': 'You do not know what happened' (134), is intransigent. It is my understanding of the text that David *cannot 'know'* what Lucy has gone through, not only because he is a man and she is a woman, but because each is trapped within the singularity of their selves – their unique human consciousness and unique experience of the world. David's relationship with the dogs is not one in which he comes to 'know' what it is to be a 'dog', but one in which he establishes sympathetic alliance. He sees himself in the dogs – alive and dead. He is 'like' a lame dog; the acts that he performs as a 'dogman' are acts as much or more for himself as for the dogs:

> Why has he taken on this job? To lighten the burden on Bev Shaw? For that it would be enough to drop off the bags at the dump and drive away. For the sake of the dogs? But the dogs are dead; and what do dogs know of honour and dishonour anyway?
>
> For himself then. For his idea of the world, a world in which men do not use shovels to beat corpses into a more convenient shape for processing. (145–46)

This is a world in which dignity, compassion and the loving attentiveness to life (and death, being part of life) in all its forms and phases is paramount. The idea that Keats might be important to understanding Coetzee's complex attitude toward Romanticism and the nature of

Love, is not corroborated in any overt way in *Disgrace*, but both oblique and transparent reference to Keats occurs on numerous occasions in the texts that followed. We might, for example, understand the work *Elizabeth Costello* as Coetzee's fictional means of putting Keatsian Romanticism on trial, a trial that might be understood to have been precipitated by what Michael Chapman has called the 'local dead end' of *Disgrace*.[2] It may be that Coetzee is cautious of Keats's notion of the chameleon poet, given the local (both in South Africa and Australia) postcolonial context out of which and into which he writes. An abusive history of colonialism and its attendant violence perpetrated by those in positions of power against those considered to be 'other' and lesser, might incline Coetzee to see a colonising impulse in the poet's desire to invade (if only imaginatively) the body of the other, to presume a knowledge and to speak for and in place of that other – this might look like capture. But I think it worth at this point, championing Keats in a way Coetzee may feel unable, by placing Keats's words about the chameleon poet back into their original context and his life.

When Keats speaks of leading a 'posthumous existence' it has been understood to refer to the overwhelming nature of his ill health and impending death (Letter to Charles Brown, 30 November 1820, *Letters* 529); but another way, or an additional way, of understanding this claim is to read it as an expression of the self-less nature of the poet – the poet for whom the self has died in order that he might attempt another mode of being and 'knowing'. It is not then surprising to read Keats's declaration in a letter to his friend, Benjamin Bailey in November 1817, that he 'scarcely remembers counting upon any happiness', and that nothing startles him beyond the moment. It is in this context that he writes: 'The setting sun will always set me to rights, or if a sparrow comes before my window, I take part in its existence and pick about the gravel' (Keats 68). What I read here is not 'capture', not colonisation, but selflessness, humbleness and attentiveness to the small things, the small moments in a life intensified by knowledge of death.

The fictional works that follow Coetzee's *Disgrace* ask, 'Is it possible to "know" the other, how effective can empathy be, and does literature aid this process?' Elizabeth Costello, or rather Elizabeth Costello's ideas and understanding of her self as a human being and her significance as a 'poet' (or novelist), are tested: I am unsure what Coetzee's final judgment is, but it is we, the readers, who must judge and apply our findings to our own case. I am not convinced that 'the way of living in the world' as promulgated by either Keats or Costello are seen to provide 'the answer', but they, like Coetzee himself, like David Lurie, and like de

Kretser's Tom, are actively working toward a better way of being, being in the world, and being in relation to others. I would certainly agree with Chapman's observation that 'Coetzee's novels seek a reciprocity that is not easily forthcoming. It is a reciprocity that harbours its selfish desires'; and speaking of *Slow Man*, he writes, 'so this later "slow man" ['later' being a reference to the Magistrate in *Waiting for the Barbarians*] has to learn to give of his own self, of his own resources, in excess of what he will receive in return' (105). There is much, as Coetzee and de Kretser are well aware, that mitigates such excess. '[O]n seeing a beggar', writes de Kretser,

> Tom's first impulse was to reach for money. Then he would imagine being observed in the act of placing a coin in a hand; a sentimental act, an act of feeling. The shame this occasioned was so strong that it triumphed over charity. He would walk on, ignoring the beggar.
>
> Now he realised that what he risked in showing empathy was to appear unironic. Irony was the trope of mastery: of seeing through, of knowing better. (287–88)

This is a knowing better that knows nothing – at least nothing outside the self, because it refuses equal relationship with the other.

Another, related, facet that both novels share is an interest in the possibility and the potential of moving beyond verbal language, in order to come closer to 'knowing'. This is not to deny that animals have and employ language, but to recognise our inability to communicate effectively through *verbal* language, and to express a belief in a form of non-verbal communication that might be more effective, less polluted. This language might be closer to something 'felt' than something 'thought' (although thinking and feeling are entangled). Ley suggests that Coetzee employs moments of dog/human sympathy to draw attention to an 'elemental state of existence [in both] that is not lower or inferior, but which suggests a common experience that is beyond the reach of language' (Ley 70) I am in part convinced by Ley's interpretation of these moments, and the response of the human in each case in relation to the moments of reaching out, indeed touching, because it fits with Coetzee's reflection on 'our ethical impulses', that once again draws on a Romantic understanding of the world (this time aligned with Wordsworth). In a dialogue conducted by Paola Cavalieri, he remarks that:

> Regarding the project of a rational ethics, so thoroughly interrogated by Cary Wolfe, it is worth saying that there are people (among whom

I number myself) who believe that our ethical impulses are prerational (I would be tempted to go along with Wordsworth and say that our birth is but a sleep and a forgetting, that what Wordsworth calls our moral being is more deeply founded within us than rationality itself), and that all that a rational ethics can achieve is to articulate and give form to ethical impulses. (Coetzee, 'On Appetite' 121)

De Kretser's Tom, like David Lurie and like Coetzee, is not only a writer, but a man who wishes he better understood the non-verbal arts, like painting. Here too, there is alliance with David Lurie's interest in pursuing the composition of an opera – not just the libretto but the music: this might be understood to be important work toward 'thinking' and 'feeling' outside a verbal language; a shift toward the possibility of 'knowing' differently.

Conclusion

Literature offers us this space – a space in which to 'enter imaginatively into a different mode of existence' (in the words of Attridge 202). The humanist aesthetic of the Romantics is the progenitor of the posthumanist aesthetic: both place Imagination at their centre; both work toward personal, social and political change; both value compassion and both desire the creation of more equitable and just relations. The posthumanist aesthetic extends this ethic to animals.

When Smutts reflects on Elizabeth Costello's claim that 'there is no limit to the extent to which we can think ourselves into the being of another', she believes this desire to better understand others should have 'less to do with the poetic imagination and more to do with real-life encounters' with those (animal) others (Smutts 120). When Donna Haraway evaluates Smutts' achievement of a more equitable ('no one is first') relationship with baboons, she highlights the importance of 'respect' and the notion of 'becoming with' (see *When Species Meet* 24–25). What place can literature have here? Given that the nonhuman animal cannot read the poet's text of attempted understanding, and that no invitation is extended from the nonhuman animal to the reader, there is no possibility of mutual learning, mutual respect or the possibility of 'becoming with'. How then are we to understand the nature of poetic response to the animal? What might its useful place be in this desired relationship? Is it merely another form of animal capture? I think not. I think it is important to recognise that literature is an imaginative response to and reflection on 'the world'. It does not

function in grand isolation from that 'other world'. It is *in and of* the world.

When Donna Haraway speaks of writing 'from the belly' of animals (*When Species Meet* 4) this strikes me as similar to Keats's notion of the chameleon poet – this too is a kind of writing from the belly. But if I accept Wolfe's argument about the meaning of the 'post' in posthumanism – that this 'post' 'marks the space in which the one using those distinctions and forms is not the one who can reflect on their latencies and blind spots while at the same time deploying them', and that this can only be done 'by another observer, using a different set of distinctions – and that observer, within the general economy of autopoiesis and iterability, need not be human (indeed, from this vantage, never was "human")' (Wolfe 122) – this would sever the link I have made between a humanist and a posthumanist aesthetic, because literature cannot of itself be 'post' humanist. This does not however mean that literature cannot help to bring about a posthumanist world.

What can literature do? Literature can present an argument, weigh differences of opinion, play with ideas. Literature can represent desirable human–animal relations. Literature can draw upon the capacity for empathy in readers in order to produce both affect and effect. In all these ways, literature can help change our world. Most importantly, if we think about the attributes of the chameleon poet, those being an openness to the world – a receptivity, a humbleness of spirit – that is, a letting go of ego, and a sensitive *attentiveness* to others, it is this last attribute that I believe to be most valuable. The chameleon poet pays careful and 'proper' attention, gives all his or her attention, to the extent of self-forgetting, that he might 'inform' the body of the animal (or any other) and thereby come in some way to better know, and to better offer that respectful understanding (however limited) to others.

In paying 'proper' attention, that is, loving attention to others in the way I have described, a work of literature (as exampled by Coetzee's *Disgrace* and de Kretser's *The Lost Dog*) might create compassion within us for the lives of animals – that is, it might have an affective impact; but it also serves to imagine or document the stories that work toward 'reciprocally cognizant compassion grown into mutual respect' (Acampora 130), that give expression to an equality of companionate relationship between animals, and that call upon us to recognise all animals (human and nonhuman) as 'potential subjects of justice' (Nussbaum, *Frontiers of Justice* 355).

Notes

1. In August 2001 the Howard Government of Australia refused permission for the *Tampa*, a Norwegian freighter carrying some 400 'boat-people' – that is, refugees fleeing Afghanistan – to enter Australian waters. This act of inhumanity and breach of international law triggered a public outcry, but the Australian Government responded by introducing a 'Border Protection Bill' and the so-called 'Pacific Solution' that 'held' asylum seekers off shore on the island of Nauru while they awaited 'processing' – that is, consideration of their refugee status and application for entry to Australia.
2. Chapman writes of *Disgrace* as a novel that signals 'a local dead end, not only for its author, but also for those of us who must find sustenance in the actual, not only the representational, realities of difficult transitions' (111).

Works cited

Acampora, Ralph. *Corporal Compassion: Animal Ethics and Philosophy of Body.* Pittsburgh: University of Pittsburgh Press, 2006.

Attridge, Derek. *J. M. Coetzee and the Ethics of Reading: Literature in the Event.* Chicago and London: University of Chicago Press, 2004.

Chapman, Michael. 'The Case of Coetzee: South African Literary Criticism, 1990 to Today.' *Journal of Literary Studies* 26.2 (June 2010): 103–17.

Coetzee, J.M. *Diary of a Bad Year.* Melbourne: Text, 2007.

——. *Disgrace.* 1999. London: Vintage, 2000.

——. *Doubling the Point: Essays and Interviews.* Ed. David Attwell. Cambridge, MA and London: Harvard UP, 1992.

——. *Elizabeth Costello: Eight Lessons.* London: Vintage, 2003.

——. *The Lives of Animals.* Princeton, NJ: Princeton UP, 1999.

——. 'On Appetite, the Right to Life, and Rational Ethics'. *Death of the Animal: A Dialogue* by Paola Cavalieri. New York: Columbia UP, 2009. 119–21.

——. *Slow Man.* Sydney: Knopf/Random House, 2005.

Coleridge, Samuel Taylor. '*Biographia Literaria*'. *Samuel Taylor Coleridge.* Ed. E. J. Jackson. Oxford and New York: Oxford UP, 1985. 255–482.

——. 'The Rime of the Ancient Mariner'. *Samuel Taylor Coleridge.* Ed. E. J. Jackson. Oxford and New York: Oxford UP, 1985. 47–65.

Derrida, Jacques. *The Animal That Therefore I Am.* Ed. Marie-Louise Mallet. Trans. David Wills. New York: Fordham UP, 2008.

Haraway, Donna. *The Companion Species Manifesto: Dogs, People, and Significant Others.* Chicago: Prickly Paradigm Press, 2003.

——. *When Species Meet.* Minneapolis and London: University of Minnesota Press, 2008.

Keats, John. *Letters of John Keats.* London: Oxford University Press, 1960.

de Kretser, Michelle. *The Lost Dog.* Sydney: Allen & Unwin, 2007.

Ley, James. 'A Dog with a Broken Back: Animals as Rhetoric and Reality in the Fiction of J. M. Coetzee.' *Australian Literary Studies* 25.2 (June 2010): 60–71.

McHugh, Susan. *Animal Stories: Narrating Across Species Lines.* Minneapolis and London: University of Minnesota Press, 2011.

Nussbaum, Martha. 'Beyond "Compassion and Humanity": Justice for Nonhuman Animals'. *Animal Rights: Current Debates and New Directions*. Ed. Cass Sunstein and Martha Nussbaum. Oxford: Oxford UP, 2004. 299–320.

——. '"Finely Aware and Richly Responsible": Literature and the Moral Imagination'. *Love's Knowledge: Essays on Philosophy and Literature* by Martha Nussbaum. New York and Oxford: Oxford UP, 1990.

——. *Frontiers of Justice: Disability, Nationality, Species Membership*. Cambridge, MA: Harvard UP, 2006.

Phelps, Norman. 'Rhyme, Reason, and Animal Rights: Elizabeth Costello's Regressive View of Animal Consciousness and Its Implications for Animal Liberation.' *Journal for Critical Animal Studies* 6.1 (2008): 1–16.

Shelley, Percy Bysshe. 'A Defence of Poetry'. *Selected Poetry and Prose of Shelley*. Ed. Bruce Woodcock. Ware, Hertfordshire: Wordsworth Editions, 2002. 635–60.

Smutts, Barbara. 'Reflection'. *The Lives of Animals* by J. M. Coetzee. Ed. Amy Gutmann. Princeton: Princeton UP, 1999. 107–20.

Wolfe, Cary. *What Is Posthumanism?* Minneapolis: University of Minnesota Press, 2009.

Woodward, Wendy. *The Animal Gaze: Animal Subjectivities in Southern African Narratives*. Johannesburg: Wits UP, 2008.

9
What Lies Below: Cephalopods and Humans

Helen Tiffin

Two days after Australian Prime Minister Kevin Rudd was deposed by his deputy, Julia Gillard, an illustration featuring a large octopus appeared in the *Sydney Morning Herald*. The so-called 'bloodless coup' was sudden and unexpected by the public and by, apparently, Rudd himself. The article adjacent to the illustration was captioned 'Grisly Thud of a Kneecapped Rudd'. Walking across a deceptively regular (if not exactly calm) sea surface, the Prime Minister is depicted exiting to the right, while, below the waves and to his left, the shape of an octopus can be seen. Projecting above the water, and snaking towards the now former Prime Minister are two red tentacles extending from the octopus's body, red where it is seen above water. (Gillard has red hair and her backers were allegedly Australian Labor Party Faction members.)[1] The 'Octopus' thus represents Gillard and a political 'mafia' (the Mafia has frequently been zoomorphised as an octopus) whose cryptic power can threaten all social and political groups. Even without the 'knee-capped' in the adjacent column, readers of the *Herald* can be expected to understand the reference, because the *Cephalopoda*, particularly the octopus and giant squid, are much more familiar as metaphors and in representation than as living animals; the exceptions to this being the foods into which the smaller species of the group are captured and 'processed'. Our most familiar relations with Cephalopods (squid, octopus, cuttlefish, nautilus) – across a number of human cultures – are with their dead remains or with their shadows in the myths and legends we have concocted about them and the anthropomorphic or zoomorphic associations they have acquired over centuries, a number of which Tennyson's poem of 1830, 'The Kraken', famously encapsulates:

> Below the thunders of the upper deep;
> Far, far beneath in the abysmal sea,

His ancient, dreamless, uninvaded sleep
The Kraken sleepeth: faintest sunlights flee
About his shadowy sides; above him swell
Huge sponges of millennial growth and height;
And far away into the sickly light,
From many a wondrous grot and secret cell
Unnumbered and enormous polypi
Winnow with giant arms the slumbering green.
There hath he lain for ages and will lie
Battening upon huge seaworms in his sleep,
Until the latter fire shall heat the deep;
Then once by man and angels to be seen,
In roaring he shall rise and on the surface die.

(1201–2)

Differentiating squid and octopus from broader impressions of the horrors of the deep in reports and sketches by those who encountered 'sea monsters' in early historical times proves difficult, as Olaus Magnus's *Soe Orm* (1555) demonstrates (see Figure 9.1). The most famous late eighteenth-century Western image of an unequivocally giant octopus or squid is Pierre Dénys de Montfort's woodcut of the ensnaring of an entire sailing vessel in an octopus's tentacles (see Figure 9.2).

Such images of the octopus (or giant squid) capturing us remain potent, particularly in Western cultures, persisting into the present century in films such as *Pirates of the Caribbean* and its epigones. In these

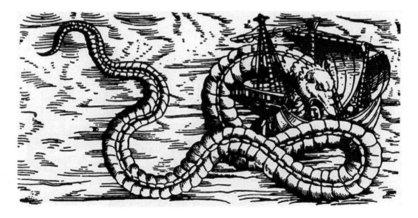

Figure 9.1 Olaus Magnum, *Soe Orm* (1555)

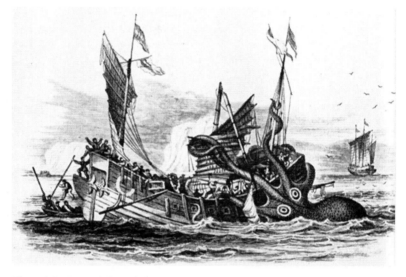

Figure 9.2 Pierre Dénys de Montfort, *Poulpe Colossal* (*c.* 1801)

popular cinematic images, writhing tentacles still threaten to capture and sink us, dragging us down to the depths of 'Davy Jones Locker'; but octopus and giant squid can also appear as part-human part-octopoid crosses, thus suggesting both a repelling distance from ourselves, and troublingly, some similarities. Through such images we attempt, paradoxically, to domesticate ancient fears while repeating and thus reinforcing them, exemplifying the very contradictory attitudes we hold and practices we pursue in relation to Cephalopods.

As Steve Baker, Nick Fiddes and others have noted, human attitudes and actions in relation to all animals are wildly contradictory and, as Charles Siebert adds, human societies everywhere, and in the West in particular (where defining what is 'human' has long been an obsession), 'demonstrate the same ongoing struggle to configure our own rightful place among animals' (88). Our minds, so Siebert argues, are 'still stranded like...beached whales, somewhere between the mythic and the matter-of-fact' (88). The underlying cause of this stranding is in large part the simultaneous recognition and denial of our own animality. The so-called 'species boundary' marks the obdurate, yet always unstable line we constantly draw (and redraw) between ourselves and other beings; and myth-making, like more 'matter-of-fact' forms of animal capture (including the accretions of scientific understanding),

facilitates an illusion of mastery over persisting insecurities and ambiguities in this regard. It is not surprising, therefore, that our relationships with animals including the Cephalopods are so often characterised by unadmitted or unrecognised paradox, irony and contradiction.

Octopus and giant squid are not the only feared creatures who – at least in the human imagination – lurk 'below', apparently just waiting their opportunity to capture and consume us; sharks too have been a perennial favourite. But from Biblical times to the present, octopus and squid have remained one of the characteristically major terrors of the deep in either their anatomically accurate form or as more enigmatic creatures having octopoid or squidoid parts. In the modern era such 'monsters' have surfaced in the fictional works of Arthur C. Clarke, in Ian Fleming's *Dr No*, Annie Proulx's *The Shipping News*, Michael Creighton's *Sphere* and Peter Benchley's *Beast*. Yet all owe debts in one way or another to two nineteenth-century classic fictions: Herman Melville's *Moby Dick* (1851) and Jules Verne's *Twenty Thousand Leagues under the Sea* (1869). In *Moby Dick* the giant squid appears as a white, ghost-like apparition:

> But one transparent blue morning, when a stillness almost preternatural spread over the sea, however unattended with any stagnant calm; when the slippered waves whispered together as they softly ran on; in this profound hush of the visible sphere a strange spectre was seen by Daggoo from the main-mast head.
>
> In the distance, a great white mass lazily rose, and rising higher and higher, and disentangling itself from the azure, at last gleamed before our prow like a snow-slide, new slid from the hills. Thus glistening for a moment, as slowly it subsided, and sank. Then once more arose, and silently gleamed...
>
> The four boats were soon on the water; Ahab's in advance, and all swiftly pulling towards their prey. Soon it went down, and while, with oars suspended, we were awaiting its reappearance, lo! in the same spot where it sank, once more it slowly rose. Almost forgetting for the moment all thoughts of Moby Dick, we now gazed at the most wondrous phenomenon which the secret seas have hitherto revealed to mankind. A vast pulpy mass, furlongs in length and breadth, of a glancing cream-color, lay floating on the water, innumerable long arms radiating from its centre, and curling and twisting like a nest of anacondas, as if blindly to catch at any hapless object within reach. No perceptible face or front did it have; no conceivable token of either sensation or instinct; but undulated there on the billows, an unearthly, formless, chance-like apparition of life. (Chpt 59)

This 'vast pulpy mass' is in many respects the obverse of Ahab's vision of the creature he seeks. Apparently without the malevolent intent attributed to Moby Dick this white 'phantom' gives 'no conceivable token of either sensation or instinct'; it is 'unearthly, formless', its slow rise and fall 'chance-like'; a glimpse of absolute otherness which at the same time captures an essential aspect of human life. Unlike Moby Dick this creature represents not the directed malignancy of the universe but an uncanny absence. Paradoxically the creature as Moby Dick's shadow potentially symbolises an absolute nothingness at the heart of the universe. The 'apparition' is a reminder that while Moby Dick may be, if not the face of a terrifying malignant universe but 'merely a dumb brute' (as the more prosaic Starbuck has it), the white squid seems to symbolise a formless universe where chance alone rules. Even malevolence can seem preferable to emptiness and as Starbuck cries 'almost rather had I seen Moby Dick and fought him, than to have seen thee thou white ghost'. Few whale ships, Starbuck tells Flask, ever behold 'the great live squid and [return] to their ports to tell of it'. And just as a single footprint – the sign of a long-feared, and as yet invisible but terrifying possibility – haunts Robinson Crusoe, so the spectre of the (also) legendary Kraken prefigures Ahab's ultimate encounter with his nemesis.

The crew of the *Pequod* are not the only whalers to be awed by the squid's size, cryptic mode of life, and spectral appearance. The saucerlike sucker marks often found on captured whales inspired wonder and fear in many seamen.[2] But it was and is Jules Verne's account of the attack of the 'poulpe' on the (ironically named) submarine *Nautilus* and its crew which became the model for later fictional (and allegedly realist) accounts of human–cephalopod encounter. Verne introduces the subject early in the novel by both reporting the presence (suddenly observed world-wide) of a mysterious denizen of the deep while simultaneously dismissing – in the face of modern biological knowledge – the older apparently mythic accounts:

> In every place of great resort the monster was the fashion...There appeared in the papers caricatures of every gigantic and imaginary creature, from the White Whale, the terrible 'Moby Dick' of hyperboreal regions, to the immense Kraken whose tentacles could entangle a ship of five hundred tons, and hurry it into the abyss of the ocean. The legends of ancient times were even resuscitated, and the opinions of Aristotle and Pliny revived, who admitted the existence of these monsters, as well as the Norwegian tales of Bishop Pontoppidan... (2)

By dismissing these traditional myths and then revealing that 'the monster' is actually Captain Nemo's submarine *Nautilus*, Verne prepares the ground for the subsequent encounter between Nemo's *Nautilus* and the giant 'poulpes' in Chapter 18; and what would come to provide – particularly through the illustrated version of the text – the classic modern image of the struggle between man and giant Cephalopod, is described by Verne in this way (see Figure 9.3).

> But hardly were the screws loosened, when the panel rose with great violence, evidently drawn by the suckers of the poulpe's arm. Immediately one of these arms slid like a serpent down the opening; and twenty others were above. With one blow of the axe Captain Nemo cut this formidable tentacle, that slid wriggling down the ladder... [Two] other arms, lashing the air, came down on the seaman placed before Captain Nemo, and lifted him up with irresistible power... (222)

Verne's account is of course imagined, but it has clearly influenced not only subsequent fictions but even the ways in which actual encounters with large Cephalopods are described and sometimes even perceived. Accounts of struggles between whales and giant squid also enhanced Cephalopod reputations as potential man capturers; and this seemed supported, especially in the late nineteenth century, by credible reports of astonishingly large bodies of giant squid being washed ashore or sighted at sea, Newfoundland being the locus of at least two of these.

However, non-fictional accounts of 'real-life' encounters between man and 'devilfish' often reveal the human as the aggressor, whatever the promise of giant octopus attack indicated in the title or apparently in the narrative. A *New York Times* report of 5, August 1934, for instance, headed 'Fierce Huge Devilfish Battle with Divers around Sunken Treasure Ship off Alaska', claims that 'the devilfish were the worst of the horrors' involved in diving on a wreck. 'These monsters', Charles Huckins wrote, 'hid in dark places and sent their slimy tentacles groping out wherever divers descended.' Huckins went on to describe his 'battle' with two octopus in the following way:

> Coming out of heavily silted into clear water, three feet away was a monstrous devilfish. I drove my spear into his body. He was about sixteen feet across. He scuttled away, tentacles waving.
>
> Later I was being lowered through murky water to the wreck, when I stepped on something soft and slimy... I came back with my spear and started hunting for him. I happened to glance upward, and there,

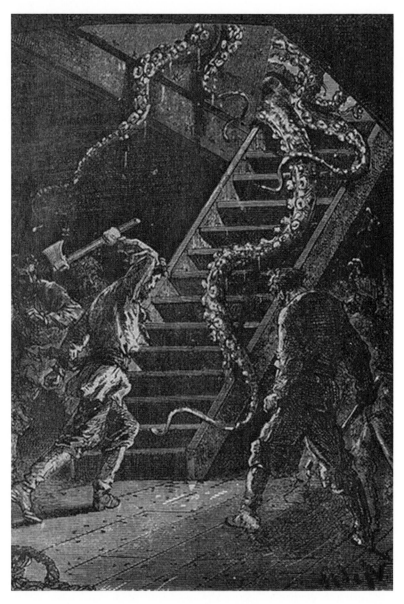

Figure 9.3 Alphonse de Neuville and Edouard Riou, illustration from Jules Verne's *Twenty Thousand Leagues Under the Sea* (1870 edition)

four feet above me, was an octopus at least twice as large as the one I had stepped on. I slashed at him. The spear glanced off the propeller blade but ripped a hole a foot long in him. Well, I stabbed him, and he finally went for deep water.

In the arena of the 'matter-of-fact' rather than the mythic there are virtually no authenticated accounts of unprovoked squid or octopus 'attacks' on humans or vessels. By contrast the cookery books of many cultures are replete with squid, octopus and cuttlefish recipes. Always a popular dish in Japan and the Mediterranean as well as in North American native cultures, squid and octopus have been increasingly consumed more widely, moving in American and northern European societies from 'exotic' to mainstream dishes. The 1912 report on the annual luncheon of the Zoological Society of France, a celebration renowned for its culinary novelties, stated that while 'gnu with cranberries, six and a half month old poached eggs and fruits preserved in mustard' were popular, stewed devilfish received a mixed reaction: 'The gourmets liked it but when someone thoughtlessly passed round a bottle containing a small octopus to show what it was like, the guests put down their knives and forks and requested the waitress to take away their plates.' No such squeamish reaction inhibited biological scientist Martin Wells (grandson of H. G. Wells) who proudly announced in the *New York Times* that he 'work[s] on octopuses and squid and things like that, when I'm not eating them' (Wells 1998, F5). Americans in general, however, were slower than their Asian and European counterparts to take to octopus and squid dishes. A Miami restaurant owner who agreed with oceanographer Professor Voss that 'Octopus tastes like heaven' acknowledged that aesthetic (and maybe even some mythic) inhibitions on the part of his patrons had yet to be overcome: 'I agree that the octopus is an ugly animal...But once people see it on the plate in a beautiful marinara, they don't know if they're eating octopus or scallops or something else' (Wells 1998, F5).

The need for some culinary disguise may perhaps proceed from a human aesthetic fastidiousness, but it is also possible, as Fiddes observes, that we are less likely to eat those carnivores (or piscivores) whom we believe (or know) have the potential to capture and eat us. The persistence of this phobia, however perplexing, may in part be explained by the paradox that underlies all eating and consumption. As Maggie Kilgow observes:

[E]ating, like all acts of incorporation, assumes an absolute distinction between inside and outside, eater and eaten, which however breaks

down as the line 'you are what you eat' obscures identity and makes it impossible to say for certain who's who. Paradoxically the roles are completely unreciprocal yet ultimately indistinguishable. (7)

If we are on the one hand repelled by the legendary monstrous otherness of Cephalopods, we are also, if we eat them, in a fleshly sense in part constituted by them. This is a biological truth conveniently obscured by our projecting our fears of 'otherness' become 'same' into myths of their potential engorgement of ourselves.

The fear of being ensnared and engulfed – when it is actually humans who capture and consume octopus and squid – is not the only paradox to characterise human–cephalopod relations. Both medical and biological sciences have had vested interests in the Cephalopods as experimental subjects. As one of the most intelligent of marine animals (after dolphins and above whales) the octopus brain and, in particular, eye-brain nervous co-ordination, is routinely targeted for vivisection. As Wells put it:

> practically every darn thing we know about how nerves work has been worked out from squid [and octopus] nerves. That's because squids have good big nerves you can put electrodes into. Unless you're prepared to cut up a few squids to get that material, there's no way we'd learn how nerves work. (F5)

Asked why he found squid and octopus so fascinating, Wells replied that:

> the whole group – squids, octopuses, cuttlefish – are interesting because they are animals, which, by and large, live on their wits. They react to the same sorts of things we react to. You can look at them and understand their behaviour. Another thing I like about squids is that they are predominantly visual animals. They see things coming and assess them. (F5)

It is because they are like us, particularly in eye structure, nervous system and some behaviour, that their vivisection (and it is vivisection at issue in this part of the interview) is particularly useful to us. But because they are not us, experiments on live octopus and squid (without anaesthetic) are still legal in most countries today. This is because Cephalopods fall on the 'other' side of the second imaginary line we have drawn to shore up human uniqueness, unquestioned superiority, and hence singular entitlement: that is the division between

Vertebrates and Invertebrates – animals with, or without, backbones. Enlightenment taxonomy was not only concerned with ordering the natural world and standardising the classification of Phyla and species generally. It was particularly interested, well before Darwin, in the vexed place of the human in relation to other animals, particularly the great apes. Skeletal features and craniometry were pivotal in this process since the European scientists were, in the case of the 'higher' animals, working largely from dead specimens and bony remains. Within this climate an obvious point of primary anatomical differentiation, separating 'higher' from 'lower', unsurprisingly became the possession (or lack thereof) of a vertebral column. By no means an irrational basis for classification, its implication of 'higher' (backbones like us) and 'lower' (no vertebral column) has however had persisting consequences, legal and otherwise, for Cephalopods. It has left an intelligent group of animals, who experience a variety of complex emotions, feel and anticipate pain, and are able to escape by manipulating mechanisms such as padlocks, without protection from 'live' experimentation; experiments routinely conducted not for our understanding of their species and its preservation, but for human benefit.

As with the paradox of capture and consumption, the interplay of difference and similarity (on the world's unequal playing field of unequivocal human domination) is tilted against octopus and squid. This applies to Cephalopods and the broader category of Invertebrates; and as the American Veterinary Association belatedly acknowledged, it exposes the same grim paradox in all anthropocentred animal experimentation: all animal research which is used to model human beings is based on the tacit assumption of anthropomorphism; and if we can in principle extrapolate from animals to humans, why not the reverse as well?

It is also the case however, that as more and more animal groups are threatened with extinction due to either over-exploitation or more broadly, habitat loss due to human overpopulation, there has been increasing scientific interest in the group for its own sake rather than for profit or alleviation of human ills. Studies of this nature have increasingly revealed our shared emotional complexities (although Cephalopods express these differently); sight dependence, tool use, general intelligence and adaptation to altered conditions.

Moreover, recent discoveries indicate that the octopus has, like us, two, not eight arms; six of its tentacles being used as 'legs' (rather than 'arms') facilitating its rapid locomotion across the sea floor. Octopus and squid also evince a synaesthesia well beyond human capacities. Put in poetic rather than scientific terms:

The headlamps of divers cast a greasy cloud of light just
Under the sea's dark skin.
Before you can blink, the octopus has played a symphony of
 russet stipples and black bands
Across its back. It thinks in colour.
Beware and welcome have twenty inflections
Like Delacroix saying mon cher monsieur...
For tomorrow's lunch they'll boil it down to an inky sauce, some
 Redon lithograph
Of spiders dancing in the afterlife.

 (McKendrick,18)

McKendrick's poem evokes the ways in which our attempts at capturing the octopus – including that of his own poem – reduce an intelligently colourful, complex creature to black and white (ink) or casual food (tomorrow's lunch), reductive and impoverished 'lithographs' of the colourful living creature we have sacrificed to our own benefit.

The interplay of similarity and difference, the paradoxes and ironies of human–cephalopod interactions also pervade two of our other relationships with octopus and squid: art and sex. In spite of the ugliness so often stressed by those who perceive Cephalopods as aggressors, or as unpalatable in their original form(s), octopus and squid have long been considered to have particularly decorative shapes. Some of the most beautiful Greek and Minoan vases, tiled Roman ruins, Japanese and Tinglit ornaments and cooking vessels as well as traditional masks have been inspired by their graceful beauty (see Figure 9.4).

Aside from Greek, Minoan and Roman art perhaps the most internationally famous art piece to employ an octopus is the nineteenth-century Japanese woodcut entitled 'The Dream of the Fisherman's Wife' (see Figure 9.5).

The Japanese are not alone however in depicting and/or describing human–cephalopod sex. A. C. Hilton's 1872 poem 'Octopus' is intentionally parodic as the name of its alleged author 'Algernon Charles Sin-Burn' indicates. In Hilton's poem, modelled after Swinburne's 'Dolores', the Victorian beloved becomes an octopus:

> STRANGE beauty, eight-limbed and eight-handed,
> Whence earnest to dazzle our eyes?
> With thy bosom bespangled and banded
> With the hues of the seas and the skies;
> Is thy home European or Asian,

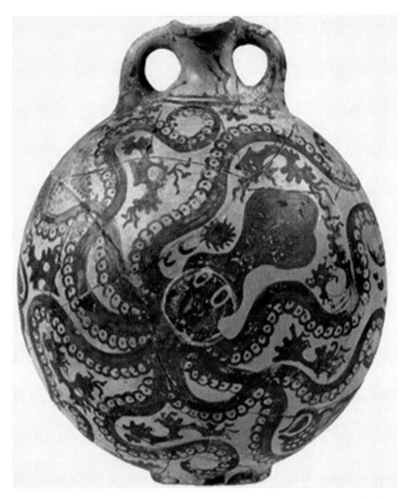

Figure 9.4 Flask decorated with a large octopus and supplementary motif of sea urchins, seaweed and rocks, Late Neopalatial period; Collection of Herakleion Archaelogical Museum

> O mystical monster marine?
> Part molluscous and partly crustacean,
> Betwixt and between...
>
> Ah! thy red lips, lascivious and luscious,
> With death in their amorous kiss!
> Cling round us, and clasp us, and crush us,

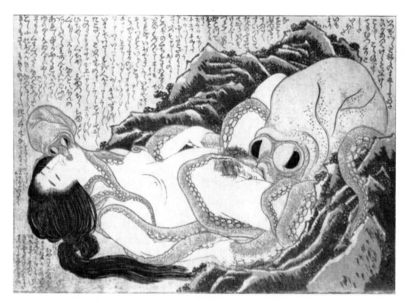

Figure 9.5 Katsushika Hokusai, *Awabi Woman and Octopus* (*c*. 1814)

> With bitings of agonized bliss;
> We are sick with the poison of pleasure,
> Dispense us the potion of pain;
> Ope thy mouth to its uttermost measure
> And bite us again!

Edward Field's even more sexually explicit piece, like Hilton's, demonstrates that not only fishermen's wives may dream of octopus entanglements. Field's octopus may be metaphoric, but its charms clearly speak to male as well as female admirers:

> I live with a giant pacific octopus:
> he settles himself down beside me on the couch in the evening.
> With two arms he holds a book
> that he reads with his single eye:
> he wears a pair of glasses over it for reading.
>
> Two more arms go walking over to the sideboard across the room
> where the crackers and cheese spread he loves are,
> and they send back endless canapés, like a conveyor belt.

While his mouth is drooling and chomping,
another arm comes over and gropes me lightly;
it is like a breeze on my balls, that sweet tentacle.

Other arms start slipping around my body under my clothes.
They wiggle right in, one around my waist,
and all over, and down the crack of my ass.

I am drawn into his midst where his hot mouth waits for kisses
and I kiss him and make him into a boy
as all Giant Pacific Octopuses are really
when you take them into your arms.

All their arms fluttering around you
become everywhere sensations of pleasure.
So, his sweet eye looks at me and his little mouth kisses me
and I swear he has the body of a greek god,
my Giant Pacific Octopus boychik.

So this was what was in store
when I first saw him in the aquarium
huddled miserably on the rock
ignoring the feast of live crabs
they put in his windowed swimming pool.

There are octopus pornography internet sites and an Australian man who attempted to access them was unlucky enough to stumble into a paedophile site en route to the octopus, thus being exposed to arrest and some subsequent ridicule.[3]

The preoccupation with the pleasurable (that is, for us, sexual) potential of Cephalopods may be seen as a little less bizarre if we consider a quasi-scientific description of human–octopus interaction by Natalie Angier in the *New York Times* (Science Times), 11 August 1998:

When you pet a cat the cat purrs. When you pet an octopus, the octopus pets you back...It loops a limb around your hand, and it explores you. And at first you jump, and then you laugh, and then you practically yodel with joy, for the sensation of an octopus fondle is unlike anything you have sensed before. Its flesh is slippery and silky like the inside of your cheek, or a spoonful of flan. And arrayed in pairs on the underside of its eight arms, are its extraordinary suckers, the animal's way of knowing the world. (F1)

Angier also stresses the grace and beauty of a creature so frequently described as ugly and dangerous: 'As he swims off, his limbs snake round him like the scarves of Chinese dancers, the membranes between them billowing into a translucent orange parachute. Baryshnikov, eat your leotards.' And of course she stresses the octopus's intelligence, not just as escape artist, or food finder or trickster: 'How smart is smart? Smart enough to want to have fun.'

British poet Ted Hughes also 'has fun' with his 'Octopus':

> 'I am your bride,'
> The Octopus cried.
> 'O jump from your vessel!
> O dive with your muscle
> Through Ocean's rough bustle!
>
> Though I look like a tassel
> Of hideous gristle,
> A tussle of hassle,
> I'm a bundle of charms.
>
> O come, let us wrestle
> With noses a-jostle!
> You'll swoon in my arms
> With a sigh like a whistle...'
>
> And she waved her arms, waiting,
> Her colours pulsating
> Like strobe lights rotating,
> Her huge eyes dilating ...

Hughes' poem wittily combines the images of the octopus as aesthetically offensive (ugly) with its potential erotic charm, a rare example of the combination, in a single verse of two of its traditional and contemporary representational aspects.

There is little belief today in the capacity of giant squid or octopus to either engulf a ship or ensnare a human and drag him into the region below – the fate of Verne's crewman in *Twenty-Thousand Leagues Under the Sea*. And while eye-brain experiments are still routinely conducted on Cephalopods for purely human benefit, there is also interest in the species for its own sake as the public dissection of a giant squid in Melbourne, Australia, in 2008 attested (Melbourne Museum June 2008). (Indeed the spectacle bore an uncanny resemblance to Rembrandt's famous painting, *The Anatomy Lesson of Dr Nicolaes Tulp*

(1632) of one of the first public scientific dissections of a human.) And for as long as they survive our predations on them, octopus and squid continue to be eaten world-wide.[4] More minor human–octopus interactions have recently emerged in the 'sporting' field in North America: Octopus 'wrestling' off the Californian coast and a peculiar ritual involving the throwing of live, dead and stuffed toy octopus onto the ice before hockey matches in Canada and the United States, supposedly for 'good luck'. Representations of octopus in the form of large pink spotted balloon-shaped creatures symbolically 'protect' bathers on some of Japan's beaches, while simultaneously (and paradoxically) supplying a very popular source of Japanese cuisine.

Relationships between human representation and 'the real' animal have always been complex. Certainly it can be demonstrated that representation of (all large) sharks as relentlessly savage has had an enormous impact on their decline in numbers. The case of the grey nurse shark (*Carcharias taurus*) is instructive here. Grey nurse have never caused harm to humans, but included in the category 'Shark' they have been pushed to the limits of extinction. Conversely, representations of most furry creatures as cuddly and benign have, for instance, provoked tourists in the Rocky Mountains to approach grizzly bears. In some cases however there is a perpetual disjunct between human representations of the species and treatment of the animals themselves; while, as is the case of those animals represented as our closest relatives (the Primates), even a tendency to want to protect all too often loses out to anthropocentrism and general human appetite and greed.

Just as the octopus was (and is) poised between the 'matter-of-fact' and the 'mythic' in our cultures and apprehended as ugly or beautiful and charming, it can be represented as both protective and/or dangerous. And while most human societies harbour, as Baker points out, major contradictions in their attitudes to animals generally, the octopus and (giant) squid have generated more than most. Such contradictions between 'theory' and practice are not so much mirrored as paralleled by the varying uses to which the image of the octopus has been requisitioned. While some of these are positive or benign, by far the majority have been negative or malignant: the enemy in war (see Figure 9.6); anti-semitic and anti-Chinese sentiment; or the 'Mafia' image noted at the beginning of this essay (see Figure 9.7).

Published in 2010, China Miéville's intriguing novel *Kraken* combines the mythic-fantastic with a very contemporary 'matter-of-factness', faith and scientific understanding, to consider our persisting human

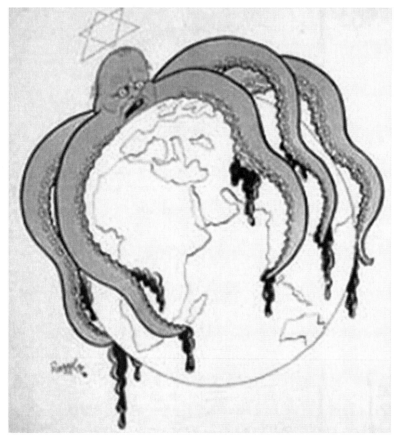

Figure 9.6 A Nazi German cartoon circa 1938 depicting Churchill as a Jewish octopus encircling the globe

need for and belief in Cephalopod monsters of the deep, together with the significance of the relationship – for humans – between writing (long associated with squid ink) and the nature of (human) being.

Escorting a party of visitors through the London Natural History Museum, Billy Harrow, preserver and curator of an 8.62 metre giant squid caught off the Falkland Islands, mentally replays his usual spiel about the squid's eyes – now empty sockets:

> 'Yeah, like plates, like dinner plates.' He said it every time... '[I]t's very
> hard to keep the eyes fresh, so they're gone. We injected it with the
> same stuff that's in the tank, to stop it rotting from the inside.'

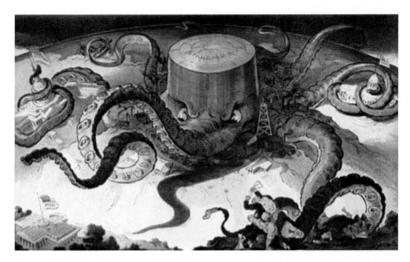

Figure 9.7 Udo J. Keppler (1904), this cartoon depicts John D. Rockefeller's Standard Oil Company as an octopus wrapping its tentacles around industry and government

'It was alive when it was caught.'

That would mean gasps all over again – Visions of an army of coils, twenty thousand leagues, an axe-fight against a blasphemy from the deep below. A predatory meat cylinder, rope limbs unrolling, finding a ship's rail with ghastly prehensibility.

It had been nothing like that. A giant squid at the surface was a weak, disoriented, moribund thing. Horrified by air, crushed by its own self it had probably just wheezed through its siphon and palsied, a gel mass of dying. (8–9)

The giant squid is kept in 'the Darwin Room' which also contains Darwin's own specimens, the preserved catalysts of the evolutionary theory which changed the (Western) world view. But the visitors are much less interested in these than in the *Architeuthis dux* (giant squid). Billy Harrow recognises the importance of these less charismatic Darwinian specimens, but most visitors make straight for the squid. 'Enter that room and you breached a Schwarz child radius of something not canny, and that Cephalopod corpse was singularity' (9). Expressed in terms of a physics of generative 'black holes', *Architeuthis dux* as 'singularity' is that which forms the unknowable centre; that around which mass and energy spin and by which it is ultimately swallowed. On 'entering'

a singularity, time and space disappear; all the 'rules' of physics as we understand them are suspended. The singularity represents the ultimate unknown – where our laws of physics fail, just as at the 'event horizon', the (metaphoric) edge of a black hole, event – that is, narrative itself (not just the stuff of fiction, but the indispensable medium of scientific thought) – also fails.

But to Billy's horror, on this day the giant squid (and its glass case container) have been stolen; and this leads the scientist into a vast London underground of religious sects (including the Church of God Kraken), fantasy creatures, mercenaries, and horrific torture where the 'normal' rules of life, death, suffering, even embodiment itself are grotesquely distorted or negated. Billy's quest (in company with the former museum guard, Dane) to find the captured Kraken is also one to save the world from an Armageddon which will somehow be energised by one of the plethora of underworld beings and gangs employing the agency of the preserved squid. Entering the library of the members of the Church of the God Kraken, Billy finds, amongst all kinds of common and esoteric religious texts, Melville's *Moby Dick*, Verne's *Twenty Thousand Leagues under the Sea*, and Tennyson's poems, open at 'The Kraken' page and facing a competing poem by Hugh Cook. Billy reads the answer to Tennyson's version of a Kraken rising, told from the point of view not of humans but of the suffering animal itself:

> The little silver fish
> Scatter like shrapnel
> As I plunge upward
> From the black underworld
>
> ...
>
> By mid-morning,
> My skin has sweated into agony.
> The turmoil of my intestines
> Bloats out against my skin.
> I'm too sick to struggle – I hang
> In the thermals of pain
> Screaming against the slow, slow, slow
> Rise toward descent.
>
> And the madness of my pain
> Seems to have infected everything –
> Cities hack each other into blood;

> Ships sink in firestorm; armies
> Flail with sticks and crutches...
>
> (105–6)

As the police, all the bizarre and cryptic underground gangs, individual necromancers and religious groups understand, the theft of *Architeuthis dux* from the Museum presages London's (and the world's) doom. The stolen Kraken, however weakened in its powers, still has some of the potency of 'singularity'. In this quest to save the earth from Armageddon, Billy, the modern knight-scientist and his assistant discover a great deal. Neither the Krakenists nor the evil Tatoo and his lieutenants, Goss and Subey, are in fact responsible, though they, like the other evil forces, also work desperately to locate the dead animal. When the Kraken is finally found, in the hands of the apparently dead – but now revived – cryptic gang leader, Grisamentum, its particular significance is also revealed. What power remains to this specimen resides in its ink; and the capacity to use it to its fullest degree is Grisamentum's because, as he expresses it in text-message form (though *written* in the squid ink with which he has merged his being), 'No No BE ITS MAGC ONLY I CAN. NO I ELS IN LONDON CN BE' (401).

> 'Jesus,' Billy said. 'This has always been about *writing* ...'
> With script... [t]raditions could be created, lies made more tenacious. History written down, sped up, travelled at the speed of ink. And all the tedious antique centuries, before we were ready, the pigment was stored for us in the Cephalopod containers – mobile ink, ink we caught and ate and let run down and stain our chins.
> ... We didn't invent ink: ink was waiting for us aeons before writing. In the sacs of the deepwater god. (402)

Dane, still wondering what Grisamentum might do with the Kraken ink, is corrected by Billy:

> What can you *be* with it?...
> The very writing on the wall. The log book, the instructions by which the world worked. Commandments. (403)

But this attempt at being the first, future and final word – The Word – in the hands of an evil agent, is thwarted by the protagonists and their friends, and by the attenuated powers of the Darwin Room specimen,

which, after all, is a dead and preserved *Architeuthis dux*; weak, watered (formaldehyded) down.

As the primary imaginary line – the species boundary – between animals and ourselves becomes difficult to sustain philosophically (though not, unfortunately, in practice) older measures of differentiation such as anatomy, tool usage, and language have come to seem increasingly less important and anthro-circular. Working from the persisting denial of our own animality, of our practices of animal abuse generally, we continue to need to maintain the line; and the possession of intelligence and to a lesser degree emotion, have increasingly become the *de facto* measures of difference and the alibi of extra-human species' dismissal and abuse. While many question this absolute of 'intelligence', its measurement, constitution and significance – especially in the face of human overpopulation of the planet where our apparent intelligence seems to be leading to our own ecological, spiritual and potentially literal impoverishment – the significance of what we categorise as intelligence may be increasingly called into doubt. Nevertheless while it remains a significant marker for the species boundary and has first order repercussions for the so-called 'lower' animals (those without backbones) it is worth finally considering the evidence for octopus intelligence (and emotion) albeit defined from anthropocentric perspectives.

Octopus synaesthesia – thinking in colour – indicates that our own separation of emotion and intelligence – as human brain research is also telling us – may indeed be a manufactured one, and one which both before and after Descartes, has often operated to our own disadvantage and that of other animals. Anatomically, we now know from observation in the wild, that the octopus has, like us, two 'arms' (not eight) and six legs. We also know that octopus react to trauma as we do, including responding with behaviours such as self harm. (An octopus in the Berlin zoo, 'lone captive' in the aquarium, ate itself to death by nibbling at its tentacles at the rate of half an inch per day.) Octopus can pick locks and conduct cryptic lab raids on preferred prey as a number of accounts indicate, 'sneaking' back into their own tanks after consuming other lab specimens. And humans are having to become smarter at catching (their) octopus prey, using the octopus's capacity for intelligence 'against itself' as it uses its intelligence to attempt to capture our baits without being captured itself. Wily and cryptic, the octopus, one hopes, may yet outwit us, while giant squid can continue to persist at depths outside our everyday reach. Meanwhile *representations* of octopus and squid will no doubt continue to emphasise, like the Kevin Rudd

illustration, their actual or potential capture of us, while in both representation and reality, we continue our unashamedly anthropocentric captures of them.

Anthropomorphism may come to work in favour of animal conservation as we increasingly recognise and acknowledge similarities between other animals and ourselves; and the practices of anthropomorphism seem less like 'captures' of animal otherness – as science would have us believe – than a recognition of the close relation of animals to ourselves which might one day confer on them an equal entitlement to their share of the planet. On the other hand, *anthropocentrism* – seeing ourselves as the species with exclusive (or even primary) entitlement to the earth's habitats and resources, will have the opposite consequences. We will one day be standing, shoulder to shoulder on the remaining terrain, surrounded by a catastrophically impoverished ocean, the marine giants of legend and reality finally reduced to 'some Redon lithograph of spiders dancing in the afterlife'.

Notes

1. The Labor Party in Australia is associated with the colour red.
2. Originally thought by some to actually attack whales, giant squid are now regarded as more likely prey for the *cetacians*.
3. *Hobart Mercury*, 18 July 2008, p. 11.
4. The nautiloids, though somewhat depredated in the nineteenth and twentieth centuries by shell collectors, remain, as a floating deeper-sea species, more protected at present from human capture.

Works cited

Baker, Steve. *The Postmodern Animal*. London: Reaktion, 2000.

Fiddes, Nick. *Meat: A Natural Symbol*. London: Routledge, 1991.

Field, Edward. 'Giant Pacific Octopus'. *Counting Myself Lucky: Selected Poems 1963–1992*, by Edward Field. Black Sparrow Press, 1992. 35–36.

Hughes, Ted. 'Octopus'. *Collected Animal Poems*. By Ted Hughes. London: Faber and Faber, 1995.

Hyder, Clyde K., ed. *Swinburne: the Critical Heritage*. London: Routledge and Kegan Paul, 1970.

Kilgow, Maggie. *From Communion to Cannibalism: Anatomy of Metaphors of Incorporation*. Princeton, NJ: Princeton UP, 1990.

McKendrick, Jamie. 'Skin Deep'. *The Kiosk on the Brink*. Oxford: Oxford UP, 1993.

Melbourne Museum (2008). 18 February 2013. http://museumvictoria. com.au/pages/6981/giant%20squid%20dissection%20media%20release. pdf?epslanguage=en.

Melville, Herman. *Moby Dick*. 1851. New York: Longman, 2009.

Miéville, China. *Kraken*. London: Pan Macmillan, 2010.

Siebert, Charles. *Roger's World: Toward a New Understanding of Animals*. Carlton North, Vic.: Scribe, 2009.

Tennyson, Alfred Lord. 'The Kraken'. 1830. *The Norton Anthology of English Literature*. Vol. 2. Ed. M. H. Abrams. New York: Norton, 2000.

Verne, Jules. *Twenty Thousand Leagues under the Sea*. 1869. Harmondsworth: Penguin, 1992.

Wells, Martin. 'He Studied Squid and Octopus, Then He Ate Them'. Claudia Dreyfus Interviews Martin Wells. *New York Times* 8 December 1998.

10
Caught: Sentimental, Decorative Kangaroo Identities in Popular Culture

Peta Tait

The Château near the town of Chantilly in France is open to the paying public and among the attractions are: a rare book library, an important art collection, and nine small grey kangaroos.[1] I was surprised to discover this zoo since there were no other living exotic animals exhibited; the kangaroos, however, did not seem surprised when I approached. The location meant that these captive kangaroos were an unexpected and pleasing encounter for me. Further, the liveness of the kangaroos contrasted with the deadness of the taxidermied animals inside the Château. Amongst the numerous paintings and sculptures of individual hunting dogs, there are two flat lion skins with heads hanging vertically on the wall either side of a large door in an expansive dining hall. In the social hierarchy of wild animals, the hunting of 'innocuous' kangaroos never acquired the status of safari hunting for 'ferocious' lions. Consequently the caught kangaroo acquired greater value as a live exhibit than as a decorative wall trophy.

This chapter contends that the kangaroo is a captive of beliefs and human embodied and emotional responses. It suggests that the kangaroo is the captive of sentimental emotional identities created through exhibition, performance and image depiction that originated in businesses begun around the turn of the nineteenth century. The discussion additionally draws on Merleau-Ponty's ideas and experiential approach to consider how a human–animal encounter with an element of surprise can impact on phenomenological perception. It proposes that while contact with live and representational animals in a familiar setting reinforces habituated patterns, less predictable sensory body-to-body contact has the potential to interrupt these patterns and to expose underlying beliefs. An unexpected encounter might catch

human attention through bodily responses that also expose emotional ones. The chapter outlines how a body-based approach might contribute to the analysis of the economic utility and contradictory status of the kangaroo. The kangaroo body has been literally and metaphorically captured within a chain of human economic activity since kangaroos began to be exported and exhibited, and decorative imagery underpins the ongoing exploitation of the kangaroo within socio-economic transactions. It is argued here that the entertainment enterprises that culminated in the widely viewed television series *Skippy, the Bush Kangaroo* obviate species attributes by staging the captured kangaroo in pleasing emotional scenarios. The series might be said to have caught the kangaroo on film and simulated face-to-face encounters, except that Skippy's identity is a cultural fiction. The legacy of identities captured in entertainment continues to influence human–kangaroo encounters.

The status of the kangaroo evokes a perplexing question within animal studies: how can free-living species be viewed with affection and endearment in cultural representation while becoming increasingly exploited and imperilled? The larger framework for the consideration of animals encompasses how they embodied and embody contradictory emotions in socio-economic transactions: for example, the kangaroo as gentle mother or aggressive fighter, as rural pest or cute curiosity. It can be argued that human-centred emotions generate contradictory perceptions, which undermine the status of free-living animals because emotions and emotional feelings are experienced as paradoxical conditions (Tait, *Performances*). Accordingly, emotional sentimentality might potentially blind humans to the destructive force of our species control.

Boxed-in bodies

The kangaroo became an unmistakable emblem of Australian identity (Souter) but as an abstracted entity, since the physiology, habits and habitat of the living animals have only recently begun to be fully studied in ongoing research (see Jackson and Vernes).[2] The kangaroo in popular culture predominated. This type of mismatch is summarised succinctly by Nigel Rothfels; 'there is an inescapable difference between what an animal *is* and what people *think* an animal is' (5, italics in original). Moreover the cultural resonances of anthropomorphised animals and how 'we think with animals' vary according to the context (Daston and Mitman). The ways in which humans think about animals are facilitated through cultural communication and cognitive and artistic ideas

shaped by language over time (Adcock and Simms 34–6), and this additionally depends on which species and under what circumstances.

While the history of practices in relation to kangaroos is indicative of human speciesism towards all animals (Singer), these practices also reflect hierarchies of value in the utility of animal species. In her fascinating history of attitudes to animals in nineteenth-century England, Harriet Ritvo points out that the colonial Acclimatization Society of Victoria, Australia, founded in 1861 openly complained about the 'paucity of serviceable animals in this Colony' because '*not one single creature*' was suitable for farming and they needed to import 'useful creatures' (*Animal Estate* 240–1, italics in original). The supposedly useless kangaroo did become variously a victim of imported farming processes as well as providing a supplementary food source for the local humans, and in 1861 was compared to a deer or a hare and called 'timid' (Wheelwright 7). The utility of animals in this way meant, as Ritvo explains, that curiosity about bodily presence was reinforced by imaginative mythmaking that matched human interests, and through 'figuration in a variety of discourses – from elite cultural productions to the technical literature of agricultural and natural history to mass-market journalism' (*Noble Cows* 132–3). In rural Australia, kangaroos continued to be inaccurately viewed as wide-roaming grazers competing with imported livestock for the same feed grasses. Kangaroo species are not protected unless severely endangered, and although kangaroos are not farmed like emus, they are hunted – or 'harvested', as it is called – as a source of human cheap meat and for pet food and more recently, also exported for human consumption.[3] Kangaroos are hunted at a level that would have been unthinkable to pre-white settler culture because Indigenous cultures in Australia have long considered the kangaroo central to both human survival and to belief systems (Dickman 148–9). Stephen Jackson and Karl Vernes outline how a legacy of contradictory attitudes is compounded within twenty-first-century values that continue to make the kangaroo a 'commodity', a 'problem', and justified by arguments that they should be farmed or even managed for environmental benefit (152–90). The kangaroo was and is treated like an unlimited natural resource.

The national imperative that positions kangaroos as an exploitable resource can be contrasted with the fantasy of international proportions about a unique and friendly wild animal (Simons). Two kangaroos were officially sent by Governor Phillip in 1792 to the King of England and the Royal Gardens in Richmond, and soon there was a baby kangaroo (Younger 56–7). An unofficial kangaroo envoy was also exhibited to the public for an expensive one shilling entry fee in Covent Garden.

During Napoleon's reign in France, kangaroos were taken to the estate of Empress Josephine.[4] As kangaroos proved able to breed in captivity – unlike elephants and other large mammals – exhibitions multiplied and kangaroos became more familiar in nineteenth-century menageries. The kangaroo was a popular public zoo exhibit, one geographically representative of the remote colonies in Australia, so kangaroos became dispersed through commercial enterprises in England and Europe. In order to maintain their appeal to the paying public, selective qualities were attributed to them and there was much praise in nineteenth-century England for the kangaroo with a joey in the pouch as an ideal of motherhood (Tait, 'Circus Oz'). This was reversed in the 1890s when the kangaroo was turned into that icon of masculinity, a boxer, and put into a circus act (see discussion below). By the 1980s, however, the international iconic kangaroo was Skippy, a cute family pet and animal friend capable of heroic action on behalf of humans.

The business enterprises that developed through the trading and exhibiting of kangaroos historically also promoted emotional qualities that created a legacy of multiple but irreconcilable identities with lasting ramifications. In commercial transactions today, for example, customers purchasing airline tickets are invited to identify warmheartedly with a cheeky kangaroo body shape in the guise of a corporate logo. Yet they are expected to ignore this type of response elsewhere when served kangaroo meat to eat. Perhaps unsurprisingly, then, the dominant utility of the kangaroo seems to be as a decorative symbol.

Attempts to utilise kangaroos for purposes other than hunting or exhibition in nineteenth-century Australia were largely ineffective, although these included 'Mr M'Intyre of Camperdown' coaxing kangaroos, emus and dingoes to pull a cart.[5] In the expansion from exhibiting in zoos or parks, however, the boxing kangaroo act proved viable. It was first presented in 1891 in Melbourne at Kreitmayer's Waxworks with Jack, the kangaroo, under the ownership of Mrs Oliva Mayne, and the act performed there for seven weeks. The human presenter was Richard von Lindeman, although his standing in relation to the training is unclear.[6] In a description of the act, Lindeman bends submissively like a kangaroo and delivers some blows to Jack's head, which Jack initially tries to avoid before attempting to strike back with his paws, then apparently stroking Lindeman (Williams and Golder 120). Mrs Mayne leased Jack to the promoters James and Charles McMahon but she took them to court for breach of contract, and ultimately lost on appeal because, as a married woman, she could not make a contract in her own right (Golder and Kirkby). The gimmick of the boxing act

multiplied during the 1890s in England and the USA, and was a circus act in England up until the 1970s and in the USA until the 1980s (Tait, 'Circus Oz'; Cushing and Markwell).

Jack's strong hind limbs allowed him to look as though he was standing up and, with boxing gloves on his short forepaws, he appeared to simulate the role of a boxer. The notion of the kangaroo that can fight back as an equal was fostered and subsequently circulated widely in culture. In a 1955 *National Geographic* article, the kangaroo 'Fights Like a Man, Bounces Like a Steel Spring', and in a caption to a photograph he supposedly uses boxing techniques, 'Boxers Aim for the Solar Plexus' (Johnson 487, 497). In circularity, scientific study appropriates the language, describing a 'mutual rapid pawing, alternating with both hands, of the opponent, leading to the wrestling stage, and finally to boxing and kicking with forearms locked' (Ganslosser 486). Body-based boxing performances became instrumental in the language surrounding the kangaroo and in creating the impression of an animal capable of fighting off humans. Kangaroo identity was effectively 'boxed in' by language and belief.

The boxing act was a unique human–animal act in the circus because of how the human and animal bodies were positioned as if in a face-to-face encounter. In outlining the way in which an animal can be said to make performance, Una Chaudhuri writes that analysing 'The role of animal – its face, body, being, meaning – in the constitution and defacing of performance genres is a vast project' (17). She explains that animal studies and animal rights repeatedly invoke a face-to-face encounter to break through the human misrecognition of other animals with an expectation that this will bring about a desired change in the animal–human hierarchy. Accordingly the question becomes, 'How to perform the animal *out of* facelessness' (Chaudhuri 16, italics in original). The kangaroo was presented as if undertaking human behaviour, as a substitute for a human. The kangaroo in a boxing act appeared to redress the absence of face-to-face encounters with animals. But this was a staged performance. The kangaroo body was manoeuvred into a front to front body position; the act mocked a face-to-face encounter between individuals.

The kangaroo integrated into a sequence of constructed actions for spectators might be termed a performer in contrast to exhibited animals in menageries, zoos and parks. While the ways in which exhibited animals and animal performers perceive spectators might depend on the circumstances, there are descriptions by circus trainers that suggest individual animal performers such as monkeys or lions respond to the

presence of a human audience in variable ways, some even prolonging or changing their performance (Tait, *Performances*). While acknowledging that humans prioritise seeing over other senses, it is an interesting proposition that sensory body engagement during performance or exhibition might be reciprocated – two of the Chantilly kangaroos paused to look out as I arrived.

Boxing is human fighting behaviour (Boddy), although the kangaroo act was utilising animal body movement. But was it relying on kangaroo fighting or playing behaviour? In a commentary that insightfully and helpfully compiles scientific and cultural studies about the kangaroo species, Jackson and Vernes detail some of the current understandings of the varied subspecies processes of wallaby and kangaroo body to kangaroo body engagement in a range of circumstances (104–19). Nonetheless their chapter on male fighting behaviour is still called 'Boxing Kangaroo'. The conditions under which male kangaroos engage in short bouts of fighting to determine their status within the group do seem to have common protocols as if there are social rules. Duncan Watson, however, outlines how there is insufficient study of the function of play across all the species within the genus. He suggests that playful fighting is distinct from aggressive fighting and appears early with a mother teaching her young, but he notes that small enclosures inhibit play (66). What might be either aggressive or playful fighting varies from 'slow-motion pawing to very vigorous sparring' with the intention of getting the opponent to the ground or grooming its throat, and can last as long as 12 minutes (Watson 68). This was the duration of a circus act. There is evidence of sex differences and self-restraint as features of playful fighting that can involve chasing another to engage in 'locomotor play', and kangaroos are observed in object play with sticks and food and manipulation of novel objects as well as exchanges with birds and cattle (Watson 72, 75–6). The possibility that a kangaroo performer was engaged in harmless play is apparent, although the now familiar motif of a boxer kangaroo reinforces a trope of aggressive or defensive fighting. Such a performance identity fosters a false impression of another species' emotional capacity to withstand confrontation with humans.

Animal-like movement framed within a narrative of human boxing confused species identity and emotional temperament. Jane Desmond, however, argues that the meaning of a live performance by animals comes not from the action or face-to-face encounters but from perceptions of difference in bodily appearance, from non-humanness framed in familiar action. She argues that 'the evidence of the body determines

the species division' and this is resilient even to crossings by 'cute' animals through the 'amplification' of 'choreographed behaviours' (Desmond 175). Animal physicality delivers species difference even as human-like action contains a pretence of inclusion within the human domain. The appeal of the boxing kangaroo lay in the incongruity of the body undertaking a familiar human action. Strangeness was bodily staged in the live boxing act. The emotional reaction of surprise, however, can coincide with an idea of strangeness but in this instance to the animal's detriment.

Perceiving bodies

How is the kangaroo body perceived? While speculative, the question opens out the idea of a human-to-animal encounter. In the twenty-first century, perhaps a more relevant subsidiary question might be: what circumstances facilitate seeing the living kangaroo (animal)? Can a sensory body-to-sensory body encounter counteract animal facelessness and human complacency?

For an Australian, any encounter with a kangaroo in a park enclosure echoes back across the contradictory values that surround free-living animals. The Chantilly kangaroos, however, presented a variation on the main distinction between a predictable meeting with so-named 'tame' kangaroos held captive in zoos or wildlife parks, and a less predictable meeting with free-living animals in a rural area. I had not expected to find kangaroos living at Chantilly. I saw one kangaroo and, questioning what I was seeing, stared intensely. I disbelieved what I saw so I was immediately aware of looking in a physically attuned way. The body shape was recognisable at some distance and I could distinguish other kangaroos close by. Of course the kangaroos were accustomed to visitors, and two paused momentarily and disinterestedly to look up at yet another human visitor on the other side of the wire fence; the group of about nine continued with their activities, eating, grooming and socialising.

I remember that I stopped, looked and then moved much closer to a wire fence. I was aware of looking in a focused way prior to other reactions, including emotional responses. Surprise made the process of sensory engagement apparent. An initial delight comparable to that of finding a familiar friend in a foreign place turned into unease as I took in a treeless, grassed enclosure with limited space. (When I asked later, I was told that it was a temporary enclosure while the permanent one was being renovated.) On reflection, however, whether I was concerned for their well-being or not, this was not like meeting with friends; there was

no face-to-face encounter, for a start. I perceived the Chantilly kangaroos possessively, and as generic animals belonging geographically and nationally in ways in which these individuals clearly do not, since they live on a French estate. The encounter exposed unquestioned cognitive and emotional preconceptions about kangaroos and how these, too, hold animals captive. Kangaroos are also caught by emotional beliefs.

The strangeness of kangaroos living at a French château mattered because it provoked awareness in what was – given the distance between us – a body-to-body encounter. Although these animals were living in an enclosure, the circumstances correspond with issues of spectator perception and the implicit values in performance. I have an ongoing theoretical interest in body phenomenology within performance reception and most recently in the implications of human spectator to animal performer encounters, and as holding meaning for social worlds (Tait, *Performances*). I mention this because I contend that commercial transactions with animals rely on habitual physical patterns as they invariably induce and reinforce human feeling responses. Humans are multifariously socially conditioned to see other animal species in selective ways and therefore to feel selectively. A body-based approach to analysis emphasises how animals are perceived through the human senses and vice versa. It proposes that animals perceive each other sensorily, bodily, and viscerally. Ralph Acampora investigates Heidegger's idea of being and Nietzsche's praise for noble wildness and rejection of how Christianity sought to tame human animality (66–9), to track the sensory being in phenomenology. Drawing on Merleau-Ponty, Acampora proposes several leads as to how to interpret ideas of a 'cross-species exchange of somatic sensibilities related to material bodies' (18). An encounter produces visceral responses such as a bodily alertness, even cautious wariness, and, importantly, from seeing, smelling and/or hearing. Perhaps for other animals, the encounter is more about sound and smell than sight. But it also points to a sensory perception of the strangeness of the other's animal body. Yet unexpected live encounters can be potentially positive because these are immediate and direct – although the hierarchy of human over other animal species may make this a negative one for the animals. Moreover sensory perception produces rapid responses that might initially short-circuit cognitive ideas. An appreciation of sensory processes contains the possibility of unravelling bodily exchanges between very different species bodies as well as exposing underlying cognitive beliefs.

An awareness of sensory responses may help to lift an individual animal out of an invisibility whereby all individuals represent their species and embody human-derived symbolic value. The Chantilly example

here suggests that the unfamiliar circumstances had contributed to the impact and this might be applicable to encounters with free-living animals. An unexpected encounter provides an opportunity for a human to become self-aware of sensory and feeling reactions and potentially even aware of bodily processes of perception. In an embodied space of heightened sensory awareness, it is possible to see the nonhuman animal as an individual animal – at least momentarily.

A larger issue in human–animal relations is the human inability to perceive how the human sensory body engages with non-humans in its surrounding world. Nonetheless it is possible to envisage the continual process described by Merleau-Ponty of a sensory body moving outwards to flesh the surrounding world, as well as the ways in which this process can be interrupted. If unthinking bodily control greatly expands the 'fraught', 'terrestrial carnality' inherent in all environments, thinking through this process exposes how the 'skin-boundary' to cross-species body contact reveals the weakness and permeability of human sensory bodies (Acampora 39). This phenomenological approach is particularly relevant for proposing that surprise heightens and/or cuts across sensory engagement that is automatic and therefore unnoticed in interactions with the surrounding world. Entrenched patterns of perceiving bodily that underlie cognitive processes also need to be disrupted in order to assist the kangaroo species, and other species, to be culturally visible.

The ways in which humans think about animals can not easily be separated from embodied feelings. While familiar surroundings are likely to produce a predictable encounter, feeling responses can still be startled out of pre-existing patterns given unexpected elements. Sensory engagement stirs physiological reactions that intersect with other bodily processes including emotional feelings which arise within embodied encounters and, as such, they are invariably implicated in cultural communication. In performance and visual art, however, it is possible to identify how the production elements contribute to the evocation of emotion. In performance the performers, including the animal performers, are surrounded by the effects of music and sound, costuming and props, staging and choreographed movement. The sum of these is intended to have an emotional impact. In performance, a spectator might viscerally feel and respond to the unexpected action of an animal performer as well as cognitively interpret the movement, but these have also been carefully staged to induce particular reactions.

As I argue elsewhere, animals are engaged by humans in the process of embodying and hence performing human emotions through the *mis-en-scène* and the constructed framing in television and cinema

(Tait, *Performances*). Humans unthinkingly transact and communicate their emotions with and through other animals, and mostly for financial gain in diverse commercial enterprises.

Decorative displacement

Acclimatised to France, the Chantilly kangaroos straddle ideas of Australian. The proprietary values surrounding species in the twenty-first century reflect human global migration routes except that the animals travelled as traded commodities in economic transactions. Living animals were unsentimentally traded on the same shipping routes as decorative objects that sentimentally depicted animals. But then, the economic function of the kangaroos on the Château estate zoo at Chantilly could also be a decorative one, although separate from the decorative function of taxidermy inside the Château.

In Australia, free-living kangaroos might be out of sight of most Australians living in a highly urbanised social world – unless the suburb is encroaching on kangaroo habitat – so encounters are the exception, but the kangaroo shape is highly visible everywhere. Images of kangaroos seem benign in comparison with practices that involve exhibited bodies, except that artistic and commercial imagery is designed to have emotional impact, and most clearly in literature and film and in ways that make animals captive to social ideas. To briefly contextualise the development of images in popular culture in Australia, historically, images of kangaroos – in an odd assortment of body shapes – appeared on precious silver and gold objects, ceramics and domestic ware, and wood carvings across the decorative arts (Younger; Simons). They appeared on coins, souvenirs, royal wedding gifts, and commemorative objects including those exhibited in the Paris Exhibitions of 1854 and 1866, and in 1878 this included a display of stuffed kangaroos (Lane). A French statue in Paris in 1878 depicted an Indigenous woman wearing a possum skin and holding a quartz rock with a (tame) kangaroo at her side (Lane, figure 5). There is little ambiguity in this promotion that groups together animal, female human and mineral elements of the geography as resources for exploitation and possession. By the twentieth century, kangaroos were on currency, the coat of arms and used as decorative shapes everywhere in culture, but with the status of a natural resource. The kangaroo image represented nationalist pride and, it might be added, species hubris (see Plate 9).

Animals are caught metaphorically within charming and endearing impressions in the decorative arts appearing on a wide range of objects

for official display and domestic use (Simons). But animal images on objects are not benign when they confer emotional significance. During the modernist era (Franklin), when kangaroo body shapes were some-times incorporated into the arts, they were depicted more accurately but as life-less shapes. For example, Edith Alsop's woodcut *Kangaroos* (circa 1930) features seven kangaroos. Similarly the American artist Mary Cecil Allen created 'Screen: five panels' (1941) with seven kanga-roos. Although depicted in groups, removed from contact with actual animals and body-to-body responses, emotive representations nonethe-less can influence social attitudes. In this way, habituated human emo-tions encircle if not entrap animals.

Conversely, in an interesting twist on how animal physicality was assimilated into modernist arts practice, D. H. Lawrence's key Australian character, Jack, in his novel *Kangaroo*, about an English couple living in Australia, is personified as bodily like a kangaroo. Lawrence writes: 'Jack himself wasn't unlike a kangaroo, thought Somers: a long-faced, smooth-faced, strangely watchful Kangaroo with powerful hind-quar-ters' (Lawrence 103). As Philip Armstrong and Laurence Simmons write, concepts of human identity rely on 'differences and similarities between ourselves and other animals' (1). As the kangaroo became omnipresent through the representational force of language symbolism and emotive image, the living kangaroo seems to recede from view.

In a further revealing precedent of displacement, the kangaroo dis-appears into an exotic place name in an early silent film featuring an athlete boxer as the central character but no actual kangaroos – only imported cattle and sheep species. The film, *The Man from Kangaroo* (1920), filmed in Kangaroo Valley in Australia, is in the genre of the American Western. An all-round swimming and diving champion and horse rider, ex-athlete Reg 'Snowy' Baker was John Harland, undertaking stunts that include leaping from high bridges and, while he seems like the physical ideal of Australian masculinity, he is characterised as a par-son, an ex-boxer who becomes a boxing parson.[7] In the moral codes of the film, the parson teaches boys boxing in self-defence which offends the sensibilities of the women in the town of Kangaroo who have him sent away. The hero is reunited with his true love, the orphaned heiress Muriel Hammond, in the dusty town where she owns a property and must fight her villainous guardian through a Wild West-style horse and stagecoach chase. Perhaps as a concession to the genre, kangaroos were not visible in the filmed countryside.

Unquestionably, the kangaroo was utilised as a populist emblem: from state symbols to domestic decoration; from sporting mascots to

entertainment icons. While decorative culture contained countless images of the kangaroo shape by the twentieth century, there was a differential gap between this popular representational field and kangaroo absence in the European-derived artistic and education knowledges within Australian-based socio-political culture. An absence of kangaroos in modernist representation of the Australian landscape was inadvertently revealing of cultural distortion.

Sentimental heroic action

If Australia is a nation with a colonial legacy of imported cultures that occupied the land of Indigenous people and animals, and of settlement patterns that were not reconciled to its flora and fauna or even its climate, perhaps its mythmaking strategies reached another level with the television programme *Skippy, the Bush Kangaroo*, featuring the Eastern grey kangaroo.[8] The television series catered to the popularity of animal shows on television in the 1960s (Chris), and this additionally compounded a history of exhibited and performing images of kangaroos into one strong, evocative identity. This family program was extensively viewed by more than one generation as a foundational cultural experience. It fostered a misleading belief that close living with kangaroos was possible since human–kangaroo physical contact was harmless. Camera shots of kangaroo bodies and close-ups of the face helped to convey an impression of intimate contact with the kangaroo for the viewer.

The highly successful television series *Skippy* relied on the appeal of the non-threatening kangaroo and in stories aimed at younger audiences.[9] The first series consisting of 91 episodes was developed from 1967 to 1969, and shown to international audiences from 1967. Repeats of the series were aired over ensuing decades and *Skippy* was briefly revived as a new series in 1992. This later series is interesting for what it reveals about late-twentieth-century values. When kangaroo meat was being used for pet food, Skippy was made to seem like a family pet. Between series one and series two, however, there were significant shifts in social values about the natural environment, and these included some recognition of Peter Singer's seminal work that was foundational to the animal liberation movement from the mid-1970s. But recognition of pro-animal values lagged well behind comparable values. In the revived *Skippy* series in 1992, while environmental concerns and Indigenous cave art could seem to be socially palatable, even de-politicised and featured in episodes, species rights were still not easily accommodated even in a television narrative starring a kangaroo.

The kangaroo character, Skippy, who is female, seems to live with a human family rather than a kangaroo social group and she is involved in rescue scenarios in each episode. Skippy, played by a number of kangaroos at any one time, makes appearances throughout each episode filmed either around the house or in a bush setting. But the kangaroo identity is less like an animal performer undertaking tricks or feats in a durational act in front of an audience and more like a photographic figure captured in different poses of short duration. An impression of face-to-face encounters between human characters and kangaroos is staged for the camera or created by juxtaposing shots in the editing. The kangaroos in the series belied even kangaroo playful or fighting behaviour, and Skippy's unnatural behaviour included numerous plots about heroic action on behalf of the human characters. The camera captured the watchful kangaroo in what are charming and endearing poses. In contrast to a sustained performance, the objectification of the kangaroo in this television series seems to belong to the tradition of kangaroos in sentimental decorative imagery for consumption.

The utility of animals as fictional characters in film and television is also about the function of emotional relationships in the narrative. *Skippy*'s appeal to children was reinforced with two younger characters, and Skippy is framed as a lovable friend, albeit one who might be smarter about the Australian bush than the human children. This provides the focus for, and reinforces belief in, a reciprocated caring human–animal exchange. Jerry and his twin live with their father, the adult Sonny Hammond, on a property called 'Habitat', with Aunty Phil as a surrogate mother figure. In an episode titled 'Skippy and the Polluted River' (©1992), Jerry and his friend Lou are fishing and notice that Skippy avoids drinking the water, after which they find dead fish.[10] When Aunty Phil suggests that the nearby mill is polluting the river, the children decide to do school projects on factories damaging the environment.[11] Grandad Bill Burgess is portrayed as a 'greenie' who has left the city, tired of the rush and pollution, and he accuses the local wood mill of being the environmental vandal as he chains himself to the gate with a banner: 'Until people put the environment ahead of greed and dollars we'll always have pollution.' A mill spokesperson claims that the mill abides by government regulations.[12]

Skippy leads the way down to the river to show the children a sick kangaroo with a joey, but the vet cannot save the kangaroo mother. Skippy is put in a cage so she does not drink the poisoned water – she found it in the first place – even though Jerry explains, 'Nothing a

kangaroo likes less than being caged.' When Burgess, the greenie grand-dad, drinks his water and becomes ill, a leaking pesticide container is discovered in his shed and it becomes apparent that he has accidentally poisoned the water. Thus the strong environmental statements sug-gested in earlier scenes are undercut as the narrative unfolds because the culprit is the greenie, Burgess, and his public protests are made to appear ridiculous.

Even with a story about pollution causing animal deaths, there was minimal species distinctive concern about how human society encroached on kangaroo lives. The final image is that of the father hold-ing and cuddling Skippy in his arms. A viewer is left with the image of human body-to-animal body contact – how to physically enfold the kangaroo body – even though this would be sensorily and physically difficult for the kangaroo. It provides a misleading depiction of physical body-to-body contact for the viewer.

The programme series had acquired token environmental and con-servation ideals by 1992 – although with limitations – but there was not a comparable pro-animal species scenario. Instead Skippy's kangaroo identity is displaced into that of lovable family pet. When the boys go rafting, Skippy is there; the portrayal of animal behaviour is misleading. Interestingly, the series was banned in Sweden because it would provide false impressions about animal species behaviour to children.[13]

The decorative function of the kangaroo was unavoidable in the epi-sode called 'Skippy and the Cave Paintings' (©1992), as the living ani-mal confronted artistic kangaroo representation. A didgeridoo musical instrument provides background sound in the opening scenes of filmed images of fauna and a cockatoo. In an interesting reversal, Skippy tries to stop two boys fighting and subsequently leads the twins through the bush to a cave. As she puts her paws up, waiting, the children explore the cave with a torch and find what appear to be Aboriginal paintings of diagrammatic black figures of kangaroos and goannas on the cave walls.[14] An Indigenous character, Joe Cooper, who works at a museum arrives and declares the cave paintings are fakes, a recent hoax. Although there is some concession to Indigenous artistic protocol with regard to the cave art, Indigenous presence does not extend to the major political issue of that time. In 1992, Indigenous land rights were being contested to reach the historic Mabo decision of the High Court that granted recognition of prior ownership (Butt, Eagleson and Lane). Joe gives a talk at the boys' school and explains that the only way that the kangaroo could escape from the hunter was tiptoeing away and then

later hopping. By implication, the kangaroo is smart enough to evade a hunter if he or she wishes – the hunter's gun is not mentioned.

Although confirming beliefs that kangaroos are smart animals, the 1992 series misleadingly portrays human–kangaroo cohabitation, and body-to-body contact with its distortion of species behaviour. The internationally prominent television series implicitly suggests that kangaroo species could share land with humans as it insidiously portrays how they are there to emotionally benefit humans. It does this with embellished narratives of well-meaning heroic action that reinforce foundational nineteenth-century myths about kangaroos as caring mother figures. The series transacts human emotions with kangaroo shapes and perpetuates a longstanding process of cultural acceptance of captive lives for animals.

David DeGrazia outlines key points in the argument about wild animals living in captivity with the example of a kangaroo. He describes life as being 'comfortable' in a zoo, with food and care, and discusses the argument about an inactive longer life versus the difficulties facing free-living animals, fending for themselves and having a shorter life span (58). DeGrazia summarises a central dilemma of rights presented by captive animals, 'whether exercising one's natural capacities – or species-typical functioning – is intrinsically valuable (conducive to well-being independently of effects on experiential well-being). [...since] liberty is valuable only to the extent that it promotes experiential well-being' (58–9). DeGrazia argues instead that captivity causes suffering by inhibiting capacities. Irrespective of ideas that the kangaroo should have subject rights or physical freedoms, the solitary Skippy kangaroo character without a social group was clearly less well off than a free-roaming relative in a group. Similarly a kangaroo – or kangaroos, in the case of Skippy – earned his or her (or their) keep by performing a false freedom of choice to cohabit while living without freedom of movement or species association. This potentially impacts on the social beliefs surrounding free-roaming species.

The *Skippy* television series perpetuated speciesist contradictions and beliefs while it implicitly demonstrated their fallacies. Narratives about human emotional relationships and animals solving problems mislead about the physical capacity of animals and other species for cohabitation. Elaborating on Singer's arguments, Paola Cavalieri explains that a group (species) might be defined by positive qualities, but in arguments against speciesism and 'human chauvinism', a range of qualities attributed to humans can also be observable in nonhumans (70, 77). Human

rights are therefore not unique to humans, and inalienable rights might also apply to species disputes including animal rights to land. But to argue for such a right and against lives in captivity is also to argue that humans should not have the privilege of control over the emotions of nonhuman bodies throughout representation.

The kangaroos in the filming of *Skippy* are pictorial. The filming repeatedly shows Skippy disappearing into the bush and makes the kangaroo body seem like a decorative feature of the Australian landscape. Skippy is depicted as being all too human through the emotional narratives, and it is this anthropomorphic emotional identity which remains detrimental to larger ideas of how to protect the habitats of kangaroo species groups.

In the twentieth-first century, human society seems more emotionally attuned to images and language than to living animals. As Skippy reigned on television screens globally, living kangaroos continued to be displaced and hunted for meat. The kangaroo shape had become pervasive in culture through its longstanding commercial and artistic exploitation which perpetuates a human – human transaction with an ongoing schismic rejection of living animals. There is a continuum of proprietary value underpinning the economic exploitation images of animals – one riddled with selective emotional stances and body-based reactions.

Kangaroo identity performs an emotional identity in Australian culture. A phenomenological physical response to cuteness and cuddliness obliterates recognition of the actual kangaroo species body; kangaroos literally and metaphorically embraced by humans are not seen as having distinctive species body needs. If encounters with animals open up the potential for phenomenological observation and sensory body engagement that might challenge the prevailing species hierarchies and falsities, the cultural familiarity of the kangaroo means that there needs to be a provocative dimension to the encounter. Further, this needs to challenge at the level of body-based emotional feeling. In a recent artistic depiction of kangaroo identity, three life-size red, white and blue kangaroos – flag colours – made with broken ceramic ware by Danie Mellor, suggest new directions in the twenty-first-century artistic representation of Australian fauna (see Plate 10).[15] The kangaroos are posed like the three wise monkeys. This understated artwork with its quotient of strangeness encapsulates how the kangaroo's exploitation in natural and symbolic economies since colonialism should also be located within a legacy of its emotional tragedy. This type of shift in

emotional depiction has the potential to emotionally recuperate kangaroo identity to benefit kangaroos.

Encounters with symbolic and living animals do open up the potential for understanding how phenomenological observation and sensory body processes function to maintain the prevailing species hierarchies. But the surprise of an encounter offers the possibility of a momentary hiatus in perception that challenges habituated responses and exposes preconceptions. Where unquestioned, predictable emotional sentimentality in culture prevails; however, decorative animal bodies remain captive to human emotions.

Notes

1. The author visited the Château de Chantilly on 11 April 2012, ostensibly to view the Live Horse Museum, The Great Stables, in the Domaine de Chantilly.
2. Christopher Dickman writes that up until the 1960s, the biological information about Australian marsupials was limited, as if 'marsupials were just '"second class" mammals' (vii). Dickman explains that only three books were available: G. R. Waterhouse, *The Naturalist's Library Vol. VIII. Mammalia. Marsupialia or Pouched Animals*, Edinburgh: W. H. Lizars, 1943; R. Lydekker, *Hand-book to the Marsupialia and Monotremata*, London: Edward Lloyd, 1986; Ellis Troughton, *Furred Animals of Australia*, Sydney: Angus and Robertson (1941, 9th edn. 1967). From the 1970s, however, studies of marsupials greatly increased after Hugh Tyndale-Biscoe's *Life of Marsupials*, London: Edward Arnold, 1973; and specialised volumes on *genus* were added. For a recently established information research centre, see http://thinkkangaroos.uts.edu.au/
3. See K. Boom, D. Ben-Ami, D.B. Croft, N. Cushing, D. Ramp and L. Boronyak, '"Pest" and Resource: A legal history of Australia's Kangaross', *Animal Studies Journal* (2012), 1:15–40. ABC, Radio National, *Australia Talks*, 1 April 2008. Kangaroo meat is popular in Russia and Mexico as a cheap source of meat protein but it is not a major meat eaten by humans in Australia. One in four Australians has eaten kangaroo meat. Ritvo finds 'kangaroo ham' on a menu in England in 1863 (*Animal Estate* 240).
4. An exhibition, 'Napoleon: Revolution to Empire' of Napoleonic era decorative arts at the National Gallery of Victoria, viewed on 24 August 2012, provided images and information about the Château grounds and gardens with Australian plants and animals. The exhibition included rare nineteenth-century charcoal drawings from Le Havre Musée d'Histoire: one was *Danse du Kangourou* (1802–04) (Dance of the Kangaroo) by one of two possible artists, Charles-Alexandre Lesueur or Nicolas-Martin Petit, and showed Indigenous dancers in costume imitating kangaroos in a line, with some crouched among trees; also see the book: Charles-Alexandre Lesueur and Nicolas-Martin Petit, *Voyage de Découvertes aux Terres Australes*: Atlas par M. H. Paris: Chez Arthies Bertrand Libraire, 1824.
5. *Table Talk*, 7 September 1888, 1.

6. It is likely that Lindeman travels to London and becomes Landeman with a different kangaroo at the Royal Aquarium in 1892, although there is also a history of imitation in this type of performance (Bostock 123; Williams and Golder 128). 'Westminister Aquarium', *The Era*, 30 December 1893, 15: 'Padrewski and his boxing bear are next on the bill, but the quadruped's achievement cannot be compared to that of the kangaroo, and he gets the worse of every round.' This supports E. Bostock's claim that he sees the boxing kangaroo in 1892.

7. It was directed by American Wilfred Lucas and American writer Bess Meredyth, and starred Brownie Vernon as Muriel. The casting of muscular athletes followed a practice used for the original Tarzan characters at that time and for film stunts. In the same year, however, a film called *The Boxing Kangaroo* (1920) was produced overseas and apparently did feature a kangaroo. See http://www.imdb.com/title/tt0011018/ accessed 3/6/2008.

8. The documentary *Skippy, Australia's First Superstar* was screened on 17 September 2009 on ABCTV One, and provides information about the series.

9. The Australian serial *Skippy*, created by John McCallum, used directors from England and was first shown in the UK during October 1967. It was produced over three seasons and 91 episodes and shown in 128 countries. Skippy was actually played by as many of 14 kangaroos.

10. *The Adventures of Skippy* ©1992, written by Allister Webb, directed by Rob Stewart and produced by Michael Midlam. Warner Roadshow Movie World Studios and Habitat Gold Coast Qld and Queensland Film Development Office. Simon James is Jerry; Kate McNess is his twin; Andrew Clarke is Sonny Hammond; Moya O'Sullivan is Aunty Phil; Jonathan Hardy is Bill Burgess; and Fiona Shannon is the vet.

11. The dialogue includes statements about recycling, and the twins photocopy both sides of the paper and advocate recycling sump oil and tyres.

12. Jerry and Lou join in protest at the mill, calling out, 'We want action. When do we want it? Now.' The boys are shown the main chemical filtration plant that is tested and monitored day and night by machine. The face of industry is a grandfather figure at the mill.

13. http://en.wikipedia.org/Wiki/Skippy_the_Bush_Kangaroo

14. Gary Cooper is Joe. The episode starts in the school ground with schoolboy competitive taunts, in which Jerry is defended because he has a (pet) kangaroo. The twins keep the cave a secret but do a school project on Aboriginal paintings, and compare the images in a book to those on the cave wall. Oral stories and the remembering of white settler culture blend with Indigenous culture and its oral traditions. The father tells his children about 'Stories of the Dreamtime', explaining the world as the Aborigines knew it.

15. These were made in 2008 and exhibited with one emu made by Laurie Nilsen from barbed fencing wire as part of the Museum of Melbourne exhibition of Indigenous art. Viewed by the author on 26 December 2009.

Works cited

Acampora, Ralph R. *Corporal Compassion: Animal Ethics and Philosophy of Body*. Pittsburgh: University of Pittsburgh Press, 2006.

Adcock, Fleur, and Jacqueline Simms, eds. *The Oxford Book of Creatures*. Oxford: Oxford UP, 1995.

Armstrong, Philip, and Laurence Simmons. 'Bestiary: Introduction'. *Knowing Animals*. Ed. Laurence Simmons and Philip Armstrong. Leiden and Boston: Brill, 2007. 1–22.

Boddy, Kasia. *Boxing: A Cultural History*. Durrington, UK: Reaktion, 2008.

Boom, K., D. Ben-Ami, D. B. Croft, N. Cushing, D. Ramp and L. Boronyak. '"Pest" and Resource: A legal history of Australia's kangaroos.' *Animal Studies Journal* 1 (2012): 15–40.

Bostock, E. H. *Menageries, Circuses and Theatres*. 1927. New York: Benjamin Blom, 1972.

Butt, Peter, Robert Eagleson, and Patricia Lane. *Mabo, Wik & Native Title*. Leichhardt: Federation Press, 2001.

Cavalieri, Paola. *The Animal Question: Why Nonhuman Animals Deserve Human Rights* Oxford: Oxford UP, 2001.

Chaudhuri, Una. '(De)Facing the Animals: Zooësis and Performance'. *The Drama Review* 51:1 (T193) (Spring 2007): 8–20.

Chris, Cynthia. *Watching Wildlife*, Minneapolis: University of Minnesota Press, 2006.

Cushing, Nancy, and Kevin Markwell. '"Fight hard, fight fair, never strike when down": Understanding the Boxing Kangaroo'. Unpublished paper, Global Animal Conference, 7–8 July 2011.

Daston, Lorraine, and Greg Mitman. 'Introduction: The How and Why of Thinking with Animals' *Thinking With Animals: New Perspectives on Anthropomorphism*. Ed Lorraine Daston and Greg Mitman. New York: Columbia UP, 2005. 1–14.

Day, David, ed. *Australian Identities*, Melbourne: Australian Scholarly Publishing, 1998.

DeGrazia, David. *Animal Rights*. Oxford: Oxford UP, 2002.

Desmond, Jane. *Staging Tourism: Bodies on Display from Waikiki to Sea World*. Chicago: University of Chicago, 1999.

Dickman, Christopher. *A Fragile Balance: The Extraordinary Story of Australian Marsupials*. Ill. Rosemary Woodford Ganf. Chicago: UP of Chicago, 2007.

Franklin, Adrian. *Animals and Modern Cultures: A Sociology of Human-animal Relations in Modernity*. London: Sage, 1999.

Ganslosser, U. (1989) 'Agonistic Behaviour in Macropods – A Review'. *Kangaroos, Wallabies and Rat-Kangaroos*. Vol. 2. Ed. Gordon Grigg, Peter Jarman and Ian Hume. Chipping Norton, NSW: Surrey Beatty. 475–503.

Golder, Hilary, and Diane Kirkby. 'Mrs Mayne and Her Boxing Kangaroo: A Married Woman Tests Her Property Rights in Colonial New South Wales'. *Law and History Review*, 21.3 (Fall 2000): 585–605.

Jackson, Stephen, and Karl Vernes. *Kangaroo*. Sydney: Allen & Unwin, 2010.

Johnson, David H. 'The Incredible Kangaroo'. *National Geographic* 108 (1955): 487–500.

Lane, Terence. *The Kangaroo in the Decorative Arts*. Exhibition Catalogue, National Gallery of Victoria, 1980.

Lawrence, D.H. *Kangaroo*, 1923. London: William Heinemann, 1964.

Merleau-Ponty, Maurice. *The Visible and the Invisible*. Trans. Alphonso Lingis. Evanston: Northwestern UP, 1995.

——. *The World of Perception*. Trans. Oliver Davis, London: Routledge, 2004.

Ritvo, Harriet. *The Animal Estate: The English and Other Creatures in the Victorian Age*. Cambridge, MA: Harvard UP, 1987.

——. *Noble Cows and Hybrid Zebras*. Charlottesville: The University of Virginia Press, 2010.

Rothfels, Nigel. *Savages and Beasts: The Birth of the Zoo*. Baltimore: Johns Hopkins University, 2002.

Simons, John. *Kangaroo*. Durrington, UK: Reaktion, 2012.

Singer, Peter. *Animal Liberation*. 1975. London: Pimlico, 1995.

Souter, Gavin. *Lion and Kangaroo: Australia 1901–1919. The Rise of a Nation*, Sydney: Fontana, 1976.

Tait, Peta. 'Circus Oz and Kangaroos: Performing Fauna and Animalness for Geo-National Identity'. *Australian Studies* 3 (2011): 1–22. http://www.nla.gov.au/openpublish/index.php/australian-studies/index0

——. *Wild and Dangerous Performances: Animals, Emotions, Circus*. Basingstoke: Palgrave Macmillan, 2012.

Waterhouse, Richard. *Private Pleasures: Public Leisure. A History of Australian Popular Culture Since 1788*. Melbourne: Longman, 1995.

Watson, Duncan. 'Kangaroos at Play: Play Behaviour in the Macropodoidea'. *Animal Play: Evolutionary, Comparative, and Ecological Perspectives*. Ed. Marc Bekoff and John A. Byers. Cambridge: Cambridge UP, 1998. 61–95.

Wheelwright, H. W. *Bush Wanderings of a Naturalist*. 1861. Melbourne: Oxford UP, 1979.

Williams, Margaret, and Hilary Golder. 'Fighting Jack: A Brief History of Australian Melodrama'. *Australasian Drama Studies* 36 (2000): 117–30.

Wilson, Maryland, and David B. Croft. *Kangaroos: Myths and Realities*. 1992. 3rd edn. Melbourne: Australian Wildlife Protection Council, 2005.

Younger, R. M. *Kangaroo Images through the Ages*, Melbourne: Hutchinson, 1988.

Index

Page numbers in italics are references to endnotes and include the endnote number.

Printed and bound by CPI Group (UK) Ltd, Croydon, CR0 4YY